The Art of the Conservator

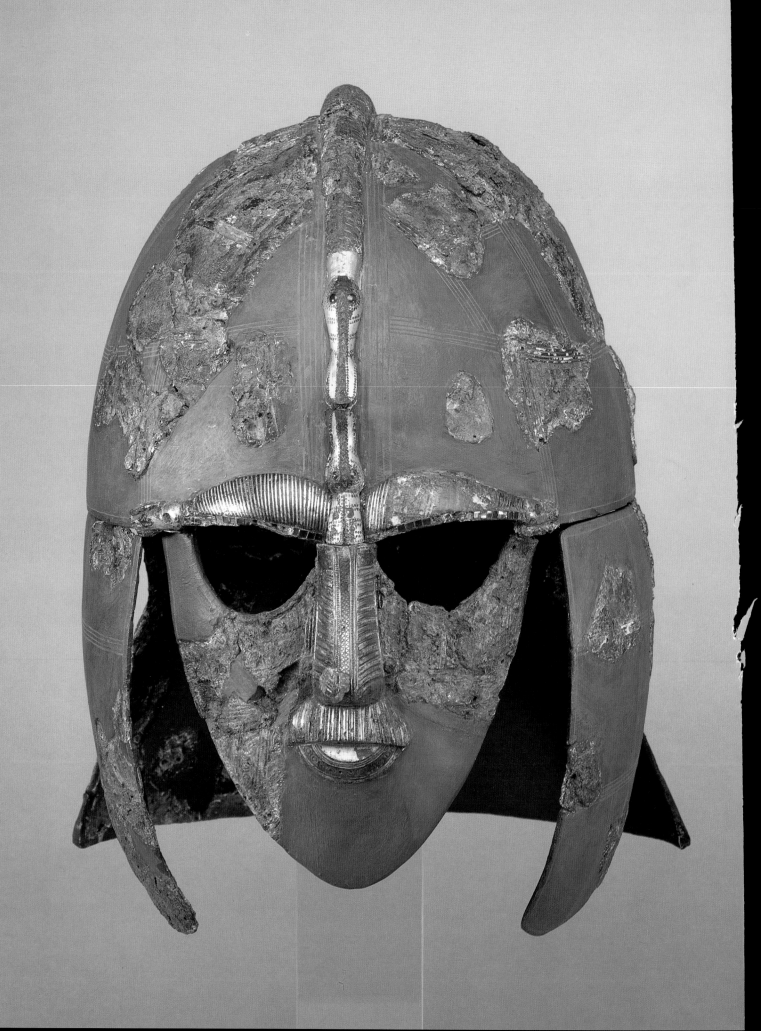

The Art of the Conservator

Edited by Andrew Oddy

SMITHSONIAN INSTITUTION PRESS
WASHINGTON, D.C.

© 1992 The Trustees of the British Museum

Published in the United States
by Smithsonian Institution Press

Library of Congress Catalog Number 92-60302

ISBN 1-56098-229-2

Designed by James Shurmer

Typeset in Linotron Ehrhardt by
Rowland Phototypesetting Ltd,
Bury St Edmunds, Suffolk

Printed in Italy
by New Interlitho, Milan

For information about American conservation
programs and conservation-related organizations,
the reader may contact the American Institute for
Conservation of Historic and Artistic Works,
1400 16th St. N.W., Suite 340, Washington, D.C.
20036

(*Frontispiece*) Anglo-Saxon helmet from the Sutton
Hoo ship burial, after reconstruction (see chapter 4).
British Museum.

Contents

The Contributors

ANDREW ODDY is Keeper of Conservation at the British Museum, where he has worked since 1966. He originally took a degree in chemistry at New College, Oxford, and after a brief spell in industry joined the Research Laboratory of the British Museum as a conservation scientist.

NORMA BORG CLYDE originally studied textile design at Glasgow School of Art. From 1980 to 1983 she trained in tapestry conservation at the Textile Conservation Centre at Hampton Court, where she now works as Deputy Head of Conservation Services, Tapestry Department.

PENELOPE FISHER has worked as a conservator of ceramics and glass in the Department of Conservation at the British Museum since 1977. She was awarded the conservation certificate of the Museums Association in 1981.

ERIC HARDING OBE is a conservator of works of art on paper at the National Gallery, London, where he has worked since 1988. From 1946 to 1965 he worked at the Victoria and Albert Museum, where he received his training as a conservator, and in 1966 he transferred to the British Museum, where he became Chief Conservator of western pictorial art.

ROBERT HOLMES originally trained as a silversmith at the School of Jewellery and Silver-smithing in Birmingham. He then worked as a conservator of metalwork in the Department of Conservation at the British Museum from 1978 to 1983, and is now a conservator of antiquities for Hampshire County Museums Service.

JOHN LARSON is Head of Sculpture and Inorganic Conservation at the National Museums and Galleries on Merseyside. Formerly Head of Sculpture Conservation at the Victoria and Albert Museum, he has also been an adviser to the National Trust, the Church of England and English Heritage.

IAN MCCLURE became in 1983 Director of the Hamilton Kerr Institute, a centre for the conservation of paintings and the training of paintings conservators and a department of the Fitzwilliam Museum, Cambridge. After studying English Literature and Art History at Bristol and Edinburgh universities, he trained as a paintings conservator in Glasgow.

FABRIZIO MANCINELLI studied medieval and modern art at the Università degli Studi in Milan. Since 1972 he has been in charge of the Department of Byzantine, Medieval and Modern Art at the Vatican Museums, and of restoration work in those areas.

ALESSANDRA MELUCCO VACCARO studied classical archaeology in Rome. Since 1979 she has worked at the Istituto Centrale del Restauro, Rome, where she is Director of Archaeological Restoration. She has been involved in the restoration of many important classical Roman monuments in both bronze and marble.

ERIC MILLER is a conservator of stone, wall paintings and mosaics in the Department of Conservation at the British Museum, where he has worked since 1979. He trained first as a graphic designer and subsequently as a conservator of sculpture and monuments at Croydon School of Art and Design.

SANDRA SMITH has worked since 1985 as a conservator of ceramics and glass in the Department of Conservation at the British Museum. She trained as an archaeological conservator at the Institute of Archaeology of London University.

NIGEL WILLIAMS is Chief Conservator of ceramics and glass in the Department of Conservation at the British Museum, where he has worked since 1961. He originally studied silver-smithing at the Central School of Arts and Crafts, London, and in 1972 was awarded the diploma in archaeological conservation of the Institute of Archaeology of London University.

Introduction

Andrew Oddy

To most people, 'conservation' means preserving the *natural* heritage, but long before the word was used in this sense the museum profession had applied it to all aspects of saving the *historic* heritage. In short, 'conservation' in the museum world means 'preserving the man-made material remains of the past'. But what is meant by 'preserving' in this context?

This book aims to answer this question by bringing together a dozen specialists who have been involved with the conservation of works of art made of eleven different materials. Some of the objects discussed, such as the Portland Vase (chapter 2), were conserved using very modern materials and technology. Others, such as the Hockwold silver treasure (chapter 8) and the Roman de la Rose tapestry (chapter 9), are examples of traditional conservation techniques carried out with consummate skill. In selecting these chapters we have looked for outstanding artefacts of international importance conserved using a wide range of materials and numerous scientific techniques of investigation, including microscopy, metallogra-

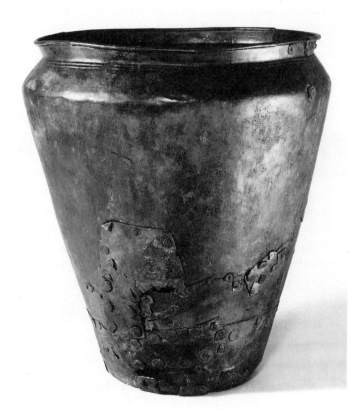

1 Bronze bucket dating from *c*.900–700 BC, found at Dowris, Co. Offaly, Ireland. The bucket was extensively repaired in antiquity by riveting on bronze patches. British Museum.

phy, radiography and chemical analysis. The eleven examples also demonstrate the differences between repair and restoration, and raise a number of questions concerning the ethics of conservation.

Repair is defined by *The Concise Oxford Dictionary* as 'to restore to good condition, to renovate, to mend, by replacing or refixing parts or compensating loss', and is a process which is as old as 'man the toolmaker'. Ever since *homo sapiens* learnt how to make useful things out of the natural materials around him, he has had to repair those objects when they break or wear out. A good example is the Bronze Age Dowris bucket in the British Museum. Numerous attempts were made in antiquity to repair holes in this bucket by riveting on bronze patches, and similar buckets, bowls and cauldrons which show evidence of having been repaired in this way are not uncommon in museum collections. All utilitarian objects are likely to be repaired, if this proves cheaper than buying a replacement, and riveting is a method of repair which applies not only to metal objects: cracked and broken ceramics were just as likely to be repaired this way in the days before the relatively recent invention of heat- and waterproof adhesives.

When, however, a non-utilitarian and purely decorative object is damaged, or perhaps just looking shabby, it is more appropriate to call the mending process 'restoration'. This is defined, again by *The Concise Oxford Dictionary*, as 'bringing back to original state by rebuilding, repairing, repainting, emending, etc.'. Thus the bronze head of Minerva in the Roman Baths Museum at Bath, which can be shown by a microscopic cross-section through a minute fragment of the surface to be covered with six separate layers of gold, must have been regilded several times in antiquity. The process of regilding can only be described as restoration. The head is presumably from a cult statue, whose only function was to be decorative and to be worshipped, but which would need regilding from time to time as the surface gold became dull, dirty, or rubbed away as a result of cleaning and polishing. Another example of the regilding of a bronze statue is that of Marcus Aurelius (see chapter 6), where again more than one layer of gold is visible on the surface and, furthermore, fifteenth-century records exist of payments for the work.

Another reason why objects may have been altered in the past, apart from the need either to repair or restore them, is as a result of changes in fashion, taste or politics. Take, as an example, the equestrian portrait of *Henry Prince of Wales* at Parham Park (see chapter 3); sometime after the untimely death of the prince in 1612, and presumably during the period of the Commonwealth, the portrait was probably rolled up and stored away, but after the Restoration of the monarchy the picture underwent a very radical restoration of its own, which altered its appearance completely. The motive may have been connected with changes in both fashion and politics during the later seventeenth century. Examples of alterations due to changing taste are the repainting during the Ming Dynasty of the statue of the Bodhisattva Guanyin (see chapter 11), which radically altered the original colour scheme, and the addition of draperies to the nudes in the fresco of the 'Last Judgment' in the Sistine Chapel (see chapter 5).

With the establishment of both private and public collections of antiquities following the Renaissance in Europe, the demand for the 'restoration', rather than the 'repair', of antiquities began to increase, and the foundations of the conservation

2, 3 (*Right*) Gilt-bronze head of Minerva, made in the second century AD and found at Bath. Bath, Roman Baths Museum.
(*Below*) Metallographic cross-section through a minute flake from the surface of the head of Minerva. Six different layers of gilding can be seen, indicating that the head was regilded several times in the Roman period.

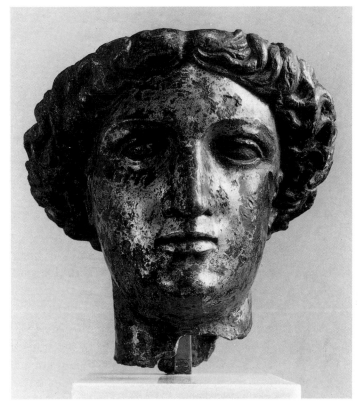

profession began to be laid. However, in the early days, the only people available to carry out restoration were craftsmen who made similar objects themselves. Many such craftsmen developed their own materials and processes for what can only be called renovation, because their main aim was to disguise the fact that the object had ever been in need of restoration.

The Grand Tours of the seventeenth and eighteenth centuries created a demand among the aristocracy for fine sculptures and other antiquities to ornament their 'modern' stately homes, and the artisans of the day were only too willing to carve the missing bits for a fragmentary ancient statue. Noses, ears and limbs are commonly found to be relatively modern replacements in any collection of sculpture which was put together before about 1950, and it is only quite recently that curators have begun to have most, if not all, non-original restorations removed, and to allow the public to use their imagination instead. A good example of the creation of a 'complete' object out of a fragmentary one for sale to Grand Tour customers is the Piranesi Vase (chapter 7). Giovanni Battista Piranesi used fragments of an antique stone vase from Hadrian's villa in Rome to create what was essentially a new work of art. However, as far as the original customer, Sir John Boyd, was concerned, he was buying a piece of antique sculpture.

In the nineteenth century in particular, when there was a boom in the antiquities trade and a tremendous demand for fine and rare objects for gentlemen's 'curiosity' cabinets, restorers would often use bits from one object to restore another, or create pastiches by joining together fragments from two or more objects to create a 'fantasy' object which could be sold as a particularly rare, or unique, item. This is especially

true of pottery and metal objects originating in Italy, where the so-called restorers of the nineteenth century would today be more appropriately described as fakers. A good example of a metal pastiche is a bronze vessel which has probably been in the British Museum since the eighteenth or early nineteenth century, although the exact date and circumstances of its acquisition are unknown. In fact, it seems that at one time it was almost thrown away, being regarded as of little interest. However, it was rescued from near oblivion in the early 1970s when a piece of genuine ancient bronze was required for experimental purposes. Close examination showed that the footring and decorated rim did not belong to the body; moreover, when these were removed, the body turned out to be an example of a rather rare type of Roman bronze bucket.

Another example is a fourteenth- or early fifteenth-century maiolica jug, made in Orvieto, Italy, and of a type which was popularly collected by gentlemen on the Grand Tour. When the jug was examined in 1986, prior to possible inclusion in a special exhibition of Italian maiolica, extensive previous restoration became apparent. The jug was dismantled, and when the pieces were examined the base and six of the sherds were found to be from a number of other vessels. This is not uncommon: maiolica commanded high prices, so 'complete' pots were fabricated for the 'tourists' by excavating the kiln sites and making pastiches of vessels from the available material.

The history of early restoration has yet to be written, but virtually nothing was recorded at the time by the craftsmen involved, and it is up to today's conservators to record what they find when conserving objects. In fact, in cases where works of art have been restored more than once, the detailed examination which is necessary in order to distinguish between the various previous interventions can be long and painstaking, involving conservators, museum scientists and curators. The work of conserving the Sistine Chapel frescoes, for instance, has also documented numerous previous attempts at restoration (see chapter 5), and the examination of the Bodhi-

4, 5 (*Left*) Maiolica jug made at Orvieto, Italy, in the fourteenth or early fifteenth century AD, in the condition in which it was acquired by the British Museum in 1913. (*Right*) The same jug after removal of nineteenth-century restoration and dismantling, which showed that the base and several sherds originally belonged to other vessels.

4

5

 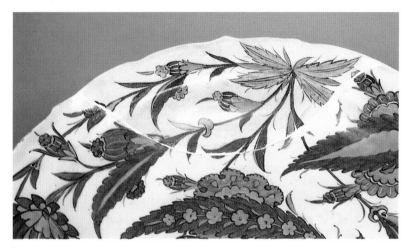

6, 7 (*Left*) Sixteenth-century Iznik dish, in the condition in which it was acquired by the British Museum in 1983. (*Right*) Part of the rim of the same dish after the removal of overpainting, which revealed a nineteenth-century restoration made of fired and glazed clay.

sattva Guanyin revealed three previous interventions, two during the Ming Dynasty and the third relatively recently (see chapter 11).

In fact, however, it is not the materials of the early restorer which are a mystery, as these were few enough (although not always easy to identify), but rather his techniques and recipes. The materials consisted of beeswax, paraffin wax, animal glue, flour paste, shellac (and French polish), plaster of Paris and powder pigments. Natural gums, such as gum arabic, and resins, such as colophony, were also used, and a wide range of materials as fillers – wood, sawdust, cardboard, paper, powdered stone or crushed pottery, and even cement. These materials were combined in innumerable ways to join together the fragments of an object and then to hide the fact that it had been restored.

Even as late as the 1960s, those restorers who had trained before the Second World War often had their own secret way of doing jobs and their own secret recipes for sticking, colouring or patinating. As the present generation of scientifically trained conservators works its way through old collections, reconserving objects treated many years ago, an amazing variety of conservation materials and techniques is uncovered. Patination of repairs on metal objects, for instance, was generally effected by grinding up the corrosion layers which had been chipped off another object, and mixing the resultant powder with animal glue or shellac. In some ways this is not too far removed from the process of surface-colouring restored areas of objects today, but the difference is that now the aim is to tone in with the original, but not match it exactly, while until recently the opposite was the case.

In museums nowadays, the 'six inch–six foot' rule is usually followed: a visitor viewing the display in a showcase (about six feet away) sees 'complete' objects, while the expert can see at once what is old and what is new when he examines the piece (from about six inches away). A very good example of this rule is the restoration of the Sophilos Vase (see chapter 10). The other basic rule of restoration is that all added 'retouching' should be 'reversible', or easily removable, and the ways in which modern conservators solve this problem vary from material to material. The damage to the Leonardo Cartoon (see chapter 1), for instance, was restored with a mixture of finely ground chalk and charcoal, which can be removed with a soft brush and gentle suction with a mini-vacuum cleaner, while the Roman de la Rose tapestry

(chapter 9) has been restored by the addition of new warp and weft threads in many places. These are also easily removable. In both these cases the retouching materials are related to those of the original object, but in the Sutton Hoo helmet (chapter 4) and the Sophilos Vase very different materials have been used to fill the gaps.

It was common in the nineteenth and early twentieth century to restore metal objects with matching metal, and stone objects with matching stone, and, as these are the natural ways that a craftsman would think of *repairing* objects, it is not surprising to find the same techniques and materials used in *restoration*. What is a bit more surprising, however, is that the same principle was sometimes also used for the restoration of ceramics, where, instead of using plaster of Paris to fill gaps, some restorers created new sherds out of clay, which were then fired and glazed before being stuck into the vessel. An example is a sixteenth-century Iznik dish 6 which has been broken and restored at one point on the rim. Only one sherd is involved, but close examination shows that although it is a very close match to the original bowl in design, there is a slight difference in colour. The question thus arose whether the replacement sherd was made by the original potter or whether it was a later restoration. The sherd was removed from the bowl and subjected to a 7 scientific examination in a scanning electron microscope which clearly indicated that the sherd was not Iznik ware. It was presumably made in the nineteenth century.

The principle of using the same materials as the original for restoration also extended to organic objects and paper. When a drawing has a corner missing, the obvious way to repair it was, and still is, to attach a new corner made out of paper with a similar weight and texture. Such a repair will always be visible, at least from the back if not from the front. But repairs to, or restoration of, other organic objects with original materials may be impossible to detect. If damaged baskets are rewoven or new feathers attached to a mask or headdress, only a documented record of the restoration will indicate what has happened. Such conservation records are very rare in museums before about 1960, and they are rare in the private sector even today. Nowadays, the conservation of ethnographic objects relies heavily on using sympathetic materials which tone in with the original ones, but which are chemically and physically different. Feathers which have become badly damaged by poor handling, or as a result of insect attack, are now repaired as far as possible, but never replaced, and the reweaving of baskets is carried out with twisted and coloured strips of Japanese paper, rather than with reeds or withies which are identical to those originally used to make them.

Modern scientific conservation is governed by an unwritten set of rules or ethics. Numerous attempts have been made to codify these 'rules', but all are doomed to failure because the approach to conservation can never be generalised, and is very dependent on the aims of the particular museum and curator. This is most easily demonstrated by considering a clock. By and large, the public is not interested in clocks which are not working. But if they do tick away, then the mechanism slowly wears out. Thus by showing the public what it wants to see, we are slowly destroying the object in question! Conservation ethics have only evolved since the process of repair turned into the process of restoration, which is a comparatively recent change, post-dating the establishment of museums in the modern sense. A good example of ethical considerations being of prime importance when deciding the course of a

conservation treatment is the restoration of the Hockwold silver treasure (see chapter 8). Because these silver cups had been deliberately damaged before burial, there had to be overwhelming reasons to restore them to their original shape.

The main principle underlying conservation today is thus that the integrity of the original parts of the object should be respected and that any additions (restorations) should be easily removable. Modern conservators are very conscious of these guidelines, but the chapters in this book reveal that they are a very recent concept. The dismantling and re-restoration of both the Sophilos Vase and the Sutton Hoo helmet have shown that previous restorers (working since the Second World War) had filed down the edges of some of the fragments in order to achieve a 'better fit'!

The Growth of the Conservation Profession

The first museum 'restorers' were craftsmen who used traditional materials to repair objects. Just like their colleagues who worked for the dealers, many of them had their own secret recipes which they might pass on to a favoured colleague after a long apprenticeship, but little is known, or has been written, about the nineteenth- and early twentieth-century practitioners and their methods. At the British Museum, however, a few have left their mark. The wanton destruction of the Portland Vase in 1845, and its subsequent restoration, have meant immortality for the conservator involved, John Doubleday (see chapter 2). Doubleday was succeeded by a dynasty of Readys – Robert Ready and his two sons Talbot and Augustus, the last of whom was still working at the Museum in the later 1930s. Robert Ready was particularly famous for cleaning and restoring cuneiform tablets, but his family also made high-quality electroformed copies of coins and antiquities, which now command high prices in the sale-room. The recruitment of craftsmen, often with a background in silversmithing, locksmithing or jewellery-making, continued until the end of the 1950s, when the graduates of the first formal training course in the UK (at the Institute of Archaeology of London University) began looking for employment.

Modern scientific conservation, in fact, has its roots in a small band of scientists who were employed in a few European museums in the nineteenth and early twentieth centuries. First and foremost was Friedrich Rathgen in Berlin, who researched a number of conservation techniques, particularly for metals, and in 1898 published the first scientifically based book on what can truly be called conservation. An English translation was published in 1905, and was the basis of scientific conservation in Britain for many years. While Rathgen was working in Germany, the National Museum in Copenhagen was struggling to conserve numerous finds of metal and wooden objects which had been almost perfectly preserved by the anaerobic conditions in the extensive peat bogs of Denmark, but which deteriorated at an alarming rate once they were removed from the ground as a result of the cutting and drying of peat for fuel. The problems associated with the conservation of objects from peat bogs were researched by Gustav Rosenberg, who also wrote a small book on conservation which was published in 1917.

In England and America, scientific conservation took root and developed between the two world wars. At the British Museum, when the collections were unpacked in 1919 after wartime storage in the Underground railway tunnels, many objects

8 Foot from an Egyptian limestone statue, covered with salt crystals. The crystals grew out from the surface of the stone as a result of the fluctuating humidity of the air inside the temporary storage area where the foot was kept during the First World War.

were found to have rapidly and unexpectedly deteriorated. Archaeological iron was rusting, and covered with droplets of a dark brown liquid; archaeological bronzes had developed spots or patches of loose green powdery corrosion (christened 'bronze disease'); some pottery and stone objects were covered in growths of salt crystals; 8 organic objects were affected by moulds, and many works of art on paper had acquired a rash of brown spots, known as foxing. The British Museum called on the services of Dr Alexander Scott, FRS, as a consultant, and then decided to set up a permanent scientific research laboratory for investigating the causes of decay and the methods of treating its effects. In 1926, Dr Harold Plenderleith, MC, was 9 appointed to a post as a conservation scientist, and since then the British Museum has been in the forefront of conservation research.

Sadly, between the wars, conservation research on archaeological objects lapsed in both Berlin and Copenhagen, but an interest was developing in the USA, which led to the establishment of the first journal for conservation and technological research on antiquities and works of art, *Technical Studies in the Field of the Fine Arts*, published by the Fogg Art Museum at Harvard. This ceased publication during the Second World War. After the war, a number of museum scientists again got together and in 1950 founded the International Institute for Conservation of Historic and Artistic Works, with its administrative office in London. Today IIC has members and fellows in sixty-five countries throughout the world, and membership is open to anyone who is interested in the preservation of the material remains of the past. IIC publishes a quarterly journal, *Studies in Conservation*, and organises a biennial conference.

As a consequence of the increasing numbers of conservators and their increasing professionalism, numerous national societies have been established which often publish their own journals and monographs. Such societies exist in the USA, Germany, France, Hungary, Scandinavia, Australia, Canada, England and Scotland, to name but a few, and the resulting proliferation of journals means that the literature of conservation is now very extensive, and growing fast. The publication of a biannual abstract journal called *Art and Archaeology Technical Abstracts*, by the Getty Conservation Institute in Los Angeles on behalf of IIC, is thus an essential aid to keeping abreast of the literature for conservators and conservation scientists alike.

Conservation is organised differently in different countries. In some, such as France and Italy, most conservators work in private practices and museums will hire them to conserve their collections as required. In others, such as the UK, USA and Germany, conservators are permanently employed in museums, often having a career structure parallel to that of the curators.

Running alongside the increasing development of international contacts in the field of conservation since the last war, has been the setting up of formal training courses in a number of countries. Among the first courses to be established were those at London University on archaeological conservation (at the Institute of Archaeology) and on easel painting conservation (at the Courtauld Institute of Art) in the 1950s. Now courses are available in many countries in an increasing number of specialisms, such as textiles, sculpture, archives, furniture, etc., but there is absolutely no uniformity about the entry requirements, syllabi and amount of practical training offered. The result is a bewildering array of qualifications, ranging from certificates of attendance via diplomas to full-blown first and post-graduate degrees. Most courses, however, last between two and four years, but some of them cater for school-leavers while others will only accept graduates from a relevant degree course. A world-wide guide to such courses has been published by the International Centre for the Study of the Preservation and the Restoration of Cultural Property in Rome (known as ICCROM), and a guide to courses in the UK is published by the Conservation Unit of the Museums and Galleries Commission.

9 Dr H. J. Plenderleith (right) and H. V. Batten examining the bronze hanging bowls from the Sutton Hoo ship burial on their return to the British Museum after the Second World War, when they were stored in the Underground railway tunnels.

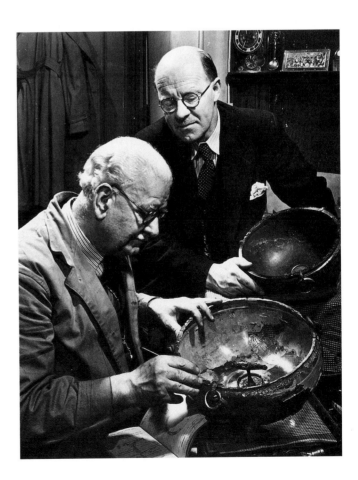

Recent and Future Developments in Conservation

The past forty years have thus seen what was originally a craft develop into a profession. But this new professionalism is not only the result of changing attitudes among – and changing attitudes between – conservators and curators; it also owes much to the increasing use of scientific techniques and the development of new materials.

While conservators had to rely on animal glue, flour paste and natural waxes, gums and resins as adhesives, the scope of their work was somewhat limited. But with the introduction of synthetic resins, the world of conservation was revolutionised. The first synthetic adhesive was cellulose nitrate, discovered more than 150 years ago and certainly used by Rathgen in Berlin in the late nineteenth century. It can also be used as a lacquer for metals. Picture restorers, too, found that they could reduce the gradual discoloration of picture varnishes by making them from synthetic resins rather than natural ones. During the past half-century, the number of synthetic adhesives which have become available is legion, giving the conservator a wide choice to suit most eventualities.

The Portland Vase, for example (see chapter 2), has been restored with two ultra-modern adhesives. One of them is an acrylic resin which polymerises when exposed to ultraviolet light. The surfaces to be joined are coated with the resin, pressed together, correctly aligned, and then held briefly in the beam of a special UV lamp, which creates an instant join. We cannot imagine what developments in adhesive technology may occur in the future, but nobody has yet produced the perfect adhesive which is colourless and easily reversible, does not react chemically with any object, does not discolour, become brittle or insoluble or lose its adhesive power on ageing. Interestingly, cellulose nitrate, the first synthetic adhesive, most nearly fulfils all these criteria and is still widely used – in spite of some recent misguided attempts to discredit it – because it is strong and yet easily removed with a little acetone. However, for joining very hard materials, like metals, glass and porcelain, epoxy resins are often used, and polyesters are frequently used on stone. The recently developed cyanoacrylate adhesives, which give an instant join (even between the fingers!) are not useful, however, because conservators need a few minutes of setting time to make sure that the surfaces are correctly aligned.

As well as new synthetic adhesives, materials available to the modern conservator include protective coatings, corrosion inhibitors, surface active agents, complexing agents, bleaches and enzymes for stain removal, tarnish removers, and modern dyes and pigments. In addition, a wide range of machines and laboratory instruments have dramatically changed conservation methods in recent years. The metals conservator will routinely use electrical or pneumatic engraving tools or airbrasive machines to assist with the removal of corrosion, and the ceramics conservator will use conductivity meters or specific ion meters for monitoring the removal of soluble salts from porous pottery by washing. Acidity in paper and textiles is routinely measured with pH meters, and traces of former adhesives and consolidants are identified by infrared spectroscopy. Textiles and other organic objects are cleaned using the latest washing technology, or by dry cleaning in specially adapted machines in which the objects stay still but the solvent is circulated, and paintings on silk may be patched

with modern silk which has been deliberately weakened by exposure to nuclear radiation in an atomic reactor to simulate the effects of ageing.

One of the problems facing a conservator when confronted with an object which has been restored in the past is to find out how much of it consists of skilfully disguised make-up. In fact, the detection of hidden restoration is relatively easy in a modern museum laboratory. A close examination of the surface of an object by an experienced conservator will often reveal discontinuities in texture or colour which indicate the presence of restoration, and this examination is often aided by the use of a low-power binocular microscope with magnification up to about × 50. When restoration is suspected, the careful application of solvents to remove small areas of 'paint' will confirm the original suspicions. As far as metals and pottery are concerned, natural corrosion layers and glazes are not soluble in organic solvents such as acetone, toluene, methylated spirits and trichloroethylene, but resinous adhesives and varnishes or lacquers used for fake patinas and glazes often are. These solvents are applied by moistening a cotton bud with one of them and then gently rolling it backwards and forwards over a small area of the surface. If the patina or glaze is soluble, traces of colour will usually begin to appear on the cotton wool within a minute or two, although it may be necessary to replenish the solvent as it evaporates. If the first solvent fails to lift any colour, the others should be tried.

However, if a range of solvents fails to reveal suspected fake patination, the next step is to examine the antiquity by the light of an ultraviolet (UV) lamp. This must be used in a totally darkened room, and the operator must wear goggles to protect his or her eyes from the UV radiation, which is harmful. The lamp is positioned so that its beam of radiation is directed downwards on to a table where the suspect antiquity is placed. The antiquity is then rotated and turned by hand so that the whole surface can be inspected. Genuinely corroded metals and original ceramics take on a dull purple colour under the UV lamp and are difficult to see in detail, but many organic compounds fluoresce, becoming more visible. This is because the organic compounds absorb the invisible UV radiation, but then re-emit it as visible light. This is called fluorescence.

If a potentially fluorescent adhesive has been used to stick the fragments of an object together, or has been mixed with pigments to create an area of false patination, the glue lines or restored area will show up as a bright yellowish or orangey colour when viewed under the UV lamp. A good example of this is a Chinese *fang ding*, a
10 ritual bronze vessel of the early Zhou dynasty, dating to the eleventh century BC. In this case, previous restoration was suspected not because the surface showed unusual changes of colour or texture, but because when it was tapped with another piece of metal it failed to respond with the usual 'ringing' sound. Examination
11 under an ultraviolet lamp showed numerous lines and areas of fluorescence, indicating the presence of a modern synthetic adhesive, and it is obvious that the *fang ding* has been broken into many fragments, but then invisibly repaired. Ultraviolet fluorescence will also show up overpainting in many cases, and a good
12, 13 example is another piece of Italian maiolica of about AD 1500 which had been extensively 'invisibly' restored.

A related technique for looking below the surface of an antiquity is to photograph

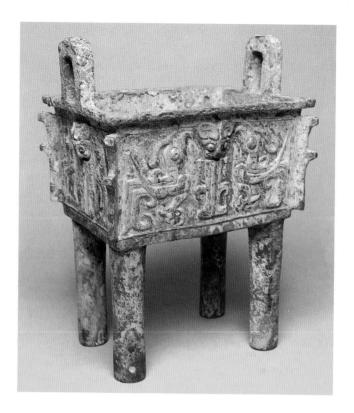
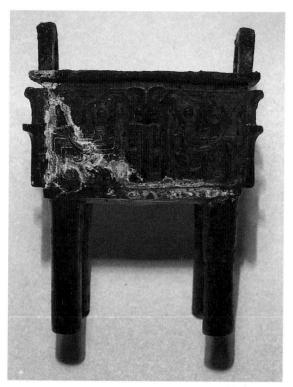

it using infra-red sensitive film or with an infra-red sensitive video-camera and TV monitor. This will often reveal overpainting, by showing up the underlying layer. A good example is the Parham Park portrait of *Henry Prince of Wales* (see chapter 3), which was shown to have undergone significant changes in composition. Although this technique does have some use in conservation, its main use is in the elucidation of changes made to objects in antiquity, for instance in examining altered documents and hidden inscriptions, and exposing inscriptions which have faded.

Finally, radiography can be used to complement and follow up a UV examination. The UV lamp will often reveal that an object has been restored and will indicate the position of glue lines, but a radiograph will give an exact picture of the fragmentary nature of the object. The principle of the technique is exactly the same as its use for medical purposes. When X-rays are passed through an antiquity and allowed to fall on an X-ray plate, the intensity of the emergent X-rays will depend on how much radiation has been absorbed by the object. In the case of a metal object, the metal will absorb a lot of the radiation and so the corresponding part of the X-ray plate will be light. But areas of restoration which were made, for instance, with plaster of Paris will absorb relatively little of the radiation, so the corresponding area of the plate will be darkened. Joins, therefore, show up as dark lines on a paler background.

One of the problems of projecting the X-ray of a three-dimensional metal object onto a sheet of X-ray film is that a two-dimensional image is obtained. This superimposes the breaks on both the back and front of, for instance, a cauldron. However, with modern techniques of examination it is possible to put the object on a turntable and view the X-ray image on a television screen while rotating the object. Another

10, 11 (*Left*) A Chinese bronze ritual vessel known as a *fang ding*, made during the early Zhou Dynasty (11th century BC). British Museum.
(*Right*) The same *fang ding* lit by ultraviolet light, showing areas of fluorescence which are evidence of modern restoration.

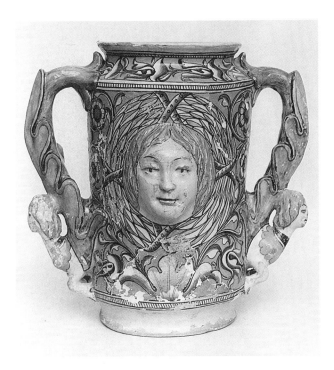
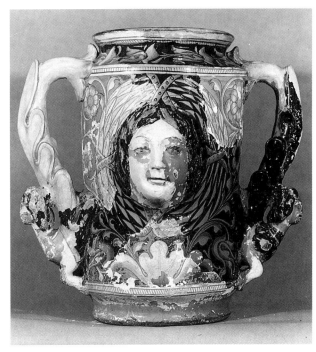

12, 13 (*Left*) Maiolica storage jar, made in Italy *c.* AD 1500, in the condition in which it was acquired by the British Museum in 1888. (*Right*) The same jar lit by ultraviolet light, revealing extensive areas of nineteenth-century restoration.

trick is to cut pieces of X-ray film and wrap them round the inside of the vessel, thus eliminating the possibility of the X-ray image from both back and front appearing on the same film.

Science has thus made a tremendous contribution to the materials and methods of conservation since the Second World War, but hardly any processes have yet been discovered which are adaptable to mass-treatment. With the possible exception of the treatment of waterlogged wood, which can be successfully carried out in batches by freeze-drying or by impregnation in large tanks containing hot polyethylene glycol, conservation still relies almost entirely on a one-to-one relationship between the object and the conservator. The materials may have changed, and been supplemented by machines and scientific instruments, but in the end the four basic stages of conservation – stabilisation (arresting the process of decay), cleaning, repair and restoration – have not changed since scientific conservation began over a century ago.

It is difficult, therefore, to look into the future and predict how the profession might change. There is no doubt that there will be new and better ways of studying the technology of objects by the scientific analysis of metals, alloys, stone, ceramic bodies, glazes, glass, enamels and other inlays. We shall learn more about methods of decoration on a wide range of materials and we shall identify more dyes and pigments. It is also likely that new chemicals for cleaning and consolidation will be invented, but these are often a mixed blessing because of their toxicity. For instance, the strengthening of seriously decayed limestone has been revolutionised in recent years by the introduction of a class of consolidants called silanes, but silanes are toxic and so can only be used in a room fitted with fume extraction equipment and by operatives wearing face masks and protective clothing.

14

Indeed, a fume cupboard, where chemicals that are dangerous to health can be

used safely, is now an essential piece of equipment in all conservation studios. Even some everyday epoxy resin adhesives, which are to be found in every handyman's tool box, can only be used in large quantities – for instance when backing a mosaic pavement – in a special workshop space fitted with full fume extraction. Similarly, the use of large quantities of adhesives dissolved in organic solvents, for instance for the strengthening and repair of large objects such as Egyptian sarcophagi, also requires a fume-extracted working area.

Another process regarded with increasing suspicion is fumigation, which should automatically be applied to all organic materials on entering a museum or on returning to the collection from an extramural loan. Wood, fur, textiles, leather, etc. may have become contaminated with insect pests, which must be killed for the sake of that object and for the sake of the rest of the collection. Numerous poisonous gases have been used for fumigation in the past, in particular hydrogen cyanide and methyl bromide, but in recent years these have been superseded by ethylene oxide. However, this is now regarded as too hazardous, and the search is on for an asphyxiating gas which is non-toxic. The answer may prove to be carbon dioxide, but encouraging results are also being obtained by freezing objects in a domestic freezer.

If freezing or carbon dioxide fumigation are found to be effective methods of pest control, they will constitute examples of processes becoming less rather than more technical. Another such example is the recent introduction of steam cleaning, particularly for marble and stone sculpture and for dirty ceramics. Steam cleaning has proved to be extremely effective for the removal of ingrained dirt on slightly porous surfaces, and infinitely quicker than the traditional poulticing and washing techniques. It was used with great success on the Piranesi Vase (see chapter 7).

For the future, effective solutions remain to be found for some long-standing problems. The removal of chlorides from the corrosion layers of iron and bronze, the removal of salts from porous stone, the consolidation of painted surfaces without

15

14 A conservator using silane to consolidate very fragile limestone from Egypt. To protect him from the fumes, he wears overalls, gloves and a helmet connected to an air-line.

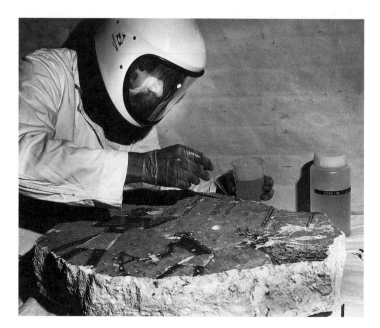

15 Cleaning dust and ingrained dirt from the surface of a large marble statue of the Amitāba Buddha, using steam. This statue was carved in China during the Sui Dynasty (6th century AD). British Museum.

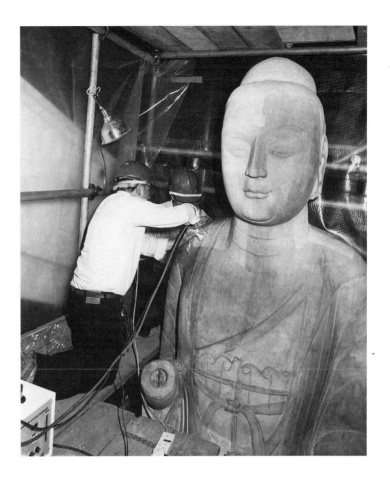

causing a colour change, and the restoration of glass with a clear inert filler which does not discolour are just a few of these, although in most cases partially successful treatments have been introduced in recent years. The key to a successful treatment is often a complete understanding of the process of decay, but for many materials the processes of decay at a microscopic level are still far from clear.

Causes of Decay and its Prevention

Understanding the causes of decay is also crucial for the long-term preservation of objects. The eleven works of art discussed in this book are all examples of 'active' or 'interventive' conservation, that is the science of evaluating the condition of an object and then treating it so as to arrest decay, clean it, repair it, and then, if necessary, restore it. 'Passive' conservation is the science of storage and display whereby the environmental conditions and the atmosphere are controlled so as to prolong the life of an object indefinitely (in theory, at least).

It is a commonly held fallacy that once an object enters a museum it is safe, whether it is a great painting or a humble medieval pot. Nothing could be further from the truth, and objects can continue to deteriorate in museums for a number of reasons: the air may be too dry or too damp (humid); the humidity of the air or its temperature may be fluctuating widely; there may be too much light; the object may be attacked by pollution in the air, by micro-organisms (moulds), by insects

and animals; and the object may be affected by man, for instance by the wear and tear caused by handling, by accidental damage, or by the occasional act of deliberate vandalism.

The effects of the above causes of deterioration are obvious to everybody from their domestic environment. For instance, if a newspaper is left in the sun it becomes yellow and brittle, while brightly coloured curtains hanging in a south-facing window will fade. Insects eat wood – as those with woodworm in their property know only too well – and moth larvae eat textiles. Even stone, which appears to be such a durable material, can be ravaged by our modern polluted atmosphere, as can be seen by looking at the effects of acid rain on the carvings of many old churches and cathedrals. Some of the factors in the above list are connected. For instance, moulds will not grow in dry conditions. If half a loaf of bread is put outside in the sun in hot weather it will become dry and hard, and shrink somewhat as it loses moisture. If it is put in a damp cellar, it will become mouldy. These examples of decay which surround us in our daily lives are potentially mirrored in museums, so it is of prime importance that the causes of decay are considered and their effects minimised when storing and displaying objects.

Temperature and humidity are generally considered together, because the latter is conventionally expressed as a quantity called 'relative humidity' (RH). As air warms up, it is able to hold more moisture and so the RH falls, and vice versa. Hence objects which are sensitive to changes in RH should be stored and exhibited under controlled conditions of both RH and temperature. Such objects are generally 'organic' – meaning that they are made of animal or vegetable products, such as wood, ivory, bone, leather, etc. The cracking of wood as it slowly dries out will be familiar to most householders, and other animal and vegetable products behave in the same way. Ivory is particularly sensitive, and carvings which have been made from fresh ivory frequently crack if displayed in modern, centrally heated dwellings. The reason for this cracking is the loss of water, which is part of the make-up of all organic materials.

Cracking may also be caused by thermal expansion and contraction. As an object warms up it expands, and as it cools down it contracts. If the temperature in a museum goes up and down regularly, the consequent expansion and contraction will cause any inherent weaknesses in the object to develop into cracks, and may even cause bits to fall off.

The regular rise and fall of temperature and humidity is connected both with the weather and with the season of the year. Obviously, when it is raining the air will be damp, and on a hot sunny day it is usually dry. But it is also dry in very cold weather, because much of the moisture freezes out of the atmosphere as frost. The environmental conditions in a museum are partly dependent on climate and season, but also on other factors. Museum heating is often switched off at night to save money, hence the air is warmed up during the day and cools at night. This will cause the humidity to fall and rise, if it is not otherwise controlled. Visitors also affect the humidity. As we breathe, we expel moisture from our bodies into the air. Hence a large number of visitors in a building will cause the humidity to rise.

Although variations in RH and temperature mainly affect objects made of organic materials, they may also affect inorganic objects. In particular, excavated objects

made of porous materials, such as pottery and stone, may have absorbed chemicals called salts from the soil during burial. Salts are crystalline materials (table salt is the most common example) which are often present in the ground-water. When an object is excavated, the moisture inside it slowly evaporates and the salts crystallise in the pores. If the salts remain in the pores they do not usually cause damage, but, in fact, they do not remain there. On humid days the object absorbs moisture and the salts dissolve; then when the atmosphere becomes drier, the salt solution crystallises again. But the crystals, which are always sharp and angular, will take on a different arrangement; hence this regular recrystallisation of salts inside a porous object has the effect of weakening the structure. Unfortunately, regular fluctuations in humidity not only cause the salts to recrystallise, but also gradually to migrate to the surface, where they concentrate. The stresses caused by crystallisation are therefore also concentrated at the surface of the object, which is often severely weakened. This explains why many limestone sculptures from Egypt, where the ground-water is particularly salty, have surfaces which are powdery, or even flaking.

Nowadays, the technology to control the RH and temperature within a building is available, but it is expensive to install and run. It is also often difficult to install in old buildings which do not have service ducts to take the necessary trunking – and most museums are housed in old buildings. The result is that very few museums have overall environmental control and they have to rely on putting sensitive objects inside airtight showcases which contain their own mini air-conditioning systems.

A recent example is the display in the British Museum of the bog-body known as Lindow Man. Although this body, which was buried in a peat bog, is about 2,000 years old, much of the soft tissue has been preserved. The body was discovered when the peat was dug up for agricultural use, but as soon as it was exposed to the atmosphere the process of decay began again. The body was therefore stored at a temperature of about 2°C while the scientific investigation work was carried out; it was then preserved by freeze-drying. It is now displayed in a purpose-built showcase which has both a humidifier and a dehumidifier built into the base. Using this

16

17

16 Lindow Man on display in a specially designed showcase. British Museum.

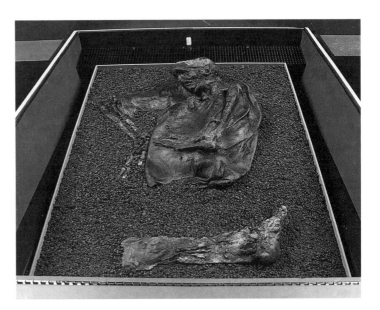

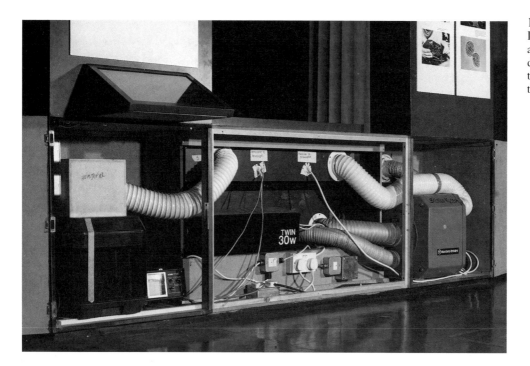

17 Inside the base of the
Lindow Man showcase
are a humidifier and a
dehumidifier which keep
the relative humidity of
the air at 50–55%.

equipment, which is connected to a relative humidity probe inside the case, the atmosphere can be controlled to give a steady RH of 50–55%.

Apart from temperature and humidity, conservators are particularly aware of the effect of light on objects. Coloured organic objects are most sensitive, because, just as curtains dyed with synthetic dyes will fade in the sun, so will objects coloured with natural dyes. It does not matter whether the dye is part of the make-up of the object, such as coloured plumage on a bird in a natural history collection, or whether the dye has been extracted from a plant and reused to colour a textile; both are equally susceptible to fading.

Light affects colours by interacting with their chemical make-up and changing it. Light is a form of energy and, like heat, it can cause chemical reactions to take place. Thus, when an object is exposed to bright sunlight, some of the compounds which make up the object may absorb enough energy to cause the molecular structure to break up, and the colour changes as a result. Light energy can also be absorbed by other compounds which can then react with oxygen, water and other chemicals present in the air in small amounts.

Suntan and sunburn are good examples of the destructive effect of light on natural materials, but, while the skin of a living person can recover and be regenerated, any changes produced in 'dead' organic matter are irreversible. Suntan is generated most quickly in bright sunlight containing a lot of ultraviolet radiation, and similarly it is UV light which is most destructive to objects in museums. Hence museums with natural history collections, textiles, ethnographia, paintings and watercolours must control both the daylight and the UV light falling on the objects. The UV light is most easily dealt with either by glazing the windows with a special UV-absorbing plastic or by attaching a special plastic film to the glass. The level of daylight is more of a problem, as all daylight is harmful to the most sensitive

colours. Thus a compromise is struck whereby the level of illumination is kept to the minimum at which objects at risk can be viewed comfortably – usually about 50–100 lux. Additional safeguards can be introduced by fixing curtains over certain showcases and by changing the objects on display at regular intervals (say every six months).

One aspect of the environment which is having an ever-increasing effect on museum collections is air pollution. As a result of the burning of fossil fuel, the air is full of traces of numerous chemicals which are harmful to a wide range of museum exhibits. The devastating effects of acid rain on forests and rivers are well known, but the chemicals which are responsible are also affecting objects inside museums. The worst culprit is sulphur dioxide, which is an acidic gas. It particularly attacks paper, causing it to become brown and brittle, and limestone, the surface of which undergoes a chemical change from calcium carbonate (calcite) to calcium sulphate (gypsum). Gypsum has a bigger molecule than calcite, and the consequent dimensional change in the surface layers of the stone causes them to become weaker. As a result, powdering and flaking is common on the surface of limestone sculptures.

Metals are also at risk from air pollution, and all housewives will be familiar with the way silver tarnishes to a blue-black colour if it is not cleaned frequently. This is due to the reaction of the silver with hydrogen sulphide in the atmosphere, which can also affect other metals. It will react not only with bright copper alloys, but also with corroded bronzes, and the formation of black 'spots' on the surface of such bronzes is a phenomenon which has only been recognised in museums during the past decade or so.

But black spots on bronzes are not the only 'new' corrosion phenomenon to have been observed in recent years. Alloys of zinc and lead are often found to be covered with white crystalline growths, identified by chemical analysis as zinc or lead formate. The growths result from the widespread use of synthetic plastics, glues and varnishes in the construction of furniture. These materials contaminate the atmosphere with formaldehyde, and the 'contamination' then reacts with those metals which are particularly vulnerable, such as zinc and lead.

This is a particular problem when designing and building museum showcases. Before the Second World War these were invariably made of solid mahogany, glued together with animal glue and finished by French polishing. All these materials are harmless, but nowadays mahogany is extremely expensive and few cabinet-makers use animal glue and French polish. They have been replaced by reconstituted woods (plywood and blockboard), resin glues and synthetic varnishes, all of which release traces of volatile corrosive chemicals into the atmosphere. In the sealed environment inside a showcase, the pollution level can build up to the point at which there is visible damage to objects.

Air pollution is now so widespread that virtually all museum collections are at risk from it, but monuments in the open air are the most vulnerable. The last two decades have seen an increasing concern for the effect of the 'weather' on monuments such as the Parthenon in Athens or Wells Cathedral in England. In both places, the weathering of the sculptured and architectural details can be shown, by comparing new and old photographs, to have greatly accelerated during this century as a result of air pollution, and heritage agencies around the world are grappling

with the problem. The answer is quite simple, but totally impracticable – ban all burning of coal and oil.

One solution to the destructive effects of air pollution is to move vulnerable works of art indoors. This has been done with the Caryatids on the Erechtheion in Athens, and with the four large bronze horses on the façade of St Mark's Basilica in Venice. In both cases, exact replicas have been placed on the monument. The bronze statue of Marcus Aurelius in Rome has been moved from the middle of the Piazza del Campidoglio into the adjacent Capitoline Palace Museum (see chapter 6).

Like the effects of air pollution, the presence of micro-organisms (mould spores) which are all around us in the air is inescapable. However, moulds will only grow if the RH is greater than about 65% for prolonged periods of time. The result is that the growth of moulds on organic materials in temperate countries is not common under normal conditions. However, leaking roofs or rising damp may cause sufficient humidity for objects to be affected. The so-called dry rot in buildings is a fungal growth, and this or other moulds will attack all materials with a biological origin if the air is sufficiently damp. These conditions are more likely to occur in little-visited store-rooms where the air is stagnant, and inside boxes and cupboards. Paper is particularly vulnerable, and most people will be familiar with 'foxing' or the brown spots which often occur on old prints and watercolours and inside old books. These spots are either the result of fungal attack on the paper or of the corrosion of minute particles of metal which have been incorporated into the paper by accident.

Controlling fungal growth, unlike air pollution, is just a matter of good house-keeping. First, the building, particularly the roof, should be maintained in good condition. Second, vulnerable areas of a collection should be inspected frequently, and closed rooms and cupboards aired. The same precautions are the best defence against insects and rodents, and keeping them out should be a matter of top priority for any museum. Insects are best dealt with by fumigation, and rodents by cleanliness and by employing a museum cat! However, once either insects or rodents are established in a collection, their eradication is a major problem because of the need to 'treat' the building as well as the objects.

Last among the causes of deterioration is the human factor. The contribution of the human body to the humidity of the air has already been pointed out, but people can also adversely affect objects just by touching them. Dirty hands will leave fingermarks on paper and other organic materials, and sweaty hands will deposit chemicals from the skin onto shiny metal, rapidly causing corrosion. Close inspection of polished metal, particularly iron and steel, will often reveal fingerprints which cannot be removed by light cleaning because they have been etched into the surface of the metal as a result of salts deposited by perspiration from the fingers. A very simple way in which curators and students can avoid damaging objects through their body chemicals and dirt is always to wear white cotton gloves when handling sensitive materials. White gloves are recommended because it is obvious when they have become too dirty to use, and cotton ones because they are very absorbent and mop up perspiration.

But the main danger which man poses towards works of art is accidental damage due to mishandling, or deliberate damage due to vandalism. The idea for this book arose from the highly successful conservation and restoration of Leonardo da Vinci's

cartoon *The Virgin and Child with St Anne and St John the Baptist*, following its attempted destruction by a man with a shotgun (see chapter 1). Similarly, the present condition of the Portland Vase, the conservation of which is also described below (see chapter 2), is due to an act of wanton vandalism by a drunken visitor to the British Museum nearly 150 years ago. Fortunately, major acts of vandalism inside museums are rare, but these days all collections are subject to minor attacks, particularly felt-pen graffiti, stink bombs and chewing gum attached to sculpture.

Vandalism can be minimised by an efficient and effective security service, but accidental damage is impossible to control in the same way. Those who work with fragile and delicate material will, from time to time, knock something over with an elbow, accidentally scratch it with their own jewellery, or drop it, and no amount of training can ever eliminate the occasional incident of this type. The moving of large and heavy objects inside a museum is a particularly hazardous process, and the increasing tendency to loan major works of art for exhibition in other places means that the scope for accidental damage is dramatically increased. There is no doubt that man poses a real threat to museum objects, but as the objects are, by definition, in museums so that they can be enjoyed we must be prepared to take some risks. It is the job of curators and conservators to evaluate those risks and to take all reasonable precautions to minimise them, so that objects can be made available as widely as possible for display and study.

In the following chapters the secrets behind eleven major works of art are revealed. The book relates how conservators, curators and scientists have used the latest scientific techniques to investigate the history of the objects and to restore them to something approaching their former glory, not only for the visitors of today, but for those of generations to come.

Acknowledgements

Fig. 2 is reproduced by kind permission of the Roman Baths Museum at Bath. All other illustrations are © The Trustees of the British Museum.

Further Reading

UNESCO, *The Conservation of Cultural Property*, Paris 1968.

H. J. Plenderleith and A. E. A. Werner, *The Conservation of Antiquities and Works of Art*, 2nd edn, London 1971.

F. K. Fall, *Art Objects: their Care and Preservation*, La Jolla, California, 1973.

S. J. Fleming, *Authenticity in Art – the Scientific Detection of Forgery*, London 1975.

G. Thomson, *The Museum Environment*, London 1978.

H. Sandwith and S. Stainton, *The National Trust Manual of Housekeeping*, London 1984.

P. E. Guldbeck, *The Care of Antiques and Historical Collections*, 2nd edn, revised by A. Bruce MacLeish, Nashville, Tennessee, 1985.

A. Plowden and F. Halahan, *Looking after Antiques*, London 1990.

N. Stolow, *Conservation and Exhibitions – Packing, Transport, Storage and Environmental Considerations*, London 1987.

J. M. Cronyn, *The Elements of Archaeological Conservation*, London 1990.

1 Leonardo da Vinci's Cartoon
The Virgin and Child with St Anne and St John the Baptist

Eric Harding and Andrew Oddy

In the summer of 1987 an unemployed ex-soldier visited a number of museums and galleries in London, carrying a sawn-off shotgun hidden under his clothing. He seems to have been looking for a quiet, little frequented place where he could get out his gun at leisure and fire it at a work of art. The early summer is the busiest period in museums and the man had difficulty in finding somewhere to wreak his havoc undisturbed, but finally, on 17 July, he entered the National Gallery and at about 5.55 p.m., five minutes before closing time, confronted Leonardo da Vinci's cartoon *The Virgin and Child with St Anne and St John the Baptist*, which was protected with laminated glass but in an otherwise empty gallery. He took out the gun and deliberately fired at the torso of the Virgin, from a distance of about two metres (6 ft).

The vandal, who made no attempt to escape, was quickly apprehended by the gallery warders, and, after being found unfit to plead in a court of law, was sent to Broadmoor high-security hospital for an unspecified period. While the law thus dealt with the criminal aspects of the event rapidly and effectively, the Cartoon itself had to undergo a lengthy period of examination and evaluation to determine how best to repair the damage. Although the attempt to destroy it seems to have been the result of pure chance, this was in fact the second time in twenty-five years – the first was in 1962 – that it had been vandalised and had needed restoration. But, as we shall see, the restorations of 1962 and 1987–9 were only the most recent of a number of interventions carried out since the Cartoon was drawn, almost 500 years ago.

Leonardo was born in 1452 near Vinci, a small town in Tuscany. The illegitimate son of a Florentine notary, he received his artistic training under Andrea del Verrocchio (*c.*1435–88), a notable sculptor, painter and metalworker, who owned the most important workshop in Florence. Leonardo became a master in the Painters' Guild in 1472, and thereafter worked in Florence, Milan, Rome and Paris. He was the archetypal 'Renaissance man', being not only a painter, draughtsman, sculptor, architect, engineer, mathematician, naturalist, philosopher, inventor and musician, but also an expert horseman. He died in 1519.

A cartoon is a preparatory drawing for a painting or fresco, made to the same scale as the intended composition. Current art-historical opinion now places the drawing of the cartoon *The Virgin and Child with St Anne and St John the Baptist* in Milan, probably in the winter of 1507–8. It was preceded by a sketch (now in the British Museum), and followed, probably in 1510–15, by a painting (now in the Louvre), in which Leonardo changed the position of the figures.

The Cartoon was drawn on a specially prepared surface made up of eight large sheets of paper, their overlapping edges stuck together with animal glue. Unlike

18 (*Opposite*) Leonardo da Vinci's cartoon *The Virgin and Child with St Anne and St John*, photographed in raking light to show the damage caused by the shotgun blast in 1987.

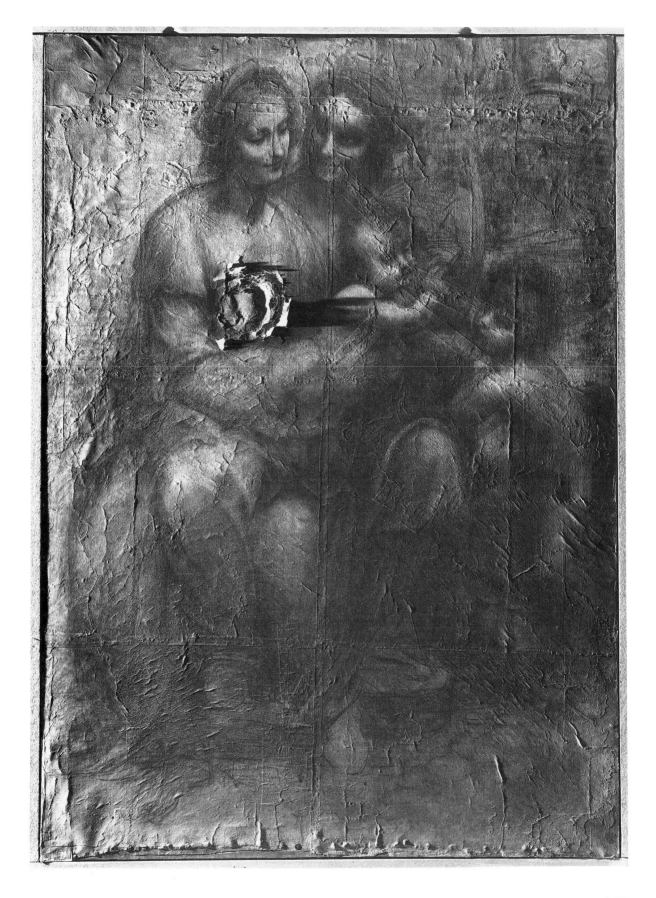

modern colourless adhesives, this consists largely of gelatin, produced by boiling down the skin and bones of animals, and discolours with age. The joins in the paper would have been visible because of the overlaps, and it was probably partly for this reason that the surface was prepared by applying a mixture of red-brown iron oxide and calcium sulphate (gypsum) with a little carbon black (soot). A number of other drawings by Leonardo are executed on papers coated with various shades of red-brown, blue, cream and white; and Vasari, in his descriptions of the drawing techniques of Florentine masters of the sixteenth century, mentions the use of tinted papers for drawings of light and shade, in which the tint provides the mid-tone.

Fifteenth-century texts describe two methods of preparing tinted papers. The dry method involved simply rubbing the powdered coating materials on to the paper surface by hand, as in this case. Alternatively, the pigments were mixed with water and a little glue and applied using a broad brush or sponge.

In the sixteenth century paper was not made of wood pulp as most of it is today. It was usually made of cotton fibres, obtained by beating and bleaching cotton rags.

19 Leonardo da Vinci: *The Virgin and Child with St Anne*, *c.*1510–15. Oil on panel, 170 × 129 cm. Paris, Louvre.

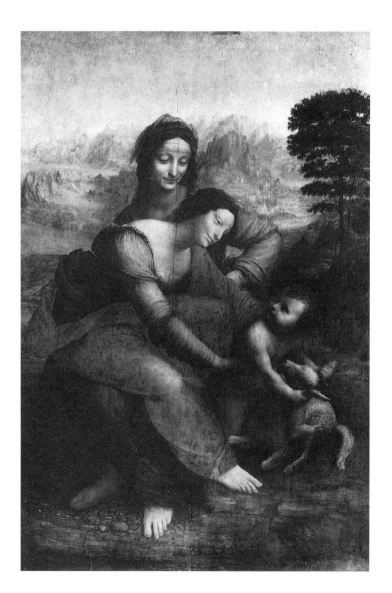

However, microscopic examination of fibres teased from the edge of one of the sheets of the Cartoon has shown that they are not cotton but flax, indicating that the paper was made from linen rags. When paper is made by hand, the cellulose fibres (cotton, linen, or, these days, more usually wood) are mixed with water to form a slurry, a quantity of which is drained through a fine sieve, called a mould. The fibres are retained by the mould, matting together to form a sheet. This is removed from the mould and allowed to dry. The mould is made of a grid of fine metal wires: those going in one direction, called the chain wires, are spaced 1–5 cm (⅜ in–2 in) apart, while those going in the other direction, called the laid wires, are very close together. Because the paper is slightly thinner where it has been in contact with the metal grid, the pattern of the chain and laid lines is usually clearly visible when it is held up to the light or examined by taking an 'X-ray' by a process called β-radiography. This pattern could indeed be seen when a fragment detached from the Cartoon was examined by exposing a β-radiograph.

The Cartoon was drawn in black, with white heightening. The bold, sweeping

20 Scanning electron micrograph (SEM) of flax fibres from the paper of the Cartoon.

21 SEM of charcoal particles from the area of the Virgin's chest.

outlines of the figures are executed in charcoal, which was traditionally used for 21
large-scale drawings and cartoons. Charcoal can be brushed off easily and is therefore particularly suitable for working out large figure compositions and making adjustments in the planning stages of a major work. No binding medium appears to have been used. Knowledge of the materials used for heightening charcoal drawings in the sixteenth century suggested that the white highlights in the Cartoon would have been produced by natural chalk (calcium carbonate), tailor's chalk (natural hydrous magnesium silicate) or gypsum (calcium sulphate). Analysis identified the presence of calcium sulphate, and failed to find any trace of the other types of chalk.

After its completion the Cartoon appears to have remained in Milan until it passed into the Sagredo Collection in Venice, where its presence was recorded in 1726. It was brought to London sometime before the end of 1763, and was in the possession of the Royal Academy by 1779. There it stayed until 1962, when the Academy decided to sell it. It was acquired by the National Gallery after a successful public appeal, a special government grant and contributions from the Pilgrim Trust and the National Art Collections Fund had raised the then gigantic sum of £800,000.

There are no records of treatment or repair to the Cartoon before it reached the Royal Academy, but it has tears and patches which probably date from the late

22 Diagram showing patches and losses. RP = repair patch behind drawing; L = loss with old toned infill; the dotted lines show possible additional repair/support patches; the hatched area is the shotgun damage.

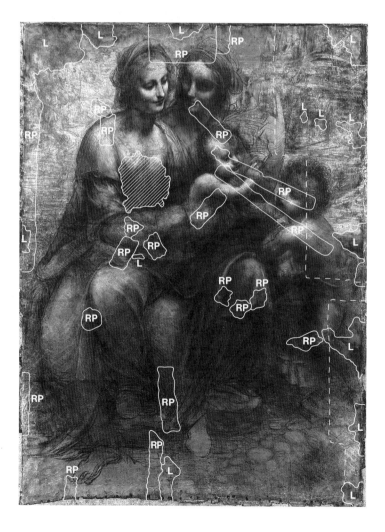

23 The Cartoon after repair, photographed in raking light. The overlapping joins, patches, tears and wrinkles are clearly visible.

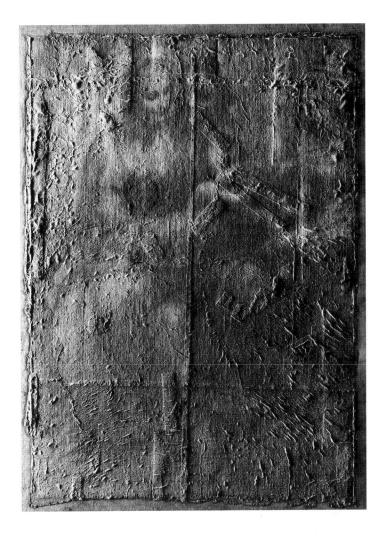

seventeenth or early eighteenth century. The main patches on the back of the original paper are shown in Fig. 22, but it is not known if these were all applied on the same occasion. The patched Cartoon was lined with canvas and mounted on a stretcher before it was transported to England in the 1760s. The adhesive used to stick the paper to the canvas was a mixture of animal glue and wheat-starch paste, commonly used on old linings for easel paintings. However, the Cartoon was not laid down skilfully, but was placed directly on to the pasted canvas without dampening the paper to relax it or first pasting it on to another sheet of thin paper. As the moisture from the paste penetrated the paper it expanded, and wrinkles and blisters began to form. The person mounting it tried to slide the paper over the canvas in order to flatten the distortions, but the sheet was too large and he succeeded only in rupturing the paper where his fingers pressed on to it. The imprint of his fingertips can still be clearly seen, and photographs taken in raking light show the wrinkles to dramatic effect.

By the time the Cartoon came to England in the mid-eighteenth century, it had been restored with chalk and charcoal resembling the original materials, and this was probably also when white lead and watercolour were used on it. Further restoration was carried out at the Royal Academy in 1791 and 1826, when zinc white, a

pigment first introduced in the eighteenth century, may have been used. Minor restoration was necessary in 1962, when the Cartoon was slightly damaged by a bottle of ink which was thrown at it during the public appeal for its acquisition by the National Gallery. Fortunately the Cartoon was protected by a plastic glazing material, but this was cracked and caused a small tear on the knee of the Virgin.

When the Cartoon was acquired by the National Gallery the Trustees decided to invite an international committee of experts to advise them on its condition and on the safest method of displaying it. The committee found that the Cartoon's state of preservation was good, considering its size and the vicissitudes it had undergone in more than four and a half centuries. However, the original paper had darkened and discoloured, and had been stained by water running down it and by adhesives. The paper had also been torn and patched with darker paper of a different texture. Some of the original charcoal had been lost, and the original white chalk heightening appeared to have been loosened and washed haphazardly over the top half of the image, where it mingled with the lead white used in an earlier restoration. A variety of other materials had been used to retouch lacunae and tears in the paper and to reinforce abraded areas. The committee made recommendations for some minor repair work and for additional support to be given to the canvas by fitting a padded backboard inside the stretcher, which would also reduce vibration and strengthen the Cartoon against accidental damage, but decided against recommending any attempt at a complete restoration because of the fragile state of the paper. As far as display was concerned, the committee recommended that the Cartoon be kept in a

24 The area damaged by the shotgun blast, photographed in raking light.

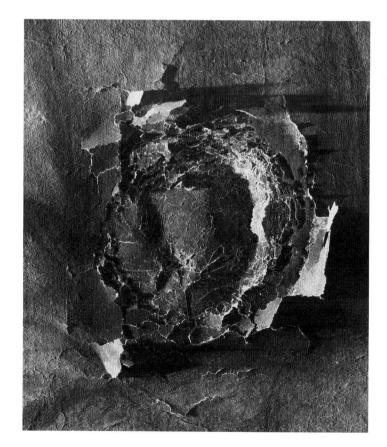

controlled relative humidity and that all ultraviolet light should be excluded. After the damage of 1987, the Cartoon was compared with detailed photographs taken in 1962–3. These showed that there had been no detectable deterioration in its general condition.

In the 1987 attack the 'unbreakable' laminated glass partly withstood the pellets from the sawn-off shotgun. Although the innermost layer of glass was shattered, the pellets themselves bounced back into the room and none penetrated the drawing. The glass, however, was pulverised and, as it was driven inwards by the force of the shot, struck the Cartoon a sharp blow on the Virgin's breast, over an area of about 15 cm (6 in) in diameter. Advice given later by the Metropolitan Police Forensic Science Laboratory indicated that had the gap between the glass and the Cartoon been larger, the damage would have been more severe. The cushioned backboard which had been fitted behind the canvas and inside the stretcher bars in 1962 absorbed some of the impact. The canvas was stretched and slightly torn, but the brittleness of the paper resulted in a series of concentric tears and in some paper becoming detached. Beyond these concentric tears, paper was loosened from the canvas but not actually detached.

24

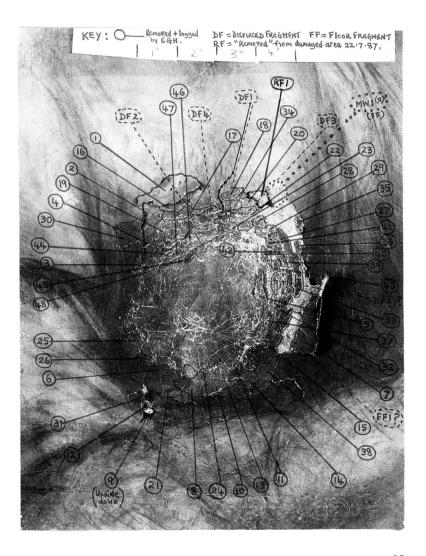

25 The map made to record the positions of fragments temporarily removed during the repair of the damaged area.

Assessment of the damage immediately after the shot had been fired was difficult because the pulverisation had made the glass opaque. The long cracks extending from the area of impact proved, fortunately, to be confined to one layer of the three-ply laminate and therefore unlikely to lead to the collapse of the whole sheet of glass and to further damage to the Cartoon. As soon as police procedure permitted, the Cartoon was removed, first from the display panel and then from its frame. Many loose fragments of paper were recovered from between the glass and the mount at the bottom of the frame.

As the National Gallery collection contains very few works on paper and its Conservation Department therefore had no expertise in paper conservation, advice was immediately sought from other national institutions with relevant experience and knowledge. An informal group of paper conservators from the British Museum, the Victoria and Albert Museum, the Royal Library at Windsor Castle and the Tate Gallery was brought together within days of the attack. Discussions between this group and National Gallery staff established two possible approaches to the repair of the Cartoon. The first was to repair only the shotgun damage; the second to attempt at the same time the radical treatment rejected by the International Committee in 1963, involving the removal of the canvas, glue and patches from the back of the drawing, the deacidification of the original paper and the remounting of the Cartoon on to a new paper backing.

The removal of the canvas and glue was considered theoretically desirable, as was deacidification of the original paper. However, there was general agreement that whatever method of removing the canvas and glue were used, the Cartoon itself would have to be wetted with either water or solvents if the paper were to be deacidified. Dry removal of the canvas and glue on the back of the Cartoon (with the drawing face down) would lead to a great risk of chalk and charcoal being shaken off the front. The damaged area, even if the loose paper fragments were removed, would be very vulnerable to further distortion and fragmentation. If the canvas were to be removed after the glue had been softened in a humidity chamber, or by some other method of introducing moisture, the Cartoon could become very difficult to handle, since the longest tears (at the left edge) were supported only by the canvas. The patches in the corners and under the tear through St Anne, the Child and St John might become detached, and the original overlapping joins, many of which were very insecure, might also become unstuck. A further danger was that the moisture could change the refractive index of the white chalk highlights, which had already been affected by earlier treatment, and might also produce light or dark stains on the surface of the Cartoon. The process of deacidification itself would expose the Cartoon to similar dangers, and might have a considerable effect on its appearance.

In the event, these risks were judged to be unacceptable. The likelihood of uncontrollable, irreversible changes in the appearance of the Cartoon outweighed the advantages of deacidification. The risks could only have been justified if the Cartoon had been in imminent danger of destruction, and that was not the case. It was therefore agreed that conservation would be confined to repairing and restoring the shotgun-damaged area and to making secure any other areas where the sheets of paper were no longer firmly attached to the canvas. Eric Harding was

seconded to the National Gallery from the British Museum to carry out the work.

The first practical task was a long and careful microscopic examination of the damaged area, and the results were recorded by taking photographs through the microscope. This was followed by the removal of the larger pieces of glass, some of which had fragments of paper attached to them. Meanwhile, a large number of identical actual-size photographic prints of the damaged area were produced to enable the original positions of fragments to be recorded, as all fragments of paper and glass would need to be removed from the surface before any repair work could be contemplated. Each fragment lifted from the damaged area was identified and drawn in on the photographs. The fragments were numbered in order of removal, then placed in small transparent boxes. The numbered location was cut out from the photograph and attached to the box lid. An uncut copy of the same photograph was used to create a full-scale numbered map showing where all the fragments belonged. There were many fragments which could not be located in this way, for example those rescued on the day of the shooting from the shattered glass, others from the gallery floor, and those displaced to the edge of the drawing by the force of the blast. These were eventually dealt with during the reconstruction, by making tonal comparisons with fragments from known positions. In all, there were about 70 larger fragments or associated smaller fragments in individual boxes, and about 200 tiny pieces, many no larger than a pin-head.

The removal of the pulverised glass sherds and particles from the damaged surface and from the loose fragments of paper was carried out in dim light using fibre-optic cold lights. These made the impacted glass particles sparkle brightly, so that it was easier to locate them and to separate them from the paper fragments. A vacuum tweezer proved invaluable for this purpose.

When all the loose fragments of paper had been safely removed, separated from fragments of glass and stored in labelled boxes, it was possible to consider ways of dealing with the severely distorted and damaged canvas support. The question was how to flatten and reform the canvas fibre structure. A vital step here was the designing of a test piece on which to experiment. Paper and canvas similar to those of the Cartoon were assembled on a wooden stretcher and subjected to mechanical stress by hammering, in an attempt to reproduce the damage caused by the impact of the shotgun blast. However, early experiments proved only partially successful, and it became obvious that comparable damage was not being produced. It was therefore decided to ask the Metropolitan Police Forensic Science Laboratory to shoot at a test piece, using a twelve-bore shotgun similar to that used in the attack. A piece of paper and canvas was prepared and artificially aged, attached to a stretcher and fixed in the corner of the original Cartoon frame where the glass laminate was relatively undamaged. The shot was fired and the result was remarkably effective, creating a perfect replica of the original damage, including the pulverised glass.

After a series of trials it was found that by using a specially modified low-pressure vacuum suction device in combination with an ultrasonic humidifier it was possible to reduce the most severe distortions of the canvas to little more than gentle undulations. These experiments demonstrated that the fragmented structure could be gradually returned to a flat plane, and both paper surface and canvas support

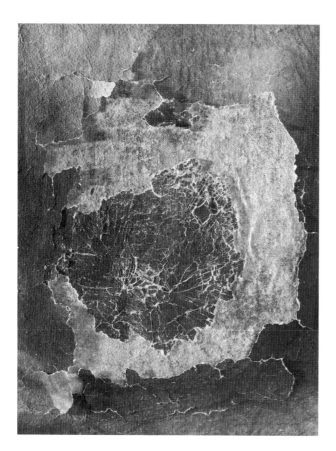 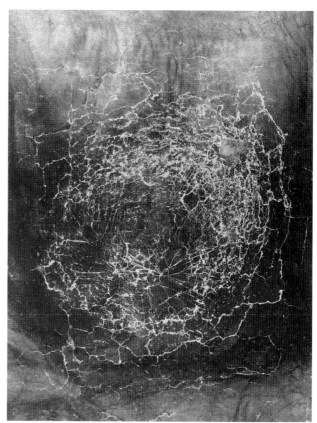

realigned. In the summer of 1988, this same technique was applied to the Cartoon. The Cartoon was laid flat, face up, and the low-pressure vacuum suction device placed underneath, immediately below the damaged area. A winding mechanism had been built in, so that small custom-made perforated suction plates could be gently raised to the required position, thus limiting the need to move the Cartoon itself. A fine mist of atomised water droplets was then wafted over the back of the canvas from the centre of the damaged area outwards, to its edge and just beyond. Moisture was also applied to the front of the Cartoon, but in view of the extremely delicate nature of the charcoal/chalk medium, this had to be very brief, just enough to 'balance' the treatment to the reverse. The deep distortions were slowly and gently coaxed outwards and into correct alignment with the aid of a tiny, flat stainless steel spatula. About 10–15 millibars of low-pressure vacuum suction were needed to control and hold the repositioned surface. After many hours of this treatment, the desired gentler undulations were achieved in the damaged area. Finally, the damaged canvas was completely flattened out using a more powerful vacuum on a conventional vacuum table, in conjunction with humidity supplied by the ultrasonic unit.

The Cartoon could now be handled safely, and before the next stage of repair could begin it was necessary to remove the old wooden stretcher. This was made of very thin pine, and had been further weakened by the removal, many years earlier, of its vertical cross-member and corner supports. Furthermore, the old tacks pinning the Cartoon around the turned-over edges had corroded to the point where they

26

26 (*Left*) The damaged area after the removal of glass and loose paper fragments and after flattening of the canvas.

27 (*Right*) The damaged area after replacement of the paper fragments but before retouching.

28 (*Opposite*) Leonardo da Vinci: *The Virgin and Child with St Anne and St John the Baptist*, c.1507–8, after restoration. Charcoal and chalk on tinted paper, 142 × 105.5 cm. London, National Gallery.

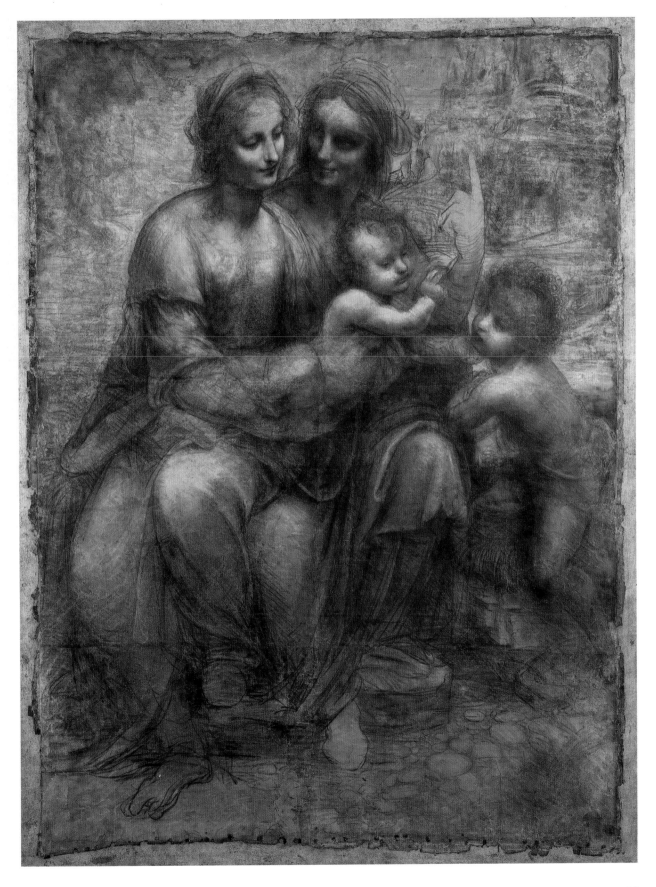

were causing serious deterioration of both paper and canvas. Another reason for removing the stretcher was that the drawing extended to the extreme edges of the turnover in some places, and as a result these marginal areas of the composition had previously been hidden. After the old tacks had been extracted, the edges of the Cartoon and the canvas, which had become hard, were straightened out, using ultrasonic humidity followed by gentle pressure from weighted plate-glass strips. During the course of this work it was found that the top left-hand corner of the Cartoon (near the Virgin's head) was reinforced by an old repair in which a Renaissance print had been attached to the corner of the Cartoon with its blank side towards the canvas.

The damaged area of the Cartoon, although now flat, was very weak, and it was decided to give it a full additional lining. After testing samples of adhesives and linen, a framework was prepared and covered with Irish linen and acid-free rag paper. The paper surface was then coated with gluten-free wheat-starch adhesive, and the Cartoon, complete with the old canvas support, was placed upon it. The entire arrangement was then transferred to the low-pressure vacuum suction table for overall bonding. The dimensional stability of the Cartoon remained unaffected during this process because the old lining canvas was still attached. It was therefore unnecessary to dampen it beforehand. The wheat-starch paste was buffered with calcium hydroxide, to reduce the acidity of the paper.

Once the relining had been successfully completed, the fragments of the Cartoon could be replaced. Wheat-starch adhesive was applied to the exposed canvas support within the damaged area, and each fragment then positioned using a surgical needle and tweezers while looking through a microscope. Light pressure applied through tissue and siliconised paper effectively bonded the very thin fragments to the pasted surface. This was followed by a further short period under gentle pressure. Because many of the fragments were very small, and their positions unknown, this stage of the restoration took several weeks. The positions of the unidentified fragments were found by comparing the tonality of the various loose fragments with known areas, classified as light grey, grey, grey-black, black, and so on. They were then further sorted by shape, until their exact location had been determined. When all the fragments had been replaced, it was found that a total area of approximately one square centimetre (0.15 sq. in) was missing. The missing pieces were replaced with hand-made laid paper of the same period, type and weight as the Cartoon. This was tinted to match the surrounding area.

The shotgun-damaged area of the Cartoon was now flat and all the fragments had been replaced. However, the area still appeared 'crazed' as a result of the 27 extensive loss of paper fibres caused by the breaking up of the surface. It was not possible to repair this loss with infills of matching paper pulp, as tests proved that the refractive index of the mixture of pulp and adhesive was quite different from that of the surrounding area, so that the infills would have been very obvious. It was therefore decided to retouch the crazed areas.

After experimenting with different materials, a combination of finely powdered chalk and charcoal was found to be the most satisfactory retouching medium. This was applied to the newly reformed surface with a fine sable brush and a tiny spatula. Successive layers of pigment could thus be built up in the 'valleys' between each

broken paper edge, enabling full and sensitive control of tonality. Where necessary, the applied chalk and charcoal could be instantly removed by sweeping the grooves with a small, clean sable brush and using a vacuum tweezer unit to remove the 'dust'. This was held 2–3 cm (about 1 in) from the surface to avoid any resettling of unwanted infill dust on the surrounding areas. By careful application of chalk and charcoal in this way, it was possible to restore and tone in the damaged areas without needing to reconstruct the original work or to interfere with it in any way.

Once the shotgun damage had been repaired, the question arose as to whether any of the other areas of the drawing which had suffered damage over the years could be improved. For example, there remain numerous areas of blackened lead white from a previous restoration, where the originally white pigment has reacted with hydrogen sulphide in our polluted atmosphere to form black lead sulphide. It is technically possible to reverse this colour change, but in the event it was decided not to attempt the treatment on the Cartoon. However, the opportunity was taken to re-attach the loose areas of the old paper patches and to repair the surface of the original paper in the numerous places where it was tending to delaminate. This was done by applying thinned wheat-starch paste through the many fractures and ruptures in the Cartoon's surface with a hypodermic syringe, and applying gentle pressure.

28 The Cartoon went back on display in the National Gallery on 26 May 1989, and the restoration was greeted as a miracle by art-historians, the conservation profession, the media and public alike. It is now subject to even more stringent safety precautions than in the past, but it can truly be said that no one who was unaware of its recent history would ever guess that a hole big enough to put an arm through had been blasted through it.

Acknowledgements

This chapter has been adapted from 'The Restoration of the Leonardo Cartoon' by Eric Harding, Allan Braham, Martin Wyld and Aviva Burnstock (*National Gallery Technical Bulletin* 13, 1989): we are very grateful for the permission of the Director, Neil MacGregor, to use the material. Fig. 19 is reproduced by permission of the Réunion des Musées Nationaux, Paris; all other photographs in this chapter are reproduced by permission of the Trustees of the National Gallery.

Further Reading

A. E. Popham, *The Drawings of Leonardo da Vinci*, London 1946.

J. Watrous, *The Craft of Old-Master Drawings*, Madison 1957.

M. Davies, *Acquisitions 1953–62*, National Gallery, London 1963.

J. Meder and W. Ames, *The Mastery of Drawing*, 2 vols, New York 1978.

M. Kemp, *Leonardo da Vinci*, London 1981.

C. de Tolnay, *History and Technique of Old Master Drawings: A Handbook*, New York 1983.

G. Petherbridge, *Conservation of Library and Archive Materials and the Graphic Arts*, London 1987.

C. James *et al.*, *Manuale per la Conservazione e il Restauro di Disegni e Stampe Antichi*, Florence 1991.

2 The Portland Vase

Sandra Smith

The Portland Vase is one of the British Museum's greatest treasures and the finest example of Roman cameo glass in existence. In 1845 it was smashed by a vandal and repaired; it then underwent conservation again in 1948. By 1987, when the Vase formed the centrepiece of an international exhibition of Roman glass entitled *Glass of the Caesars*, the adhesive used in the 1948 repair was showing severe signs of ageing and had turned a dark yellow-brown colour. More alarmingly, when the Vase was tapped it produced not a ringing tone but a dull, lifeless thud. This was a sure indication that some of the pieces of glass were held in place only by the surrounding fragments. The Vase was therefore in a very fragile state and needed immediate attention.

After detailed discussion with the curators responsible for the Vase, it was agreed that immediately after the *Glass of the Caesars* exhibition it should be taken off display for a year. This would allow time for it to be dismantled and reconserved, and would also provide an opportunity for further research to be carried out into how the Vase was originally made. The Museum anticipated world-wide interest in this unique vessel, and a press conference was arranged to inform the public of its imminent reconservation. The resulting press coverage was sensational, with headlines like 'Museum to smash Roman vase'.

The main body of the Portland Vase consists of a deep blue glass which appears almost black in reflected light, but dark blue in transmitted light. The surface decoration is provided by a thin layer of white glass, on top of the blue, which has been carved and engraved with great precision so that a sense of real depth is given to the finished scenes.

Exactly how the Vase was made has been something of a mystery. It was widely assumed that it was made by a technique known as 'casing', meaning that the glassblower formed a 'cup' of white glass and blew the blue glass into it. Having thus 'cased' the blue glass in the white, he would then have given the Vase its correct shape and size by further blowing and marvering (rolling it on a flat slab known as a marver) before finally adding the handles. It was hoped that this theory could be proved or disproved once and for all during the course of the conservation process. What was more certain was that, once cool, the Vase was transferred from the glassblower to a cutter or engraver, probably a gem-cutter, who must have worked the outer layer of white glass with engraving tools and files.

The cutter's skill is apparent in the treatment of the masonry and the figures, though it is possible that the surface was reworked in the seventeenth or eighteenth century. The interpretation of the scenes has been hotly debated for many years. The scenario is evidently one of love and marriage with a mythological theme, in a marine setting which includes a sea-snake. The precise identification of the figures

remains uncertain, though several scholars have suggested that the two sides are to be 'read' as one, with the principal figures being Peleus and Thetis.

Attempts have been made in more recent years to produce a replica of the Vase. However, apart from versions by John Northwood and Joseph Locke, made in the 1870s, few have been successful and most have ended with the vessel breaking under the intense working required.

The Portland Vase as we know it is incomplete, the base of the original vessel, which would possibly have tapered to a point or ended in a base-ring, having been broken and repaired in antiquity. During this ancient repair, the bottom edge of the Vase was trimmed to allow it to stand upright, and a disc of blue and white cameo glass was added as a new base. However, this disc clearly does not belong to the Vase, as it differs in colour, composition and style. It was evidently cut down from a much larger cameo plaque. This is no longer attached to the base, but exhibited separately.

The Vase takes its name from the Portland family, who owned it from soon after its arrival in England in 1810. The Dowager Duchess of Portland bought the Vase for the sum of 1,800 guineas, together with four less important pieces, from Sir William Hamilton (1730–1803), then British Ambassador to the court at Naples. (Sir William is of course better known as the husband of Lady Emma Hamilton, the mistress of Lord Nelson.)

Before the Vase came to England it had already had quite an eventful and well-documented history. It was reported to have been discovered in or shortly before 1582 inside a marble sarcophagus excavated under the Monte del Grano on the southern outskirts of Rome. This was thought to be the burial place of the emperor Alexander Severus, who reigned from AD 222 to 235, and of his mother, Julia Mamaea. However, the Vase would already have been an antique when it was placed in the tomb; it is most likely to have been made around the turn of the first century BC/AD, during the reign of the emperor Augustus (27 BC–AD 14).

After its discovery in the sixteenth century the Vase became the property of Cardinal Francesco Maria del Monte (1549–1627) and was included in a work on Roman cameos by Cassiano dal Pozzo (1578–1657). After del Monte's death the Vase came into the possession of Cardinal Francesco Barberini, who allowed dal Pozzo to draw six sketches of it for his *Museum Chartaceum* ('Paper Museum'). This extensive collection of drawings still exists, divided between the Royal Library at Windsor Castle and the British Museum.

By the mid-eighteenth century the wealth of the Barberini family had declined, principally as a result of compulsive gambling by Donna Cornelia Barberini-Colonna, Princess of Palestrina and the last of her line. The princess was a very passionate but unsuccessful card player, and lost most of the family fortune. The Vase was sold to James Byres, a Scotsman living in Rome, who bought it with a view to reselling it almost immediately. Before doing so, however, he had a mould made and sixty copies cast from it in plaster of Paris by James Tassie, after which the mould was destroyed on Byres' instructions. One of these plaster copies is in the collection of the British Museum.

It was in 1783 that the Vase came into the possession of Sir William Hamilton, an avid collector of antiquities. The Vase was now famous throughout Europe, and

even Queen Charlotte, wife of George III, specially asked to see it. However, the £1,000 that Sir William paid for the Vase crippled him financially, forcing him to sell it to the Dowager Duchess of Portland, who included it in the Portland Museum, a collection of natural and artificial curiosities. On her death in 1785 the museum and its contents were sold at auction, but the Vase was bought back by the 3rd Duke of Portland. In order to secure the Vase for his family, the Duke had to do a deal with Josiah Wedgwood, the famous porcelain manufacturer. Wedgwood agreed not to bid for the Vase on the condition that the Duke would lend it to him for one year so that he could model it for reproduction in his range of Jasperware. In 1810, after a minor breakage had occurred, the 4th Duke of Portland entrusted the Vase to the care of the British Museum.

The next significant moment in the 'life' of the Vase was 3.45 p.m. on 7 February 1845, when a young man who later gave his name as William Lloyd walked into the gallery where the Vase was displayed and, wielding a heavy object, brought it crashing down on to the showcase, smashing both the case and the Vase into hundreds of pieces. The culprit was apprehended, and when questioned at Bow Street police station gave as his excuse that he was suffering from 'a kind of nervous excitement'

29 Jasperware copy of the Portland Vase, made by Josiah Wedgwood c.1790. British Museum.

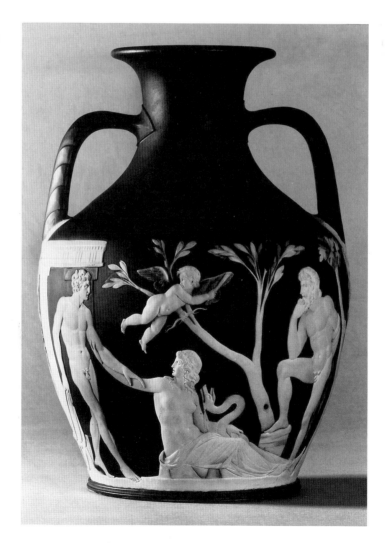

as a result of a week-long drinking session. Why he had chosen to destroy the Portland Vase he was unable to say. Charges were brought against him by the Museum, but because of ambiguities in the wording of the Wilful Damage Act which only covered damage to property up to the sum of £5, Lloyd could be charged with breaking the showcase but not with breaking the Vase itself. He had a choice of a £3 fine or two months' hard labour in a house of correction. Unable to pay the fine, he went to prison, but was released two days later when his fine was paid for him by an unknown benefactor, mysteriously rumoured to be the Duke of Portland himself.

Meanwhile, the British Museum had to try to repair the damage to the Vase. John Doubleday, a museum craftsman, was entrusted with this arduous task, and by September of the same year the Vase was restored and back on display in the galleries. However, Doubleday had been unable to locate the positions of thirty-seven of the smaller fragments of the Vase, and these were given to a certain Mr Gabb, who was commissioned to make a special box to contain them. Unfortunately, Gabb died before he could complete his task, and the fragments were lost to view for the next hundred years.

In 1945 the Vase was purchased by the Museum from the Portland family, and the resultant publicity moved one of Gabb's descendants to return the chips of glass to the Museum. The curators took some convincing before they would believe that they were actually fragments of the Portland Vase. By this time Doubleday's restoration had begun to show signs of ageing and in 1948 it was decided to make a second attempt to restore the Vase in order to replace the now 100-year-old adhesive and, it was hoped, to incorporate some of the returned fragments. This second restoration was carried out by J. H. W. Axtell, a senior conservator in the Department of Greek and Roman Antiquities, who specialised in the conservation of Greek vases. Axtell was able to insert only three of the previously unplaced fragments into the Vase.

The 1988 restoration of the Vase was undertaken by Nigel Williams and Sandra Smith of the Ceramics and Glass Section of the British Museum's Department of Conservation. A great deal of advance preparation was needed to ensure that the most sympathetic methods and materials would be used. Furthermore, arrangements had to be made to accommodate the BBC Archaeology and History film unit, who wanted to record all the processes involved for a programme in the *Chronicle* series.

The involvement of the BBC, as well as the interests of scholars who wished to examine the glass, meant that a strict timetable had to be established for the dismantling. The first task, however, was to find out as much as possible about the previous conservations. The only records of the 1845 conservation were a black and white
30 photograph of John Doubleday with the completed vessel and a line drawing of the fragments, which was discovered in the Museum archives. It was hardly surprising that there were no written records of the materials used in 1845, but something of a shock to find that neither were there any records of the techniques used by Axtell in 1948.

It was therefore necessary to resort to the memories of four longer-serving or retired conservators who had been at the Museum at the time of the 1948 restoration. Each was absolutely certain that he remembered which adhesive had been

30 John Doubleday, the first restorer of the Portland Vase, seated beside the reconstructed Vase and a detailed watercolour made in 1845 to record all the individual fragments before the reconstruction began.

employed: one stated emphatically that it was animal glue, another that it was an early epoxy resin, while a third declared that it was shellac. A fourth suggestion was that the adhesive was a combination of shellac and animal glue! As a result of this confusion, attempts were made to extract samples for analysis from the existing joins. These were unsuccessful, however, as Axtell – quite properly – had carefully cleaned all the excess glue off the surface.

Meanwhile, the Vase was extensively photographed to show its condition before reconservation. Special techniques were used to reveal all the break lines and filled areas in both the blue and the white glass. The inside of the vessel was 'bathed' with an intense ultraviolet light, so that the filled areas appeared dark and the break lines showed up clearly. A plan of the position of each fragment of glass was made on a scale drawing of the Vase. This would be useful when the glass was dismantled.

The first restoration had lasted for 100 years; the second only 40 years. The aim was now to find an adhesive which would make the present restoration last as long, if not longer, than the first. The requirements were that it should remain clear for a long time and should not lose adhesion, while remaining easy to remove. It was also important that it should be easy to apply. A number of possible adhesives were selected by the conservators and sent to the British Museum's conservation scientists for testing.

The conservators also had to find the safest possible way of dismantling the Vase so that all the 200 or so fragments could be removed without damage. As the adhesive used in the previous restoration had not been identified, any one or more

31

of at least four different solvents might be needed to dissolve it. It was therefore decided to use a combination of solvents.

Before the glue could be softened, precautions had to be taken to prevent the uncontrolled collapse of the glass sherds and smaller slivers. A scheme was thus devised which involved making inner and outer support moulds to hold the fragments in place once the adhesive was dissolved. Thin strips of blotting paper moistened with water were overlapped on the inside of the Vase until the whole of the inner surface was completely covered. Two more layers were then applied over the first, each with the paper strips running at a different angle. The Vase was then left overnight, but in the morning it was found that the old adhesive had already begun to soften in some areas, as a result of the penetration of the moisture into the glue. The whole Vase could have collapsed at any moment, so quick thinking and even quicker action was needed to stabilise it. Very carefully and very gently, a thin layer of plaster of Paris was painted on to the blotting paper, and as this dried out a rigid inner support mould was formed. The drying process was a nerve-racking time: there was a chance that the water used to mix the plaster would cause the old adhesive to break down even further. A close watch was therefore kept on the Vase,

31 The break lines and filled areas were emphasised by flooding the inside of the Vase with an intense ultraviolet light. The individual sherds of glass could then be identified.

but the inner support hardened successfully. An outer support mould was then made using three layers of blotting paper. While the outer mould was still damp, plastic bindings, elastic bands and cotton tape were carefully applied around the Vase, like small tourniquets, to give additional support. Each binding had to be tightened gently; too much pressure might cause the fragile sherds to crack or shatter.

One of the solvents that was to be used has been known to react with glue and turn pink: if this were to happen on the Portland Vase the resulting stain would be very difficult to remove, particularly from the white glass. Holes were therefore cut in the blotting paper so that the process could be monitored and the treatment stopped if any adverse effects began to appear. The Vase, completely shrouded in blotting paper, was then put into a glass desiccator (a large airtight vessel) and transferred to a fume cupboard. The solvents (acetone and methylene chloride) were mixed together with water and slowly introduced into the top of the container with a hypodermic syringe. The blotting paper absorbed some of the solvent, while the rest evaporated to form a dense vapour around the Vase.

There was now no turning back. After forty-eight hours the adhesive had broken down, the handles were moving, and only the blotting paper and plaster supports were holding the glass fragments in place. The television crew immediately made their way across London to the Museum. Museum photographers were also called to record the dismantling in both colour and black and white. The room was full of people, all with their own jobs to do, and the conservators – already tense at the thought of taking apart almost 200 sherds of glass – had to contend with the added pressure of the film crew and the photographers needing access to a view of the proceedings as well as the thought that they would be recording their every move. A third colleague, Denise Ling, was brought in as an extra pair of hands to steady the Vase should events happen more quickly than expected.

32

32 (*Above, left*) Strips of blotting paper dampened with distilled water were applied to the outside of the Vase to form an outer support while the old adhesive was softened prior to dismantling.

33 (*Above, right*) Nigel Williams removes the first rim sherds from the Vase.

Before dismantling could begin, the Vase had to be removed from the desiccator. It was lifted as slowly and smoothly as possible, as sudden jolts might have dislodged the sherds. The room was silent, apart from the whirr of the cameras, and as the Vase was placed gently and safely on to the work bench a sigh of relief went round. The first piece of the Vase to be removed was one of the handles, followed by fragments of the rim. Once dismantling had begun, speed was of the essence: as each sherd was removed, the surrounding pieces began to give way; but at the same time the solvents were evaporating, perhaps allowing the adhesive to reharden. There was therefore no stopping for any reason until the Vase was completely dismantled. Nor was there any possibility of the film crew doing retakes of the process, and filming continued at times literally over the shoulders of the conservators.

The outer support mould was slowly peeled away, and as the sherds were revealed they were removed, numbered and placed in the appropriate position on the plan. Work continued at a steady rate, and samples of the adhesive were taken from the edges of the sherds for chemical analysis. The results showed that the glue was a very early epoxy resin. This was quite a surprise, particularly as some of the epoxy – which is not supposed to be water-soluble – had softened in water. However, this did confirm the original view that the adhesive was unstable and that the decision to reconserve the Vase had been the right one. When the dismantling was complete, there were 189 sherds spread out on the bench.

The edges of the sherds were still covered with the remains of the old adhesive and a wax filler. These were removed mechanically, using a scalpel blade and paper

34 The BBC *Chronicle* team filmed the whole dismantling process, at times literally over the shoulders of the conservators.

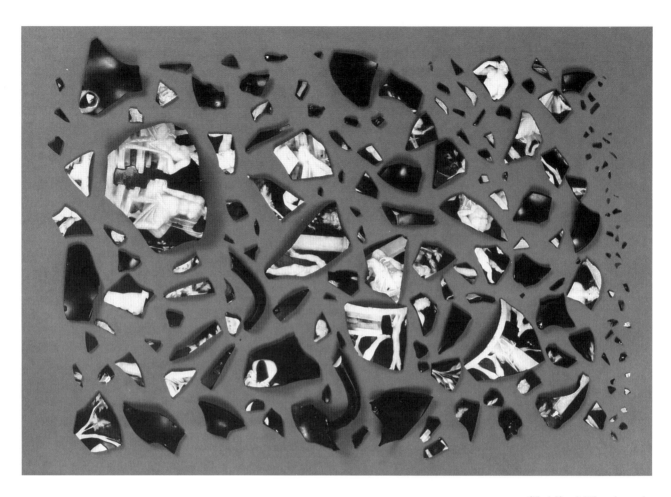

35 (*Above*) The cleaned sherds laid out ready for reconstruction.

36 Each fragment was cleaned by brushing in a solution of soap and water, to remove the surface dirt and grime built up over nearly forty years of continuous display.

37 The sherds were tacked into position using an acrylic resin cured by an intense ultraviolet light source. A slow-drying epoxy resin was used as the main adhesive. Self-adhesive spots indicated the position of the tacking adhesive.

tissue dampened with solvents. Amid the sticky, soft glue, tiny chips of glass remained in place; these had to be separated, cleaned and put in small glass sample tubes to keep them safe. Every last remnant of glue had to be removed, otherwise the sherds would not fit together properly when the time came to reassemble them. The surface of the glass was covered with a thin layer of dirt, the result of years of continuous display. This was dulling the brilliance of the contrast between the blue and the white glass. Each sherd was cleaned by brushing in water and a mild detergent and then patted dry with paper tissue. The beauty of the figures began to glow once more against the dark background.

36

This was the first time in over forty years that the opportunity had arisen for experts from the various fields of glass technology to examine the sherds of the Portland Vase, and national and international specialists came to the Museum hoping to solve the mystery of how the Vase was made. The sherds were examined for unevenness of colour and changes in thickness; they were examined by eye and under the microscope, but still the experts differed in their opinions. However, according to William Gudenrath of the New York Experimental Glass Workshop, the Vase was almost certainly made by a technique best described as 'flashing', whereby the cobalt-blue body was blown and marvered (manipulated) into a preliminary shape and then dipped into molten white glass, which formed a surface skin. The vessel was then blown to its full size, and the shoulders and neck shaped before adding the two handles. The Vase was then transferred to the engraver.

One interesting suggestion is that the glassblower who made the Portland Vase may have been left-handed. The air bubbles within the glass are elongated towards the right, indicating that the glass was swung in that direction during the blowing process. The Museum also took the opportunity to produce a new profile drawing of the Vase, a painstaking process involving the precise measurement of the thickness of the vessel at numerous points across the surface of the glass.

Meanwhile, scientific testing continued on the adhesives proposed for the reassembly. These were an acrylic, which cured under intense ultraviolet light in

a matter of seconds, and an epoxy resin, which cured over five days at room temperature. Each adhesive was tested and retested to make sure that it would cause no damage to the glass and that it would function efficiently as an adhesive for many years. Doubts had been voiced about the reversibility of the acrylic adhesive, and the scientists therefore had to find a solvent which would dissolve it even after a long time. There was also a suspicion that the ultraviolet light would be absorbed by the coloured glass and that this would prevent the acrylic adhesive from curing. This supposition was found to be false when an intense ultraviolet light source was used.

The second adhesive, a very clear epoxy resin, had been tested by the manufacturer under the extreme conditions of the Arizona desert over a number of years and found to retain all its clarity and adhesion. As the British Museum would never have a climate as severe, the conservators felt very confident about this adhesive and an extra pure batch was produced by the manufacturers specifically for use on the Portland Vase. Its only drawback was its long curing time – five days – during which a join could easily move out of alignment. For this reason it was felt necessary to combine it with a fast-drying 'tacking' adhesive, such as the acrylic, which would hold the sherds in place while the epoxy cured. However, each adhesive had been tested only on its own; if they were used together, would one react against the other, stopping it curing or turning it yellow? The adhesives were returned to the scientists for further testing and were again found to give good results.

Once all the visitors had gone, the task of reconstructing the vessel could begin. Normally reconstruction begins either at the rim or at the base of a vessel, whichever is most complete, and the vessel is built up from that point. The Portland Vase was severely shattered on one side (probably the point of impact when it was broken),

38 The sherds laid out on a plan of the Vase during the process of building the smaller sherds up into larger, more manageable panels.

39 The reconstruction
of the shoulder area
revealed file marks,
where the glass had
been abraded during a
previous restoration.

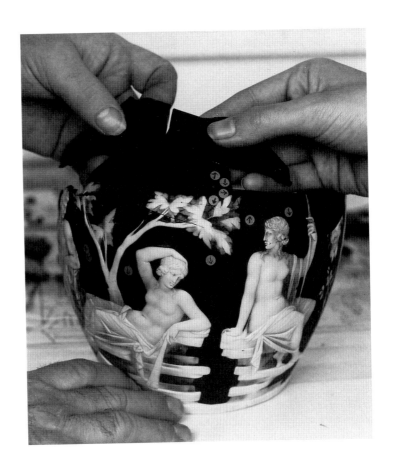

making the normal procedure very difficult. The small fragments were therefore
38 built up into larger panels which were easier to handle and which could then be
fitted together in the usual way, as if they were single sherds. This was a process
fraught with difficulty, as building up separate panels increased the risk of misalign-
ment when these panels were eventually stuck together.

To retain the clarity of both adhesives and to enable them to achieve their
maximum strength, the edges of the sherds had to be cleaned with almost clinical
thoroughness, using cotton wool swabs dipped in a mixture of 15% ethanol and
85% acetone. The epoxy, which had to be mixed with great care, was painted on
to one of the sherd edges, leaving a small space into which a drop of the acrylic
adhesive was introduced to act as a tacking agent. The two sherds were then pressed
together and any excess adhesive wiped from the surface of the glass with swabs.
Each join had to be checked and double-checked by hand and under a microscope
to make sure the sherds were exactly aligned before the adhesive was allowed to
cure. A sticky label on each join indicated the position of the acrylic adhesive, so
37 that the ultraviolet light source which would cure it could be accurately directed.

To a conservator the senses of sight and touch are essential, and the goggles and
gloves worn to protect the eyes and hands from the intense ultraviolet rays seriously
impaired both. Slight misalignments of the sherds could only be detected once the
protective clothing was removed, that is, after the tacking adhesive had cured. If
this occurred, the adhesive had to be dissolved, and the sherd edges recleaned
before another attempt could be made to stick them together correctly.

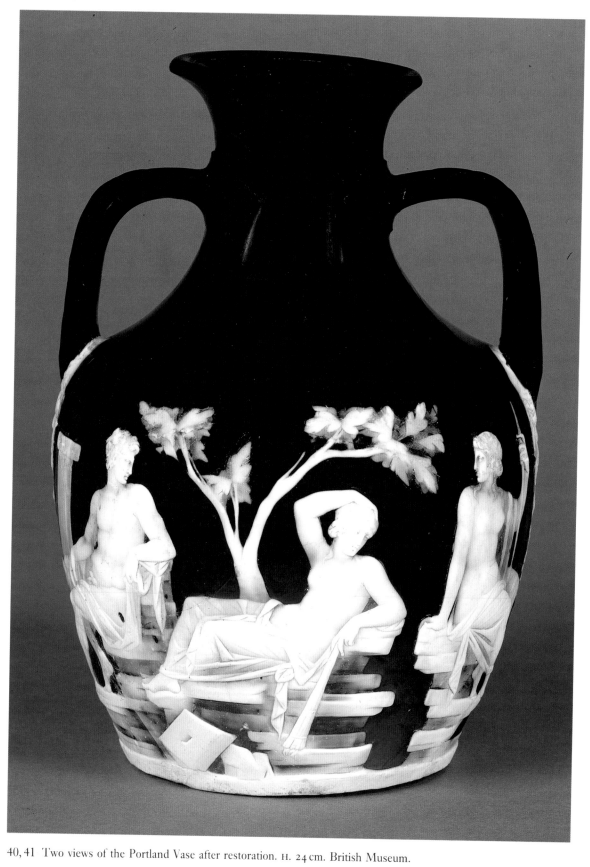

40, 41 Two views of the Portland Vase after restoration. H. 24 cm. British Museum.

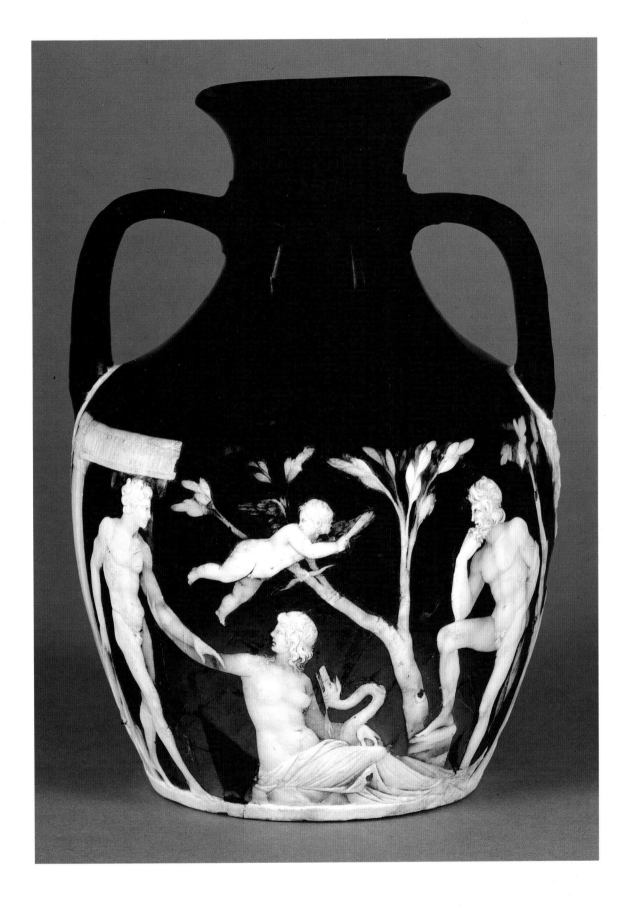

Gradually the fragments of the Vase were reformed into panels which were then treated like large sherds and reconstructed in the more conventional way, beginning at the base. The curve of the vessel was recreated, and the last fragment completing the circle of the body – always the most difficult to align – slotted in perfectly. This had all been achieved within a few days, and by a week before Christmas 1990 the Vase was complete from the base up to the shoulder. The BBC crew wanted the whole reconstruction 'in the bag' that week, but suddenly things began to go wrong. The next sherds were tacked into place, carefully aligned with the fragments beneath, only to find that they did not fit together correctly.

The sherds were dismantled and reassembled, but still the problem remained. Assembling the Vase right up to the rim showed how serious the misalignment was, and yet it seemed impossible that it should be so. If a mistake had been made in the reconstruction lower down the Vase, this would have been clearly visible in the engraved scenes. The film crew stood by as the Vase was dismantled and reconstructed time after time. It was then noticed that the edges of a number of the shoulder and neck sherds were heavily scored with lines made by a file. Abrading the edges of sherds in this way, rather than dismantling and re-reconstructing an object, was formerly a common procedure when pieces were misaligned and did not fit exactly into place. This misalignment becomes more acute towards the end of a restoration, so it is not surprising that the offending sherds were only discovered when the new restoration of the Vase was nearing completion.

Amid their shock and disbelief that such a thing could have been done to the Portland Vase, the conservators had to find a way of restoring the damaged area to its original dimensions. The edges of some sherds had been so heavily worked that the pieces did not join together at all. By the end of that week a perfect reconstruction

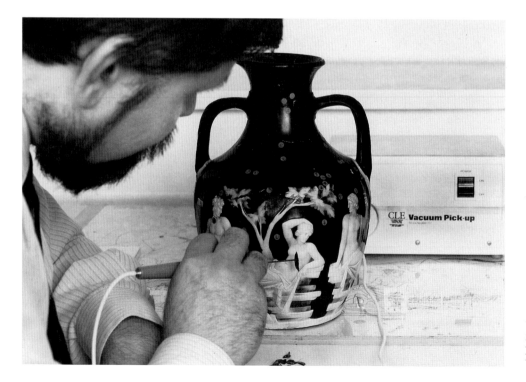

42 The smaller chips of glass were lifted and positioned using vacuum tweezers.

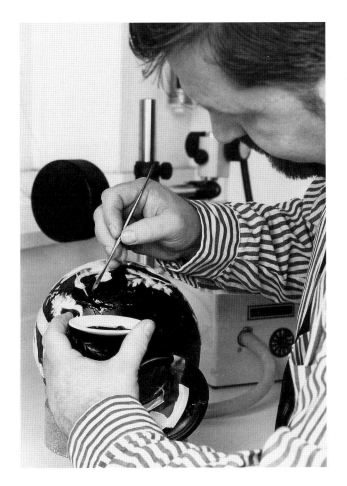

43 (*Left*) Missing areas of blue glass were filled using precoloured epoxy resin, which was slowly built up layer by layer to the same height as the original surface.

44 (*Right*) A detail before restoration showing losses in the white glass. The nose of the seated figure was remodelled using a plaster cast of the Vase made by James Tassie in the eighteenth century as a reference.

was no closer than it had been at the beginning, and the conservators left the Museum for a sleepless Christmas holiday. The New Year brought an acceptable compromise in the form of a decision to leave gaps between some of the sherds, allowing the original shape of the vessel to be restored. The gaps would later be filled with resin.

Attention now turned to the tiny chips which had remained unplaced in the previous restorations. Vacuum tweezers were used to handle the slivers of glass and to position them. After a number of weeks, all but eleven of the fragments had been fitted into the Vase. It was known that all those that remained came from the inside of the vessel and it was therefore difficult to justify spending any further time on trying to find places for them.

When the Vase was shattered in 1845 some areas were damaged beyond repair because the glass was reduced to dust and tiny slivers. These areas of loss, as well as the gaps between the abraded neck sherds, had to be filled with a modern resin to make sure the Vase was sufficiently stable and strong to withstand handling, and also to give continuity to the scenes carved in the white glass. The same epoxy resin used as an adhesive in the reconstruction of the vessel was used as a filler, but now it was precoloured to match the surrounding glass; other inert fillers were also added to give the resin a similar texture to that of the glass.

The blue colour of the resin was made up of three different pigments, a deep

42

blue, a turquoise blue and a violet. Violet is a notoriously difficult pigment to deal with, as it is unstable and often fades with age. The adhesives had been chosen for their long-lasting qualities, and it was necessary to ensure that a change in the colour of the resin filler would not be the cause of a further reconservation. After much testing and retesting, a violet colour (used by a leading American car manufacturer) was found which had good permanence.

In order to apply the resin to the gaps, a support was made on the inside of the Vase by taping sheet dental wax over each gap and letting it cool. The resin was then poured into the gap from outside. In some areas several applications of resin 43 were needed before the contour of the vessel could be built up. The gaps were deliberately overfilled so that the hardened resin could be worked back flush with the surface of the surrounding glass and then polished to give a sympathetic finish.

Once the areas of blue glass had been filled, the white areas could be built up on top. In some cases this was a very simple procedure, but in other places parts of the figures were missing and remodelling was necessary. The ethical question now 44 arose: was it right to restore these missing areas? If the Vase remained as it was, the continuity of the scenes and their beauty would be impaired by the areas of loss; but if these areas were filled, the conservators had to be very careful to retain the original style. Fortunately, they could refer to the Tassie plaster copy, made before any major breakage occurred, and this was eventually used as a template for the accurate remodelling of the damaged areas. Once all the filling had been completed, the whole vessel was given a thin coating of a microcrystalline wax to restore the sheen to the glass surface.

This completed the third conservation of the Portland Vase. The BBC crew returned to the Television Centre to edit well over 1,000 hours of film footage into a fifty-minute programme, while the conservators went back to more routine tasks and the Vase was put back on display in the Museum galleries, where it continues 40, 41 to excite the admiration and curiosity of scholars and public alike.

Acknowledgements

The author would like to thank everyone involved in the third conservation of the Portland Vase, but in particular Nigel Williams, Chief Conservation Officer and leader of the project, Denise Ling, Conservation Officer, and all other members of the Ceramics and Glass Section of the Department of Conservation at the British Museum. Trevor Springett made the invaluable photographic record of the whole process, and Sue Bradley and the British Museum Conservation Scientists carried out the essential analysis on the adhesives and pigments used. Finally, thanks are due to Kenneth Painter, then Deputy Keeper, and members of the Department of Greek and Roman Antiquities for their assistance in this project; also to Veronica Tatton-Brown for her advice on this chapter. All photographs are © The Trustees of the British Museum.

Further Reading

D. E. L. Haynes, *The Portland Vase*, 2nd edn, London 1975.

D. Harden, *Glass of the Caesars*, Milan 1987.

N. Williams, *The Breaking and Remaking of the Portland Vase*, London 1989.

Journal of Glass Studies 23 (1990): entirely devoted to the Portland Vase.

W. Gudenrath, 'Techniques of Glassmaking and Decoration' in Hugh Tait (ed.), *Five Thousand Years of Glass*, London 1991, pp. 227–8.

3 *Henry Prince of Wales on Horseback* by Robert Peake the Elder

Ian McClure

People often expect the cleaning of a painting to lead to an unexpected discovery of some kind. This is in fact quite rare: more often the removal of old varnish and repaintings – the accumulation of past restorations – from the surface of the painting simply reveals once more the qualities of the original work. But sometimes the conservator does stumble on an extraordinary find, and the rediscovery of the original composition of the great equestrian portrait of Henry Frederick, Prince of Wales, from Parham Park in West Sussex was one of these rare occurrences.

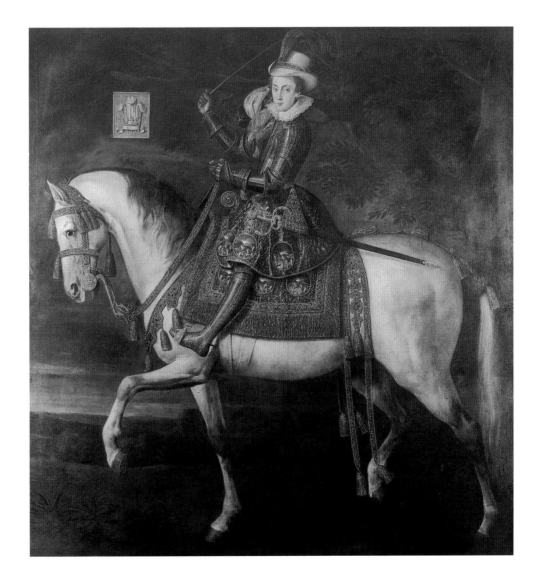

45 Robert Peake the Elder: *Henry Prince of Wales on Horseback,* c.1610–12, before restoration.
Oil on canvas, 231 × 219.5 cm.
Mrs P. A. Tritton.

The painting was first inspected when its owner was asked to lend it to the *Treasure Houses of Britain* exhibition held in Washington in October 1985. Some minor structural treatment was required to make the painting safe to travel, and it was felt that removal of the existing discoloured varnish and obviously discoloured repainting over damaged areas would greatly improve its appearance. To this the owner agreed, and early in January 1985 the painting was sent to the Hamilton Kerr Institute of the Fitzwilliam Museum, Cambridge, where examination and treatment were carried out by Renate Woudhuysen, Sally Thirkettle and the author.

The portrait, measuring 231 × 219.5 cm (approx. 7½ × 7 ft), was one of a series either painted for the Prince or commissioned by someone close to him. Born in 1594, the eldest son of King James I of England, Henry Frederick was created Prince of Wales in 1610 and rapidly attracted to his court scholars, artists and architects, most significantly from abroad. His clear intention was to rival the courts of Italian princes. Among those whom Henry invited to London, for example, was Constantino da Servi, a sculptor, landscape gardener and designer of masques who had worked for Cosimo II de' Medici in Florence and at the courts of Bohemia and France. The Prince commissioned many projects, but almost all failed to materialise through lack of funds. However, a series of portraits survives, made by his court artist Robert Peake the Elder (*c.*1551–1619) and including paintings showing the Prince in the hunting field and as a warrior. But in little more than two years, in November 1612, the Prince contracted typhoid and died. Assuming the Parham portrait is not a posthumous one, it can therefore be dated between 1610 and 1612.

The Parham portrait had always proved puzzling. It showed the Prince in splendid armour, riding out on an elegant horse with flowing mane across a landscape lit by the golden light of the setting sun. A tree spreading out behind him supported on a slender branch a stone plaque bearing the device of the Prince of Wales. While the figure of the Prince seemed to be by Peake, the relative sophistication of the composition, with its Titianesque overtones, suggested an artist who had travelled and worked abroad, such as Isaac Oliver (d.1617). The broadly executed landscape was in contrast to the meticulously painted details of the Prince's armour, where the *imprese*, the repeated pictorial devices, allude to the Prince's qualities as a future king. The reason for this inconsistency was soon explained.

Before conservation treatment began, the condition of the painting was fully recorded and documented with the aid of photographs. The original canvas had been lined with three supporting canvases. This is unusual, although double-lined canvases are quite common, particularly where the original canvas has been badly torn and requires further support. A strip 9–10 cm (approx. 3½ in) wide had been added at the top of the original canvas. The wooden stretcher supporting the painting was slightly larger than the original canvas to allow for the fact that it had become distorted and was no longer square at the corners. The paint layer seemed generally secure, with no signs of structural weakness such as flaking or blistering. The painting was covered with a very discoloured layer of varnish. Discoloured repairs to locally damaged areas of paint could be seen along a seam running roughly down the centre of the painting and in the lower foreground, where the painting would be particularly vulnerable to knocks and abrasions while hanging in a house.

Tests were then made to determine the most suitable solvents to remove the

45

varnish, which was a natural resin, probably dammar. This proved readily soluble in mild solvents, suggesting that it had been applied comparatively recently. It was found that a mixture of ethanol and white spirit (one part to eight) swelled and dissolved the varnish without endangering the paint. Later in the treatment an inscription was found on the inside of the canvas stretcher, dating the most recent lining to 1902, and it is possible that the painting was also restored and the varnish applied at that time.

Several of the areas of later repainting proved to be soluble in the same solvent mixture. It was during a test removal of a larger area of retouching below and to the left of the horse's nose that it was found that the repainting covered an area where the paint of the sky had been removed, revealing a section of landscape on an entirely different scale beneath the visible one. Subsequent examination by infra-red reflectography, which projects an infra-red image on to a television monitor and can reveal damages and repairs, and sometimes preparatory drawings and changes in the composition, showed that the landscape beneath the visible paint layer extended over a larger area, and what appeared to be pollarded trees could be seen. Scanning the right-hand side of the painting, however, produced a very confused image which was difficult to interpret.

Examination of the paint surface also showed that the horse and landscape seemed thickly painted around the figure of the Prince. Normally, the artist would have painted the image of the Prince before blocking in the landscape, while the meticulously painted details such as the trappings of the harness would have been painted

46 The removal of an area of retouching revealed the presence of a different landscape underneath the overpaint.

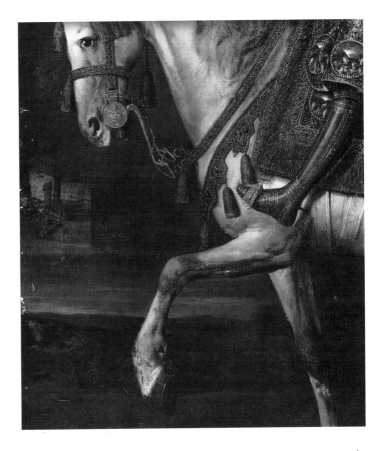

over the finished landscape. Here it could be seen that the horse and landscape had been painted around the fringes of the saddle and harness.

At this stage an X-ray image was made of the upper right portion of the painting. A number of slightly overlapping plates were exposed and then cut and fitted together. It was hoped that the X-ray would provide information about the composition beneath the present layers of paint as well as an idea of the condition of the underlying paint layers. When passed through a painting, X-rays are absorbed to a greater or lesser extent by different pigments. Thus lead-based pigments, such as lead white used in flesh areas, absorb X-rays and appear light on the X-ray plate, while earth pigments such as ochres, or lakes, where the substrate may be chalk or aluminium hydroxide, absorb very little and appear dark. The image will thus reveal alterations to figures or other areas where lead-rich paint, in particular, might have been used. In this case, the X-ray image was quite dramatic and clearly showed the figure of a man walking behind the horse. It was evident that an extensively different composition lay beneath the landscape.

47

The X-rays also revealed losses in the paint layer, including fragments of the lead white in the flesh tones of the man and in the horse. Some losses, such as those on the horse, had been made up with lead-white filler and were visible on the existing surface of the painting. However, the losses which the X-rays showed to be covered by later, less X-ray-absorbent paint revealed, first, that the picture had been dam-

47 X-ray of the centre right portion of the painting, showing a figure behind the horse.

49 (*Right*) Detail of the horse's head, taken during cleaning. The thickly applied overpaint can still be seen on the neck, but has been removed below the tassles.

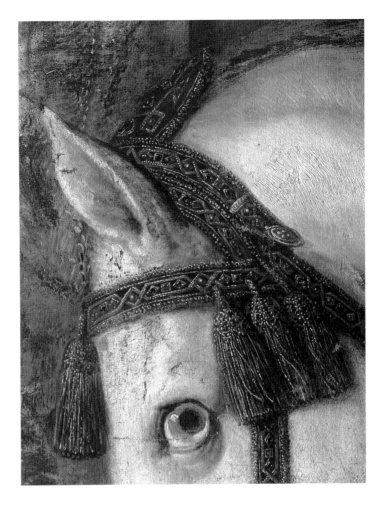

48 (*Above*) Magnified paint sample showing, above a fragment of ground, successive layers of paint and varnish.

aged and restored before the repainting – indicating that some considerable time elapsed between the painting's completion and its subsequent alteration – and, secondly, that the areas of damage, though numerous, were small and not extensive. Most of the paint losses appeared to have occurred when the canvas was kinked or creased, perhaps when removed from its wooden stretcher and rolled up. This was later confirmed when the overpaint was removed.

The paint layer was now examined again. There were marked differences in technique between, for example, the precisely painted detail of the Prince's armour, where thin layers were built up and details applied in impasto, and the thickly painted leaves of the tree. (This can also be seen clearly in Fig. 49, a detail taken later during cleaning, where the original paint is visible immediately below the tassles to the right of the horse's ear, while on its neck the thickly applied overpaint remains.) A microscopic paint sample, approximately half a millimetre square, was taken from the sky to the left of the horse's head. This sample was taken from an area of damage and would, it was hoped, include all the layers of the painting. The sample was embedded in a clear polyester resin and then cut away and polished on one side so that all the layers could be viewed under a microscope. Only a fragment of the ground was present, but above this was a blue layer with a thin greenish-blue layer over it, then a greenish-blue layer with some white. Above that could be seen

63

a dark layer of varnish which had seeped vertically into cracks in the paint layer beneath. Covering the varnish was a layer of very fine blue pigment particles, with traces of another varnish layer on top. This cross-section showed clearly that the first layers of paint had aged and cracked and had then been varnished over before the top layer of paint was applied. How long the original paint would have remained uncracked is difficult to assess, as so many factors affect it – the technique of the artist, the materials he used and the conditions to which the painting was subjected thereafter – but on average one might say a minimum of about thirty years. The overpaint therefore probably dated from around 1640 at the earliest. This structure, with a layer of varnish separating the overpaint from the original, was confirmed in other areas of the painting.

Analysis of the pigments showed that while the blue layers beneath the discoloured varnish layer contained azurite, a naturally occurring mineral pigment in common use in the West from the Middle Ages to the seventeenth century, the top fine blue layer of overpaint was indigo, a pigment extracted from the indigo plant since prehistoric times. Indigo tends to fade in light, even when mixed with other pigments, and with the discovery of Prussian blue around 1705 and its introduction into England by 1725, indigo was largely superseded as a pigment for oil painting, although it continued to be used for watercolours. The evidence therefore suggests that the overpaint was applied between 1640 and 1730.

The decision whether or not to remove the overpaint now had to be made, and here several factors had to be taken into account. The X-rays indicated that the original paint was in good condition. The fact that the overpaint did not follow the contours of the original also suggested that it had not been applied in an attempt to conceal a disastrous overcleaning in the past. Because the overpaint could only have been applied thirty years after the Prince's death at the earliest, it seemed unlikely that it would have been an act of historical significance, such as the removal of a particular iconographic scheme which, after the Prince's unexpected and untimely death, might have been thought inappropriate and macabre. It therefore seemed most likely that the painting had been 'improved'.

With the gift of hindsight, the quality of the thickly applied overpaint now appeared considerably inferior to that of the original. The painting of the tree and leaves seemed very schematic and wooden. Some spatial ambiguity in the way in which the horse and rider related to the landscape was noticeable. The image of the horseman in a landscape seemed to hark back to Titian's equestrian portrait of Charles V at Mühlberg of 1548 (now in the Prado, Madrid), but here the landscape seemed to serve only as a painted backdrop, unlike the synthesis of mood between rider and landscape apparent in Titian's painting.

After discussion with the owner, who also took independent advice, it was decided to go ahead with the removal of the overpaint. The success of this operation was due to the presence of the layer of varnish between the overpaint and the original. A system was developed which enabled the solvent mixture (acetone and ethanol) to penetrate the overpaint and swell the varnish layer. The solvent was prevented from evaporating by covering the surface with clear plastic sheeting. After some experiment, it was found that one minute was enough to swell the varnish and overpaint sufficiently for it to be removed with a mixture of white spirit and ethanol.

50

Some areas of the original paint layer proved more soluble than others and it was therefore necessary to make constant checks and to vary the length of time that the paint layer was exposed to the solvents.

Gradually the original composition began to emerge. The elegant grey horse with flowing mane was transformed into a sturdy tilting horse capable of carrying a man in full armour. The Prince was seen to be riding in front of a wall. Walking behind him was a naked, winged old man with a beard, suggestive of Father Time, who carried the Prince's lance and a helmet luxuriant with coloured plumes. The plaque bearing the insignia of the Prince of Wales, formerly suspended on a branch, was seen to be built into the wall and balanced by another on the other side of the Prince. Glimpsed through an arch set behind the wall on the left was a view of a garden of pollarded trees with a stream and a wooden bridge, reminiscent of the descriptions of the Prince's garden at Richmond Palace (see Roy Strong, *Henry Prince of Wales and England's Lost Renaissance*, London 1986). Tied to the Prince's raised arm was a striped cloth or favour bearing his colours or the colours of his lady in the tradition of courtly love romance, in readiness for the tilt, the formalised jousting contests of which he was so fond. His favour is tied to the bearded figure's forelock, the only hair on his head. Sir Roy Strong has suggested that 'what we are looking at is the Prince seizing Opportunity by the forelock. The more familiar

50 Detail taken during cleaning, showing the repetitious execution of the overpainted foliage. The head of the figure behind the Prince is revealed and seen to be in good condition, as the X-ray had indicated.

Renaissance casting of "Occasio" was as feminine, due to her fusion with Fortuna, but here we have the original masculine figure of Time as "Kairos", that is that brief, decisive moment which marks a turning point in the life of human beings or in the history of the universe.'

The removal of the overpaint showed that the original canvas had no major tears or rips, although there were numerous small losses and damages. Some of these had been filled and retouched, confirming that the painting had been restored before being repainted. The addition at the top of the canvas was clearly later than the overpaint, as the indigo blue sky of the overpaint was matched with Prussian blue, which overlapped the painted landscape. At the top edge of the original canvas, where it met the addition, traces of blue and green could be seen, indicating that foliage and sky originally appeared above the wall.

Further clues about the painting's original size could be gleaned from an examination of the stretcher-bar marks on the canvas. When a canvas is stretched on a wooden frame, the outline of the frame eventually tends to become visible on the surface. This can be caused by the buffering effect of the wooden framework, which

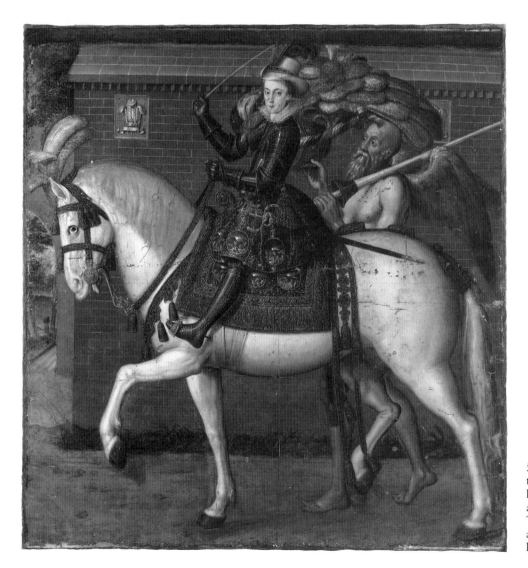

51 The painting after the removal of the varnish layers and the overpaint, and before restoration. The stretcher-bar marks are visible in the lower left corner.

52 Detail showing the stone wall painted over the original brick wall, and the alteration to the Prince's armour.

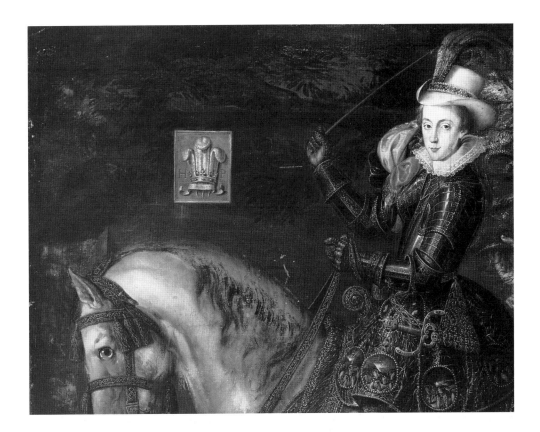

enables canvas and paint in these areas to remain uncracked, or by the canvas becoming slack, especially in humid conditions, and folding slightly around the wooden structure. The patterns visible on the painting – diagonal marks in the corners, and horizontal lines across Father Time's shoulder, the horse's rump and below the wall – suggest that approximately fifteen centimetres (6 in) of canvas were removed at some stage from the top edge of the painting. Moreover, the vertical seam of the original canvas is not central. This may indicate that about fifteen centimetres are also missing from the right-hand side of the picture, although artists did adjust the position of seams so as to avoid important areas of the composition, such as the Prince's face.

It was clear by now that the painting had undergone at least five separate restorations. In the first alteration, minor retouchings were carried out and the red brick wall behind the figure of the Prince was changed to a grey stone wall with large regular-sized blocks. The outline of the front of the Prince's armour was also altered, possibly to make his pose less rigid by twisting his torso towards the viewer. This alteration covered the crease-like losses, suggesting that the painting might have been first removed from its stretcher and rolled up for storage for some time. This time-scale would fit quite well with historical events: perhaps the painting was rolled and stored after the outbreak of the Civil War in 1642 and brought out again and restored and altered after the Restoration of Charles II in 1660.

The fact that another thirty years or so must then have elapsed before the large-scale overpainting was applied (when the landscape was painted around the figure) is suggested by the fact that the retouchings on Father Time's chest in turn

developed cracks into which the indigo paint layers of the overpainting flowed. This takes the date of this second restoration to the very end of the seventeenth century and before 1730. The complex iconography of the painting would by this time have appeared very dated and obscure, and it is probably for this reason that it was decided to 'improve' it and bring it more into line with contemporary taste. It was probably also during this restoration that the painting was trimmed at the top. The reason can only be guessed at: perhaps it was to fit a particular room space or frame.

A third restoration saw the addition of a strip to replace the missing section at the top, although the replacement was narrower – about 9–10 cm (3½–4 in). This was painted to match the landscape, although principally with Prussian blue, which dates it after 1730. Presumably the strip was added to recreate some of the space above the Prince's head which had been lost when the canvas was cut down. The painting was double-lined and the added strip supported by the two lining canvases. The pressure applied when gluing the canvases together caused the impasto of the overpainted landscape to be impressed into the original paint, leaving a ghost-like impression still visible in strongly raking light. Filler was applied to smooth the join between the new strip and the original canvas, as well as to other losses in the painting, particularly around the edges. In the fourth restoration, in 1902, the painting was strengthened by a third lining canvas. Finally, there is evidence that minor structural repairs were made later, perhaps before the painting's sale in 1946. During this fifth restoration, or that of 1902, the test cleaning through the landscape overpaint (see Fig. 46) must have been made and a decision taken not to proceed. Perhaps it was feared that the figure of the Prince himself might also be an overpainting.

During cleaning of the fillings and retouchings, the grey wall paint and the alterations to the Prince's armour were removed, except where abraded details in his skirt had been accurately and skilfully strengthened in an earlier restoration.

The painting was now as close to its original state as possible, and stylistically it was clearly by Robert Peake. It had always been regarded as an important work, being a very early royal equestrian portrait painted in England, but it had now become a much more complex image. From an examination of the artist's technique it was also possible to see that the composition had been significantly altered as the artist went along, as if the iconography of the image had been developed gradually. This was indicated both by large numbers of *pentimenti*, or alterations in the composition, which had become visible as a result of the abrasion and increasing transparency of the paint layers with age, and by the way in which the artist had painted over completed sections of the painting rather than planning the composition from the start.

Peake appears to have begun with the idea of painting a straightforward portrait of the Prince on horseback. The model for this might have been the equestrian portrait of Henri II of France attributed to Clouet (Metropolitan Museum of Art, New York), in which the king is shown riding in a narrow space in front of an elaborate stone edifice. A portrait of Henri IV of France by Federico Zuccaro (Boughton House, Northamptonshire) shows the king riding in front of a wall with a landscape seen on one side of it. Zuccaro visited England in 1574 and it would

be likely through frequenting court circles that Peake knew of his work, or that the Prince wished his own painter to emulate Zuccaro. Peake applied his paint with little detectable underdrawing on to a canvas prepared with two layers of ground. The first ground, which was red, was covered with another gritty light grey ground applied broadly with a priming knife and producing the patchy pattern visible in the top right and lower left of the X-ray. The use of double grounds is quite common, especially in seventeenth-century Dutch painting, but the reason for them is not completely understood. It is possible that artists purchased canvas already primed with the red ground and applied a neutral grey ground with a gritty key for the paint, or that the red ground might have been thought to prolong the life of the canvas.

47

The figure of the Prince was painted on to the ground and the wall painted around him and the horse. However, the figure of Time was painted over the red wall and the greyish foreground, with the result that his legs are now greyer than his torso and his wings seem reddish. It seems, therefore, that at this stage the content of the picture was dramatically altered and a complex statement made about the Prince and his potential as a ruler. After this alteration only minor changes were made: to the position of Time's wings, the placing of the horse's feet and details of the wall. The revised composition may owe a debt to Dürer's sombre engraving *The Knight, Death and the Devil*, and Henry Frederick certainly knew Dürer's prints. However, the *impresi* on the Prince's suit of armour, with their rich allusions to Hope (anchor and rising sun) suggest a celebratory image, anticipating that his reign will be glorious and fruitful. It is clear from the technical evidence that the tragic death of the Prince so soon afterwards was not the reason why the painting was covered. The figure of Time was not seen with hindsight as the figure of Death

53
54

53 The development of the composition. The dotted lines indicate alterations made during the progress of the painting, and the vertical strip 'A' on the right suggests what might have been removed. During lining the canvas has been cut off square.

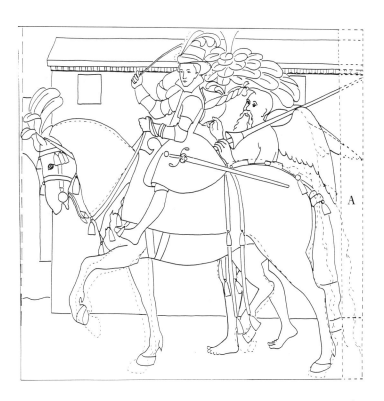

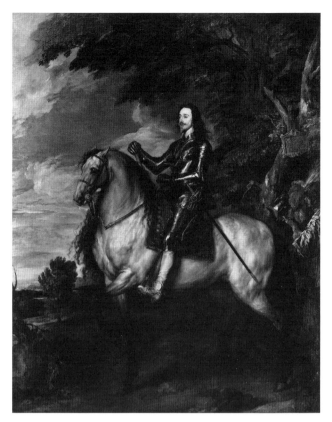

stalking the Prince, as Dürer's image might have suggested. For the same reason, there is no evidence that the painting was a posthumous portrait.

Christopher Brown (in *Van Dyck*, Oxford 1982) has noted that Charles I, like his elder brother Prince Henry, commissioned portraits of himself on horseback and in the hunting field. Where the Prince had commissioned Peake, the King employed Van Dyck. It is tempting to see in Van Dyck's equestrian portrait in the National Gallery, London, echoes of the Parham picture before its repainting, for instance the plaque and the groom holding the plumed helmet. Van Dyck painted his portrait in 1637, and it is possible that he could have seen Peake's portrait in its unaltered state. However, Van Dyck set his king in a broad landscape strongly reminiscent of Titian's portrait of Emperor Charles V. When the anonymous artist in the late seventeenth century set about altering the portrait of the Prince, he seems in turn to have attempted to give the picture a Van Dyckian cast, with particular reference to the portrait of Charles I. The horse was rendered elegant and slender, with a flowing mane. The broad landscape was painted in, and the plaque of the Prince of Wales was suspended from the branch of the tree.

After cleaning, the tacking edges of the 1902 lining canvas were strengthened with strips of canvas (known as 'strip-lining') stuck with a reversible synthetic adhesive. The addition along the top was retained, but the overpaint of the fourth restoration removed. This strip at the top returned the original canvas to something close to its original dimensions, and without it the Prince's head would have been too close to the top of the painting. From the fragments of original blue, green and

55

54 (*Above, left*) Albrecht Dürer: *The Knight, Death and the Devil*, 1513. Engraving, 25 × 19 cm. British Museum.

55 (*Above, right*) Sir Anthony van Dyck: *Charles I on Horseback*, 1637. Oil on canvas, 367 × 292.1 cm. London, National Gallery.

56 *Henry Prince of Wales on Horseback*, after restoration.

yellow along the top of the wall it was decided to reconstruct the area of foliage and sky above it. Before any restoration began, the whole painting was varnished with a synthetic picture varnish (MS2A, a reduced polycyclohexanone dissolved in white spirit) that will not discolour significantly or become increasingly insoluble. Fillings of gelatin and chalk were then applied to areas of loss. The surfaces of the fillings were textured to match the surrounding paint layer. Once the fillings were sealed, the colours of the grounds were matched and applied to the losses. The retouching medium was whole egg mixed with finely ground pigments and applied thinly in many layers. Although colour matching is difficult with egg tempera, as it darkens initially on drying, the medium does not visibly change colour and remains easily reversible, either by dissolving the synthetic varnish on which it is applied or by wiping it away with a swab moistened with water. By varnishing thinly between layers it is possible to match exactly the build-up of layers of paint in the original. These retouchings do not extend beyond the area of loss.

The reconstructed foliage and sky above the wall was repainted in the same way. It would have been possible to create a schematic reconstruction that was obviously a restoration when viewed at close quarters, but this would have produced a visually discordant element in a picture that, apart from minor losses, was generally in such good condition. The painting is full of carefully drawn, precise details, and too obvious a restoration consisting of an abstraction of toned hatchings would simply have been out of key. Final adjustments for an exact colour match were made with pigments dispersed in the same resin as was selected for the varnish. Areas of original paint where there was abrasion were retouched with this medium, as it can, in future, be removed with the varnish layer if required.

Finally, the painting was spray varnished. It was known that at Parham it would be lit from the side, so some reduction in gloss was thought desirable in order to cut down reflection. A microcrystalline wax was therefore added to the varnish, diminishing its shine without significantly affecting the saturation of the colours.

Acknowledgements

The author would like to thank in particular Mrs P. A. Tritton of Parham Park for her enthusiastic support and interest. The photographs for this chapter are by Christopher Hurst, with the exception of Fig. 45, which was supplied by Parham Park, Fig. 54, which is © The Trustees of the British Museum, and Fig. 55, reproduced by permission of the Trustees of the National Gallery.

Further Reading

R. H. Marijnissen, *Paintings: Genuine, Fraud, Fake. Modern methods of examining paintings*, Brussels 1985.

R. Strong, *Henry Prince of Wales and England's Lost Renaissance*, London 1986, particularly pp. 86–138.

R. Woodhuysen-Keller, I. McClure and S. Thirkettle, 'The examination and restoration of *Henry Prince of Wales* by Robert Peake', in *Hamilton Kerr Bulletin* no. 1, Cambridge 1988.

4 The Sutton Hoo Helmet

Nigel Williams

In 1939 archaeologists excavated the largest of a group of burial mounds at Sutton Hoo, near Ipswich in Suffolk, and discovered what was to be called 'the richest find ever made on British soil' and 'the million pound grave'. The mound contained the remains of a 90-foot clinker-built boat. The boat had been the grave of a king, and it contained the domestic objects he would need in the next life: bronze bowls, buckets, bottles, cauldrons, drinking horns, silver bowls and dishes. Also in the grave were his weapons and personal possessions, including spears, a sword, a shield, a helmet, a lyre, a sceptre, gold and garnet jewellery and a purse full of coins which helped to date the grave to about AD 625, suggesting that it may have been that of Raedwald, an Anglo-Saxon king of East Anglia. Because of the impending war, the treasure was stored in the Underground railway tunnel at Aldwych until 1946. During the years that followed, many of the excavated objects were examined and conserved. The helmet, which was made of iron covered with bronze decorative plates, was restored by Herbert Maryon, who spent nearly six months piecing together the hundreds of fragments that had been found.

57

57 The Sutton Hoo helmet as reconstructed by Herbert Maryon in 1949.

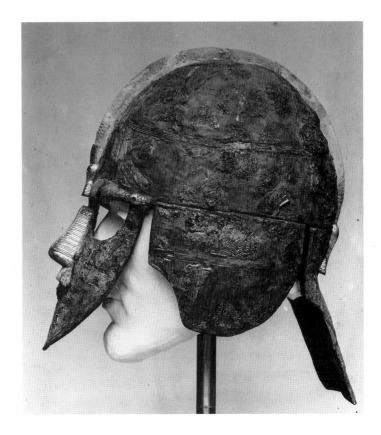

58 The 1949 reconstruction: X-ray of the removed ear flap, showing the individual fragments and the method of construction.

When the restored helmet was presented to the world it was generally acclaimed. Since it was at that time the only known example of a decorated Anglo-Saxon helmet, photographs of it found their way into every book on Anglo-Saxon art and archaeology. However, a few experts were unhappy with certain features of the reconstruction. They pointed out that the decorative bronze plates were haphazardly arranged, particularly those on the crown of the skull cap. The rigidly fixed neck guard was felt to be wrong, for it prevented the wearer from looking up without 'stabbing' himself in the back. The eye holes were so large that they would allow a sword to pass through. There was a hole at the junction between eyebrows and nose. The angle of the face mask looked strange, not least because it rendered the wearer's nose vulnerable in the event of a blow to the face; it also left the neck very exposed. The skull cap was so narrow that there was barely room for a normal-sized head, and certainly no space for the padding which would have been necessary inside the helmet.

Despite these objections, the helmet remained on display for the next twenty years, becoming a very familiar item among the Anglo-Saxon objects in the British Museum. In 1968 Dr Rupert Bruce-Mitford, Keeper of Medieval and Later Antiquities, decided that the evidence for the reconstruction should be re-examined. After several months' consideration, the conclusion was reached that the only way to answer all the questions was to dismantle the helmet and reconstruct it anew.

Almost nothing was known about Maryon's reconstruction, apart from the fact that the iron fragments had been embedded in a solid block of plaster of Paris. An essential requirement of the proposed new restoration was of course that none of the fragments should be damaged during the dismantling. As a preliminary, an ear flap was removed by cutting through the holding screws with a small saw. An X-ray 58

showed that the flap was constructed in three layers, two of plaster and one of wire mesh. It appeared that the wire had been cut and shaped and then covered in plaster, on to which the helmet fragments had been placed, the missing areas being filled with more plaster. To dismantle the ear flap, the underlying layers, including the wire, were rolled back like a carpet. The fragments were then cut out, using the X-ray to plot possible saw lines. This process left the original iron sunk in a bed of plaster, which was chipped away using a scalpel and needles. As this proved successful, the same procedure was used on the other ear flap, the neck guard and the face mask.

The next problem concerned the skull cap. How could such a solid block be removed without damaging the iron? The crest was an obvious weak point, and it was decided to undermine it with long pins until it could be removed. This produced a surprising revelation: the upper part of the cap was hollow. Contrary to Maryon's account of his restoration, the fragments surrounding the crest were not embedded in the plaster. Clearly, he had experienced some difficulty in fitting the fragments to the plaster head he had made, and had had to build it up rather differently from the way he had first planned. After removing the crest, it was possible to cut the

59 The 1949 reconstruction after removal of the lower sections.

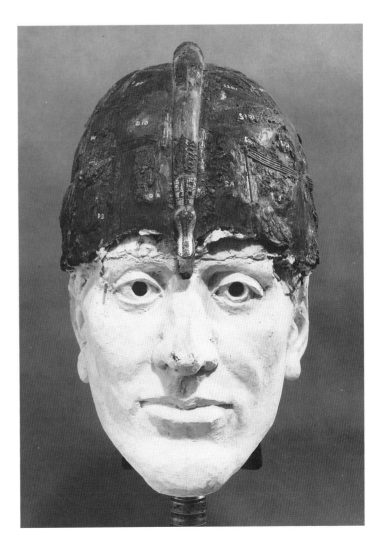

60 (*Above*) The helmet fragments after dismantling.

61 (*Left*) The three gilded dragon heads. The small one had not been incorporated in the first reconstruction, but was later found among the reserve fragments.

plaster head into two halves. Once this had been done, it was clear, from the presence of a granular line running around the outside of the skull, that the iron fragments had been embedded in a second layer of plaster of Paris applied to the head after it had dried: the dry plaster had sucked water from the new layer, causing a line of weakness between the two. It was a comparatively simple matter to work along this line and remove the central core of plaster, leaving a thin skin of plaster and iron which could be treated in the same way as the ear flaps, neck guard and face mask.

60 After four months of painstaking work all the fragments had been removed. They totalled 252, to which were added the numerous fragments that Maryon had not included in his reconstruction. These were mostly featureless pieces of iron, but one startling discovery was made: in a box marked 'head' was the jaw of a dragon-
61 head similar to those at either end of the crest. If this was part of the helmet, where did it belong? Over 500 fragments were now spread out on the work table, making an awesome and alarming sight. It was probably only at this point that the enormous difficulty of the venture was realised. One of only two known Anglo-Saxon helmets, an object illustrated in almost every book on the early medieval period, lay in pieces.

Where to begin? How could the fragments be stabilised? On what framework should the new helmet be built? What should it look like? These were some of the questions now facing the conservator. It was evident that the answers lay in the fragments themselves: they would dictate how the helmet should be reconstructed. Maryon's mistake had been to impose his ideas on the fragments.

The first step was to get to know each fragment intimately. Every fragment which had any significant characteristics or markings was individually numbered. There

62 The back of a complex of fragments, showing the wrinkled appearance which helped to verify the joins.

were 198 such pieces, and these fell into two groups, those with a pattern and those without. A life-size drawing was made of each patterned piece, with painstaking care for detail, including its thickness and any curvature. Each piece was handled and examined in sequence over and over again, so that matching features could be noted. This process of familiarisation took two months, but no real progress was made in fitting the pieces together. However, a number of general features had become obvious. The backs of many of the fragments had a very strange appearance, 62 wrinkled like screwed-up paper and very black in colour. This was unlike any iron corrosion in the conservator's previous experience. There were also three noticeably different thicknesses. Finally, the edge pieces were finished with a U-shaped strip of bronze: where this was missing, the marks it had left were clearly visible.

The decorated bronze plates could, at this stage, be divided into two broad categories, those with animal interlace pattern and those with figural scenes. It was obvious that there were two kinds of interlace pattern, one forming a squarish rectangle and the other a narrow rectangle. The figural scenes were more complex, however: there could have been two or three. Common to all of them was a narrow dividing strip of bronze with three fluted lines cut into it.

By now the work had been in progress for six months, but none of the fundamental questions had been answered, nor had any of the fragments been reassembled. Doubts were setting in; pressure was mounting from every quarter. Then came the first breakthrough. It was discovered that the separate pieces of the crest, which Maryon had joined together with plaster inserts, actually formed a continuous component. The removal of the plaster infills made the crest more than five centimetres (2 in) shorter than on Maryon's reconstruction. It also proved to be hollow.

63 The newly constructed ear flap.

64 The crest: cross-section and decoration.

64 X-rays confirmed that it was inlaid with silver wires in a recurring pattern of three straight lines and a zigzag. At either end this changed to a scale pattern. A section through the crest appeared to show that it had two bases. The first fitted inside the crest and was clearly part of it; the second, which was present only in small areas, had the same wrinkled appearance noted elsewhere. Could this be part of the skull cap, and could other iron fragments be joined to it? X-rays had been taken of all the patterned and the apparently featureless fragments. They revealed many rivet holes, but no lines to indicate that the skull cap had originally been constructed in sections. The only three fragments which showed joins under the corrosion did not appear to come from the cap area: in fact, two of them were corner pieces.

Another significant discovery came when examining the fragments that had been removed from Maryon's ear flaps. These fragments, which were very thin and had a concave curvature, formed a very distinctive group. The bottom curve of the left flap on Maryon's helmet had been made up of two fragments. It became clear that three large fragments from the other flap joined them, making the whole thing 63 considerably longer, though still incomplete. When this was shown to Dr Bruce-Mitford, he was at first unconvinced, coming back again and again to check the new joins. Another surprise awaited him a few days later.

From an examination of the layout of the pattern, it was obvious that the original maker had used offcuts from the animal interlace panels to decorate the flap, for none of the panels was complete. The layout was indeed very haphazard, as had been pointed out by one of the original critics, but this appeared to be the fault of

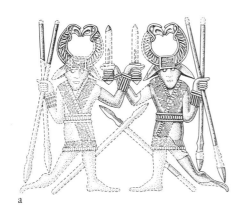

a

b

65 The decorative panels:
(a) the dancing warriors; (b) the 'square' animal interlace pattern; (c) the fallen warrior; (d) the narrow rectangular animal interlace pattern.

c

d

79

the maker rather than an error on Maryon's part. There were ten other fragments which resembled those from the ear flap, but only four had any pattern. Two were corners, one contained some kind of hinge, which was not yet fully understood, and the fourth was an edge piece showing part of a human leg and foot, which had been positioned by Maryon in the skull cap. The hinged piece proved, unlike any of the other ear-flap fragments, to be made of two layers of iron. It did not appear to come from either flap. The surprise was the foot fragment, for which a perfect join was found. It was part of a figural scene known as the 'dancing warriors', and proved that there had been a figural scene (not present in the old reconstruction) on one of the ear flaps. For days Dr Bruce-Mitford kept returning to examine this join, for its implications were quite unexpected.

Meanwhile work had continued on identifying fragments of the decorative panels. 65 It was fairly easy to identify the two interlacing animal panels, as several were complete or nearly so. The figural scenes proved much more difficult, as these had to be made up from a large number of fragments. Eventually two scenes were identified: the 'fallen warrior' and the 'dancing warriors' already mentioned.

The extra layer of iron on the base of the crest had always been borne in mind, but the finds on the ear flap had tended to push it into the background. As always, after weeks of fruitless effort progress came in a flood. No sooner had the ear flap been completed than a fragment was found which seemed to join on to the crest. Even though this fragment was almost five centimetres (2 in) long, it joined at only two points of no more than six millimetres (¼ in) in all. Microscopic examination showed, however, that the lines of the wrinkles matched perfectly, proving that the join was correct. The fragment was highly decorated: in the centre was a rectangular panel of animal interlace surrounded by lined strips; to one side of this panel was 66a a badly corroded area which partly obscured the decoration. The fragment was sent for further X-raying, and another discovery was made: the fluted bronze strip next to the crest had traces of gilding. Using both manual and chemical treatments it was possible to clean this strip and expose more of the gold. No gilding was found on any of the other strips on this fragment. Was it therefore possible that only the bronze strip next to the crest was gilded? If so, this would reduce the number of fragments that could be joined to the crest.

All the fragments with strips were examined for gilding, and five more came to light. The last of these proved to be the one that was wanted, for it and another small fragment which joined on to it came from the area next to the first crest join. It was now possible for the first time to see a pattern forming. Radiating down from the centre of the crest, and at right angles to it, was a line of decorated panels. On either side of this was a space, which the new X-ray had shown to be undecorated, and then the beginning of a line of differently decorated panels coming from the 66b crest at a more acute angle. This pattern was completely different from Maryon's design, which had panels encircling the cap in rows. Such was the excitement created by all these developments that visits to the laboratory had to be restricted, with entry by invitation only.

A substantial part of one side of the skull cap had now been identified, but what of the other side? Did it have a different pattern, or did the two sides mirror one another? One of the fragments with traces of gold on its strip was found to join the

66 The reconstruction
of the skull cap: (a–c) the
right side; (d) a complex
from the left side.

crest directly opposite the fragments already in position. Its pattern – a small square
of animal interlace with part of a fallen warrior below it – matched the corresponding
panel on the other side of the crest.

An idea of the helmet's eventual appearance was beginning to emerge, but it was
important to remember not to try to impose this idea on the fragments. Sometimes
an apparent join would be found, but there would be something worrying about it:
the feel or the look of it was not quite right. Sometimes other members of the team
studying the objects found in the Sutton Hoo ship would be asked to look at a join:
one particular join had four members of the team arguing over it. It would be put
aside to see if other joins could be found either to confirm or to disprove it.

During the next few days three more very important joins were found. The first
two pieces fitted on either side of the central complex of the skull cap and completed
the diagonally radiating strips of animal interlace panels. The third piece fitted on
to the bottom of the central strip, continuing the line of fallen warrior panels;
however, this was clearly not the bottom of the skull cap, for a fluted strip was visible
at the bottom of the panel, rather than the bronze U-shaped band noted elsewhere.

As work progressed on the joins to the crest, other pieces were being found which
at the same time could be neither positioned nor fully comprehended. The most
baffling was the group relating to one of the dancing warrior panels. Two fragments
which joined each other had parts of both warriors on them. This made sense, but
the fluted strip above them rose at a very sharp angle instead of lying horizontally.
Why? Above this strip things became even more complex, for there was evidence of
two interlace panels and an area of undecorated iron. Until now, not much account
had been taken of thickness, but this complex was clearly much thicker than the
restored ear flap, the only other place on the helmet where a fallen warrior panel

66c

66d

a b

67 The nearly completed
skull cap (a) made it
possible to work out the
overall design (b).

was known to belong. Its thickness did, however, match that of the rest of the skull cap. Three more fragments were eventually joined to this complex, with a fluted strip marking the edge of the warrior panel but with no other features.

The complex was now too long to fit into the right side; it must therefore come from the left. Under a × 20 microscope small traces of gold were seen on the fluted strip above the interlace panel, and the complex was therefore placed alongside the crest. No edge-to-edge join could be found, but it seemed to sit naturally in one particular position. A join like this may not be seen so much as felt; the two pieces seemed to lock together under the fingers. The complex sat next to the only other fragment associated with this side of the cap, but it did not join it conclusively. However, some weeks later a fragment about the size of a fingernail was found to link these two fragments together, and any lingering doubts were removed.

In the meantime, a second complex was emerging. It contained the last fluted strip with traces of gold on it, though it did not actually join any part of the crest. Even more importantly, it had on one edge the bronze tube which was known to run along the bottom edge of the cap. This bottom edge was defined when a large piece was found to join the vertical decorated strip in the centre. At this point, above the ears of the wearer, the cap was four panels deep, comprising three fallen warrior 67a panels and one of animal interlace. As both sides of the skull cap had proved to be identical, by using information from each it was possible to work out the complete 67b design.

Combining knowledge of the overall design with other features such as thickness, curvature and pattern, it was possible to work out the position of some of the other fragments. For example, a piece which had on it a dancing warrior and a fallen 68 warrior separated by a fluted strip was distinguished by the fact that the fluted strip curved upwards just like that in the large complex. Even though the reason for this curve was not known, its position was certain and the fragment could be placed with confidence.

After eight months' work the main parts of the skull cap and one ear flap were complete. There remained two outstanding problems: the three dragon heads and the unexplained curvature of some of the fluted strips. There had almost certainly been a dragon on each end of the crest: the question was, which ones? The two

68 The completed skull cap
(right side).

from Maryon's helmet were both of gilt bronze, but were very different in shape. One had a long jaw and head, with the eyes set high, but the neck was missing. The other had a shorter head and jaw, and the underside of its neck had a hollow, as though a bite had been taken out of it. The third one was made of a grey, putty-like material, which on analysis proved to be a corroded high-tin bronze. Unfortunately the only part remaining was its jaw. Traces of this grey material had been found on the back end of the crest, and suggested that this dragon belonged there. However, only one of the other two heads could belong to the front end of the crest. Could it be that one of them came from another object altogether? For the time being this question could not be answered.

The next section to be reconstructed was the face mask. Here there were five important pieces: a large gilt bronze nose, cast in one piece with moustache and mouth, two bronze eyebrows inlaid with silver wires and garnets and with gilt bronze boar heads at either end, and two iron fragments covered with the animal interlace pattern found on the rectangular panels. These two fragments had been correctly joined to either side of the nose and had created the eye holes. Their thickness was greater than that of the ear flaps, but not as great as that of the skull cap. Using this thickness as a yardstick, it had been possible to add three other fragments to the mask during work on the skull cap. These were easily joined to their partners, enabling the face mask to be completed. The eyebrows sat neatly on top of the nose;

69 The face-mask fragments: only the narrow rectangular animal interlace panels were used as decoration.

there was even a small cut-out in the inner edge of the eyebrows to accommodate the tang at the top of the nose. The only problem was that a large space was left between the eyebrows.

The number of unplaced fragments was by now much reduced, and it had become possible to allocate each one provisionally to a particular area: the cap, the second ear flap, or the section which was still a total mystery – the neck guard. It soon became obvious that very little remained of the second ear flap. The most substantial fragments were a corner piece and one large piece from the middle; both had traces of animal interlace and fluted strips. The other pieces consisted of four small fragments and part of the U-strip which enclosed all the edges of the helmet. Even though only a small percentage of the flap remained, it was possible to reconstruct it by combining knowledge of this and the more complete one.

During work on the other components, it became apparent that the rectangular interlace panels occurred mainly, though not exclusively, on the face mask and the neck guard. The fragments differed from each other in one important respect: those from the face mask were almost twice as thick as the others. Working on this principle it was possible to narrow down to seventeen the number of fragments that belonged to the neck guard. These could in turn be assigned either to the square or to the rectangular animal interlace panels. After some days' work, a small complex had been built up from seven of these fragments. It proved to be a corner piece, the upper part of which was covered in square panels, with rectangular panels set vertically below them. The complex showed a general curve, and in addition a very sharp bend in the upper corner, with the lower panels fanning out at an angle to the upper ones. An X-ray of one large fragment covered in square panels revealed that the neck guard was not a single piece of iron but had been made in two sections. This matched the piece containing the hinge, excluded from the ear flap at an earlier stage. The hinge was clearly the means of attaching the neck guard to the skull cap, and the X-ray showed it to consist of two rivets and a bronze bar. A second complex proved to have the remains of two rectangular panels one above the other, each surrounded by fluted strips, with an area of undecorated iron to either side. The basic design on the neck guard was therefore made up of a square panel with two rectangular panels end to end below, all divided by fluted strips. It was not clear at this stage how many times this design was repeated across the top of the neck guard.

After more than nine months' work it was now possible to form a reasonable picture of the original helmet, though what actually existed was several complexes and single fragments which now needed to be brought together. A featureless plaster dome was made, considerably smaller than the helmet. This was thoroughly dried in a kiln to make sure that it did not contain any moisture which could cause the iron to rust. Once dry, it was placed centrally on a wooden board under a movable plumb bob.

The crest was placed along the centre line of the dome and checked against the plumb bob. As the dome was smaller than the helmet, it was necessary to lift the crest on a cushion of oil-free plasticine. The initial joins had been stuck with a soft adhesive, but as the complexes became larger and heavier there was a danger that they might break. Some of them had therefore been left unjoined until they could be supported on the dome. This was true in particular of all the fragments that

70 The fragment complexes being brought together on the plasticine dome and held in position with long pins.

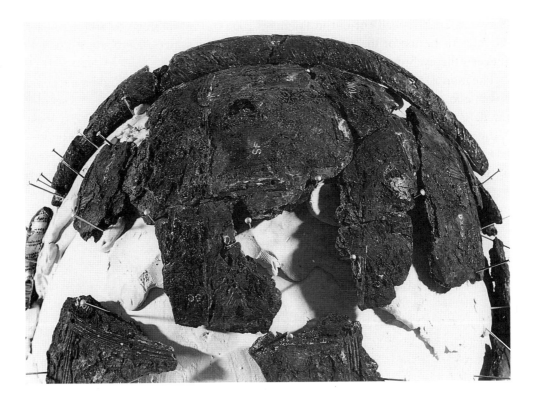

70

joined on to the crest. Each piece or complex was positioned on the dome and supported by long pins sticking into the plasticine. Slowly, for the first time, the skull cap was recreated in its original form. This was a time for reflection: all the evidence for what was being done was considered and reconsidered, and only when no doubt remained was a piece finally positioned. After several more weeks all the fragments were in place. During this process it at last became clear that the fluted strips which turned upwards did so because the dancing warrior panel had to be raised in order to allow the eyebrow to be positioned below the panel without obscuring the warrior's legs. It was therefore possible to say that this panel came from the front of the helmet.

It was now necessary to replace the missing areas in order both to strengthen the cap for handling and to prepare it for display. A light but strong textile of jute stiffened with adhesive was cut into long strips: these strips were heated so that they could be shaped into the correct profile and then stuck to the edges of the iron fragments with soft adhesive. A very thin layer of plaster of Paris was spread over the jute to bring the fill level with the outer surface of the helmet and to give it a smooth appearance. The finished cap was now strong enough to be removed from its plaster and plasticine support.

At this stage the face mask and the ear flaps could be added. The mask was placed vertically under the front of the cap. There were none of the plaster inserts which Maryon had needed to add, so the eye holes were much smaller. The ear flaps were placed with the cut-away edges nearest to the face mask, as on Maryon's reconstruction, though they did not look right in this position, as the sides of the neck were left exposed. An expert on arms and armour advised that the ear flaps

should change places so that their cut-away sections combined with those of the neck guard to form a curve large enough to enable the wearer to raise his arm. With the ear flaps in place, the correct width of the top of the neck guard was evident. It proved to correspond exactly to five of the square interlace panels.

During the rebuilding process, the problem of the remaining dragon head had been constantly in mind. The solution came like a bolt from the blue: one of the eyebrows and the smaller dragon were being handled together when it was noticed that the curve cut into the dragon's neck fitted the convex shape of the eyebrow. When the two eyebrows, the dragon head and the nose were put together they formed the shape of a flying bird, with the eyebrows as its wings, the nose as its body and the moustache as its tail. Now the other head could be placed on the free end of the crest, forming a snake-like dragon coming down to meet the bird flying upwards. This confrontation now became the central and most dramatic feature of the entire helmet.

Once all the sections were fitted together, the infills were painted brown to match the corroded iron, and lines painted in to show the position of the missing panels.

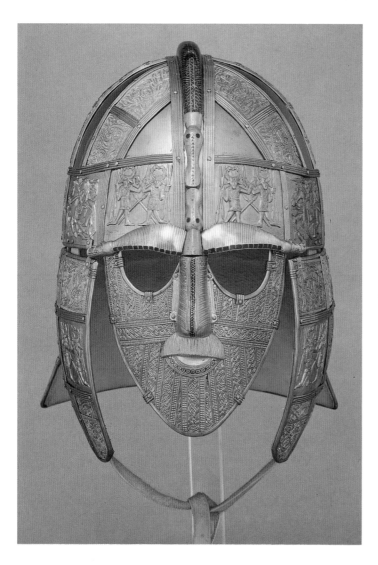

71 (*Left*) The helmet as it would have been seen by the Anglo-Saxons: a replica made by staff of the British Museum and the Royal Armouries.

72 (*Opposite*) The Sutton Hoo helmet after reconstruction. British Museum. The front view is illustrated opposite the title page (p. 2).

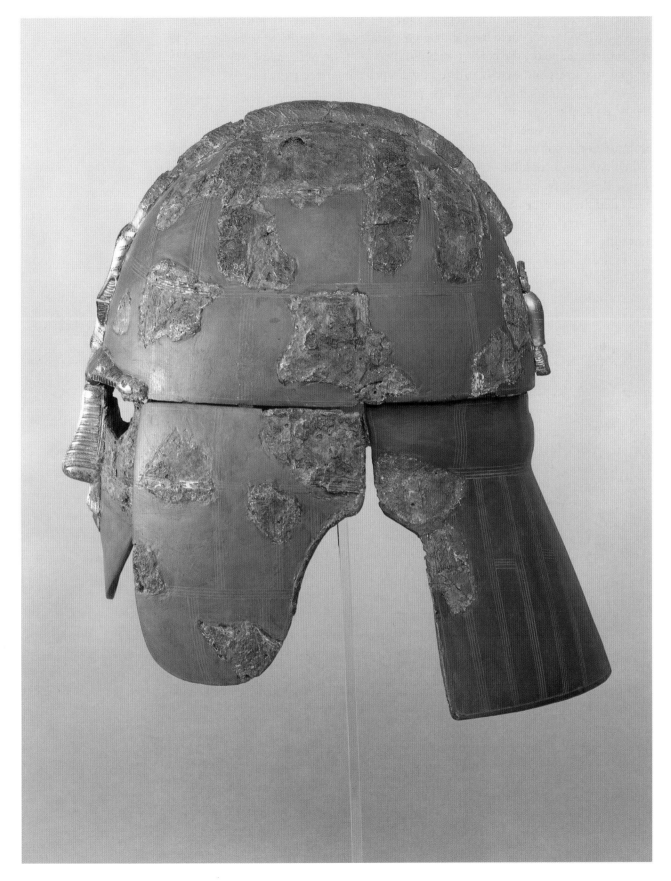

73 The newly reconstructed face mask, showing the bird formed by the eyebrows, nose and moustache and the dragon's head on the end of the crest coming down to meet it.

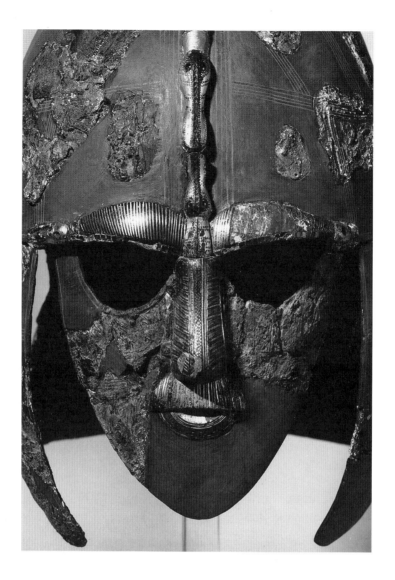

After more than a year, the helmet was now complete. It appeared brown only 72 because the iron had rusted: originally, because the surface was tinned, it would have been a bright silvery colour. A replica produced later in collaboration with the 71 Royal Armouries at the Tower of London gives a striking impression of how it would have looked when first worn, about 1,400 years ago.

Acknowledgements

All illustrations in this chapter are © The Trustees of the British Museum.

Further Reading

H. Maryon, 'The Sutton Hoo Helmet', *Antiquity* 21 (1947), pp. 137–44.

R. Bruce-Mitford, *The Sutton Hoo Ship-Burial: Vol. 2, Arms, Armour and Regalia*, London 1978, chapter 3, 'The Helmet', pp. 138–231.

A. C. Evans, *The Sutton Hoo Ship Burial*, London 1986.

5 Michelangelo's Frescoes in the Sistine Chapel

Fabrizio Mancinelli

The Sistine Chapel is the chapel of the papal court of the Vatican, and was used by the popes for private devotions and public ceremonies as well as for regular court functions. Conclaves to elect a new pope are held there to this day. It occupies the middle floor of a building with a dual purpose, religious and military, which explains its fortified external appearance. On the floor above were once the quarters of the papal guard, while below were the apartments of the masters of ceremonies and the cellars. The chapel is the result of a restructuring operation undertaken in the years 1477–80 by Pope Sixtus IV della Rovere (1471–84), after whom it is named, and the present building incorporates the side walls of a pre-existing medieval chapel. Of the decorations executed for Sixtus IV, there remain a series of portraits of the first thirty popes (minus those originally on the altar wall, which have been destroyed) and – below these on the side walls – six scenes from the life of Moses and six from the life of Christ, with painted damask curtains to floor level. These frescoes were executed in 1481–3 by a team of mainly Tuscan artists: Pietro Perugino, who co-ordinated the work, Sandro Botticelli, Domenico Ghirlandaio, Cosimo Rosselli and, at a later stage, Luca Signorelli.

The areas on the entrance wall, damaged by subsidence in the early 1500s, were reworked in the third quarter of the century by Matteo da Lecce, who painted the 'Dispute over the Body of Moses' and Hendrick van der Broeck, whose theme was the 'Resurrection of Christ'. The decoration commissioned by Sixtus IV for the altar wall was destroyed in the time of Paul III Farnese (1534–50), who commissioned Michelangelo to replace it, in 1536–42, with his painting of the 'Last Judgment'.

Meanwhile, almost thirty years earlier, in 1508, Julius II della Rovere (1503–13) had instructed Michelangelo to repaint the ceiling, which had been decorated with a starry firmament in Sixtus' time. The frescoes we see today – nine scenes from Genesis flanked by figures of *Ignudi* (Naked Youths) and Prophets and Sibyls, and below, in the lunettes above the windows, depictions of the Ancestors of Christ – were completed in 1512.

The cleaning of Michelangelo's frescoes is only the latest stage in a long-standing restoration campaign in the Chapel. The work was begun in 1964 by Deoclecio Redig de Campos, who was succeeded in 1979 by the present writer under the supervision of Carlo Pietrangeli. The first stage, put in hand between 1964 and 1974, was concerned with the two cycles on the side walls depicting scenes from the life of Moses and of Christ. Although the scale of the operation was fairly modest, and in practice the paintings were only half-cleaned, when the grime of centuries had been removed the results caused quite a stir.

In 1975, the 500th anniversary of Michelangelo's birth, attention turned to the room above the Chapel (originally the papal guardroom), the walkway and parapet,

and the roof, which had fallen into disrepair and was again letting in rainwater, despite work undertaken in the time of Pope Leo XIII (1878–1903). A lightweight mezzanine floor of metal mesh was installed in the guardroom, allowing any future maintenance work on the roof and the room itself to be carried out without walking on the extrados of the vault or subjecting it to other pressures.

Cleaning work on the Chapel's frescoes began again in 1979, with the restoration of the two scenes on the entrance wall, the 'Resurrection of Christ' by van der Broeck and da Lecce's 'Dispute over the Body of Moses'. The cleaning of these two large areas, completed in July 1980, raised a technical problem. Redig de Campos's cautious policy of removing only part of the layer of grime and foreign substances deposited on the fifteenth-century frescoes was not appropriate in this situation. In the case of da Lecce's painting, removing only the retouchings of previous restorers and a limited thickness of foreign matter resulted in an extremely uneven, patchy finish, with a general loss of relief and dulling of the colours. It also left eighteenth-century overpaintings of certain details completely untouched. Much of van der Broeck's 'Resurrection' scene had been finished *a secco*, after the underlying fresco painting had dried, with the result that earlier attempts to clean the work had caused a lot of damage. Merely treating the large areas retouched by

74 Head of the Naked Youth above and to the left of the Cumaean Sibyl: close-up before cleaning. Contracting glue has pulled away many tiny flakes of pigment.

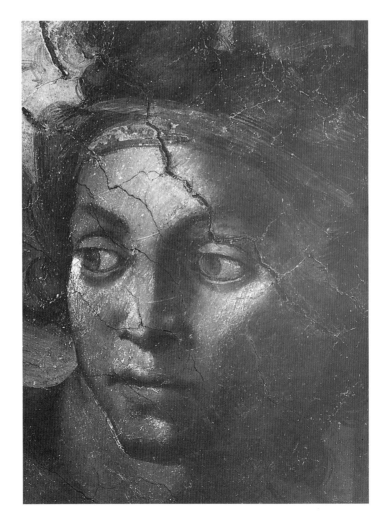

earlier restorers and removing only some of the glues and fats they had used as varnish gave similarly disappointing results. A more radical cleaning was indicated, even though this might mean having to return to the scenes on the side walls and doing a more thorough job there too.

The original intention had been to limit further restoration work to the fifteenth-century series of Popes, but inspection of the lunette depicting Eleazar revealed minute flaking and loss of pigment. Further examination showed that this was not 74 a local phenomenon, but that all Michelangelo's decoration was to some degree affected. Laboratory tests confirmed what had already been surmised by Ludovico Seitz in 1904 and reported by Biagio Biagetti in 1936: that in addition to dust, grease and soot, the original painting was covered by a thick layer of glue, evidently applied and reapplied at various times in the past. It was this glue that was causing the pigment to flake away, since it tended to expand and contract with changes in the Chapel's microclimate, pulling away the layer of colour at its weakest points. Restoration was imperative and could no longer be delayed. It was therefore decided to proceed in three stages, using scaffolding which would not exclude the general public from the Chapel and which would enable visitors to follow the progress of the work. Three cleaning programmes were planned: the Popes and the lunettes (1980–84), the ceiling (1985–9), and finally the 'Last Judgment' on the end wall, due to be finished by 1993.

Before setting to work on the frescoes themselves, it was essential to ascertain what technique Michelangelo had used in decorating the ceiling, when and why the glue had been applied, and what methods and solvents should be used to achieve as even a result as possible. This preliminary phase lasted for several months, during which the painted surface was minutely examined by daylight, by quartz lamp, by ultraviolet light and under infra-red and sodium monochromatic light in order to understand how the painting had been executed and to detect what foreign substances were present. Samples were then removed for laboratory analysis. To study the foreign substances, infra-red spectrometry, thin-layer chromatography and liquid chromatography techniques were used; the pigments were analysed using absorption spectrophotometry.

Analysis of samples from the lunettes revealed a surface layer of insoluble silicon 75 particles (dust) over soot mixed with long-chain unsaturated fats (from the burning of candles and oil lamps). This in turn covered a thick layer of animal proteins of the keratin type, i.e. glue, mixed with linseed oil (apparently to assist application).

75 A cross-section of the painted surface of the ceiling seen under ultraviolet light and much enlarged. Starting from the bottom, it is possible to make out the pigment layer, followed by a narrow band of dust and soot, one or more layers of glue, and a further deposit of dust and soot on the surface.

Under the glue were further traces of dust and soot. A similar sequence of deposits was found on the ceiling, with the addition of vegetable resins such as gum arabic applied here and there over the animal proteins.

The main difference between the two areas, apart from the gum arabic, was the far greater thickness of the glue layer over the lunettes – a sign that glue had been applied there more frequently. The effect was to make the lunettes artificially dark, quite contrary to Michelangelo's intentions, as later became apparent. Because it tended to form a dark skin over the painted surface, giving an uneven, patchy effect quite alien to any known artistic practice, this glue has given rise to the most contradictory and bizarre interpretations of Michelangelo's painting method. This is not surprising, since, despite the closest scrutiny, the Chapel would not have yielded its secrets but for the use of sophisticated optical equipment, complex laboratory analyses, cross-sectional examinations and the indispensable cleaning tests.

The way in which the glue had been spread gave an important clue. In the case of the lunettes the aim had clearly been to form an overall covering, with no distinction between the figures and their background. In places the glue concealed large surface deposits of sulphates and carbonates, evidently caused by rainwater. There is documentary evidence that this damage occurred at an early stage, most probably following a fire in the Chapel roof in 1545. In a letter dated 7 May 1547, Paolo Giovio, Michelangelo's first biographer, informs Vasari that Michelangelo's work 'is being destroyed by saltpetre and by cracking'. Similar signs of deterioration are visible on many of the corbels, where putti support tablets bearing the names of the Prophets and Sibyls. Here the glue could not entirely hide the damage caused by the salts – especially by silicates – and the painted surface has been irreversibly stained and spoilt. The glue was spread carelessly and in extreme haste on both ceiling and lunettes, mainly with sponges, and in areas where it was applied particularly thickly and has yellowed with age it is possible to discern the sweep of the sponge. On the ceiling, however, there is an important difference: while a thin coating was applied fairly evenly over the whole surface, particular figures and details were singled out for additional treatment.

Glue was often used in sixteenth-century wall painting as a medium and as a base for retouching and finishing and for painting on dry plaster, but it was never used, then or at any other time, to treat a finished work, except as an expedient in restoration.

Although the brownish, stained-leather tone of the ceiling before cleaning was due even more to oxidation of the fatty acids in the glue than to the presence of grime and soot, it should be borne in mind that, when first applied, the glue would have been transparent and only slightly yellowish, very much like a varnish. It was used mainly to refresh the colours – a treatment which Michelangelo's frescoes most definitely did not require when they were originally painted.

Apart from the structural settlement of the Chapel in the years between 1504 and 1565, the main threat to the paintings was from smoke rising from altar candles, lamps, fires for heating and so on, gradually blackening the walls and ceiling and causing the paintings to lose their depth. The problem is mentioned by Johannes Fichardus as early as 1536 in his *Observationes . . . rerum magis memorabilium quae Romae videntur*. This, combined with the rapid appearance of an efflorescence of

76

77

76 Detail of the lunette depicting Roboam and Abias, during cleaning, showing the carbonate formations revealed by the removal of surface glue and foreign matter.

whitish salts caused by rainwater (the carbonates and sulphates mistakenly taken by Giovio for 'saltpetre'), explains why in 1543 the office of *mundator* or cleaner was instituted. His charge was to keep the frescoes clean 'ac a pulveribus et aliis immund-itiis, etiam ex fumo luminarum' (from the dust and other filth, and also from the smoke of the lamps).

In addition to the day-to-day maintenance work of the *mundator*, more radical cleaning and restoration work was undertaken from time to time. The first documented effort of this kind was carried out between the pontificates of Pius IV (1559–65) and Gregory XIII (1572–85), when da Lecce and van der Broeck repainted the frescoes on the entrance wall and the Modenese painter Domenico Carnevali restored the ceiling, reworking some of the figures in the scenes of 'Noah's Sacrifice' and the 'Punishment of Haman', and details of other scenes and Naked Youths.

In 1625 a cleaning operation was carried out by Simone Lagi. According to a contemporary report, 'the figures were dusted one by one with a linen cloth and the grime removed by rubbing them hard with slices of a penny loaf or even coarser bread. Where the dirt was more resistant, they moistened the bread and so restored the paintings to their pristine state without the slightest damage.' All the recorded payments were for work on the walls, and it is not clear whether the ceiling was cleaned at this time.

Between 1710 and 1712, Annibale Mazzuoli, working with his son and an assistant, again cleaned the ceiling, probably under the supervision of Carlo Maratta. It is likely that they adopted methods similar to those used on Raphael's frescoes in the papal apartments. The invoice refers to Greek wine and sponges as cleaning agents.

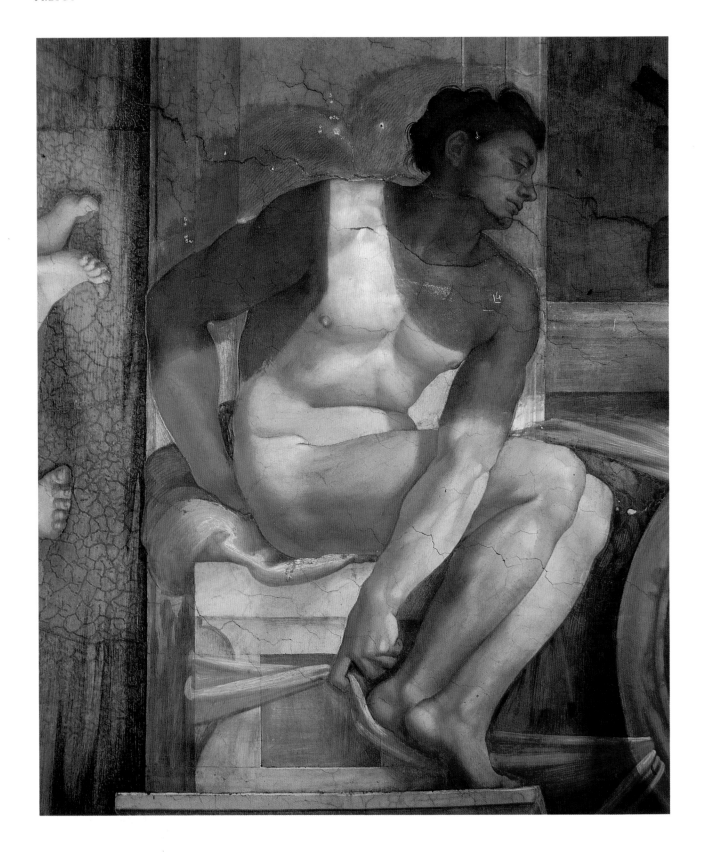

77 Naked Youth above and to the left of the Prophet Ezekiel, during cleaning.

78 (*Above*) Detail of
Carnevali's repainting of
part of 'Noah's Sacrifice',
taken in raking light during
cleaning. Note the darker
tone of the repainted part
and the scribing done when
the design was transferred
from the cartoon.

79 (*Right*) 'The Temptation':
detail before cleaning,
showing Mazzuoli's hatched
retouching of Adam's face.

80 Putto supporting the tablet beneath the Prophet Isaiah, before cleaning. Note the shading and the redrawing of the features in black by an earlier restorer.

The archives have not so far yielded any evidence of restoration work in the nineteenth century, apart from a general dusting of all the Chapel's frescoes in 1877 and Vincenzo Camuccini's well-documented cleaning trials on the 'Last Judgment' in 1824–5. The signature of a gilder and the date 1814 have nevertheless been discovered on the figure of the prophet Ezekiel, which may mean that small-scale work was carried out but not recorded. Similarly, J. Richard states in his *Description Historique et Critique de l'Italie* (Paris 1766) that in 1762 ecclesiastical censorship resulted in some overpainting of figures on the ceiling and in the 'Last Judgment', though there is no official mention of these modifications.

More recently, the restoration work conducted by Seitz in 1904 and Biagetti in the 1920s and 1930s was limited to thorough consolidation and sealing of the plaster. Seitz did carry out some cleaning tests, but called a halt because 'they provided practical proof that any washing or rubbing would have done more harm than good. The process would have given very uneven results because the varnish, i.e. the glue, proved highly resistant to treatment.' From these words it can be inferred that, once it had been applied, the glue defeated all later attempts to clean the paintings underneath. It was impossible to remove it evenly with the means then available.

It was in the second half of the eighteenth century that contemporaries began to talk of the dingy appearance of the ceiling. Shortly before that time, according to the records, Mazzuoli carried out his cleaning operation, and it seems highly likely that glue was then applied on a large scale for the first time – by Mazzuoli himself. He may have adopted this method after failing to get satisfactory results by cleaning alone. After Mazzuoli's time, retouching was frequently undertaken and all attempts at restoration were done by repainting on top of the glue layer, using many different

80 techniques, including tempera, pastels and oils, but always in dark colours. The aim was to emphasise shadows and contours and so restore volume to figures which had come to look flat under the layer of dirt and yellowed glue. The result was a *chiaroscuro* effect, completely opposed to the striking chromatic contrasts intended by the artist: cleaning has since revealed that Michelangelo's shadows are always coloured, never black.

Although the application of glue to the walls and ceiling as a whole can probably be ascribed to Mazzuoli, it is almost certain that some local applications, particularly on the lunettes, date from a much earlier period and were made to hide the salt stains which defied contemporary attempts at removal, the glue serving to modify the play of light on those areas. The circumstances of Carnevali's repainting of the two figures in 'Noah's Sacrifice' would seem to indicate that this glue was applied by the first *mundatores*. Although he sought to be as faithful as possible to the original – and even made a tracing before removing the area of probably crumbling plaster – the Modenese artist repainted in green the clothing of the person wearing a laurel wreath, even though, as surviving fragments show, the colour was originally blue. Carnevali would not have made this mistake unless the painting had been covered with a yellowish layer of old glue as well as the predictable accumulation of dust and soot.

81 In addition to the presence of grime and soot under the glue layer, further proof that the glue was not generally applied until long after the frescoes were painted came to light during the cleaning process. On the chest of the Naked Youth to the left of the Persian Sibyl, the restorers discovered a deep crack, which had probably been repaired at the time of Carnevali's restoration. On removing the old filler, they

81 Naked Youth above and to the left of the Persian Sibyl: detail after cleaning, showing an original fragment, fixed with a broad-headed nail, used to fill a crack; also the severe deterioration of some sixteenth-century retouching.

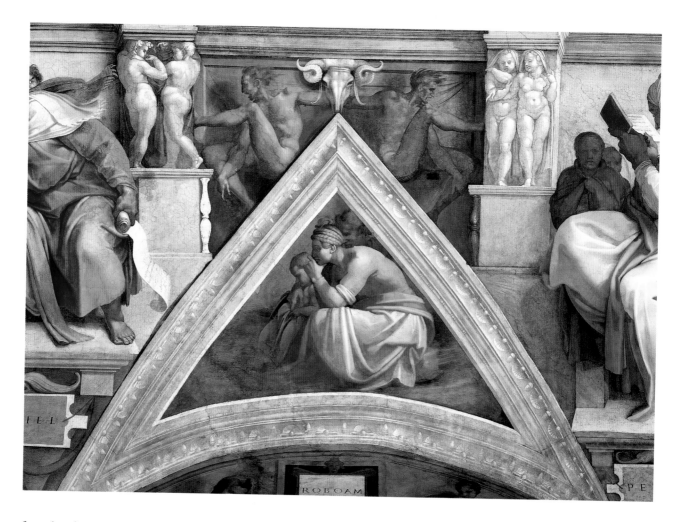

82 Triangular vaulting
and bronze-coloured
nudes above the lunette
of Roboam and Abias,
after cleaning.

found a fragment of the original painted plaster which had been used to plug the deepest section of the crack. The fragment showed no signs of having been treated with glue – conclusive proof that glue was not applied until long after Michelangelo had completed his work.

As soon as they began cleaning tests and removed the thick layer of glue, the restorers found vivid, luminous colours in varying tones, often juxtaposed to achieve brutal and at the same time exquisite contrasts and shimmering effects, the pigments always perfectly bonded with the plaster. It emerged that Michelangelo had used the classic fresco technique, as codified – with all the possible variations – by Cennino Cennini and Giorgio Vasari; this was the technique commonly adopted by his contemporaries, including the artists who had executed the paintings on the lower sections of the Chapel walls.

Michelangelo's palette was typical of the accomplished fresco painter: St John white (hydrated calcium carbonate); Mars brown (iron oxide), umber (iron oxide, manganese dioxide and argillaceous silicates), and burnt sienna (argillaceous silicates with anhydrous iron oxides); Mars yellow (hydrated iron oxide) and various shades of yellow ochre (argillaceous silicates more or less rich in hydrated iron oxides); *terre verte* (iron silicates); natural ultramarine (lapis lazuli) and smalt (glass containing cobalt blue); light red (natural iron oxide), morel or *caput mortuum* (iron sesquioxide)

82

98

and lead orange (lead oxides such as litharge and minium) – used only in the 'Flood' scene; ivory black and blue-black.

The support consisted of a rough coating (*arriccio*) of lime and pozzolan (a volcanic ash), 15 mm (½ in) thick on the lunettes but thicker on the ceiling owing to the less regular nature of the surface, overspread with a thinner coating (*intonaco*) of similar material, approximately 5 mm thick. The pozzolan probably came from the Foglia area near Magliano Sabina. Research is still in progress to discover whether the lime was obtained, as Vasari maintained, by heating travertine or by heating crypto-crystalline limestones, such as those from the quarries on the Via Tiburtina or at Capistrello Avezzano.

The colours were generally painted on in a very liquid state – like watercolour –

83 Detail of the Naked Youth above and to the left of the Prophet Ezekiel, after cleaning. (see also Fig. 77)

in washes which let underlying colours show through, or applied more thickly, 84
but with open, flat brushstrokes, the brush held tightly between the fingers as 83
recommended by Cennino. The radiant effect produced by this technique was
intended to make the scenes 'legible' whatever the light conditions. Because of the
way the paint was applied, the seepage of rainwater and the resulting salt deposits
have not spoiled the paintings to the extent one would normally expect. Rather than
encountering a thick, compact pigment barrier and causing it to become detached
by pressure from behind, the salts have simply filtered through the *intonaco* and the
pigment layer and emerged on the surface without causing more serious damage.

Although the ceiling and the lunettes have much in common, there are neverthe-
less significant differences between the two areas, which in the past were explained
in terms of chronology or style but which are, in fact, due to sophisticated technical
factors. Whereas the lunettes were painted at lightning speed, almost without *penti-*
menti (changes), with some details carefully finished and others summarily sketched 85
in and left in outline, Michelangelo's work on the ceiling was always extremely
painstaking. In some scenes, despite the distance from the ground and the dimen-
sions of the picture, the amount of detail is that which one would expect in an easel
painting. The difference is due to the fact that Michelangelo painted the lunettes
without the help of preparatory cartoons. There is no trace of pouncing (piercing
the paper at intervals along the lines of the drawing, then, with the cartoon held
over the *intonaco*, dusting it with a bag of powdered charcoal so as to transfer a
pattern of black spots to the *intonaco* itself) nor of the indirect incision technique

84 (*Opposite, left*) 'The Expulsion from Eden': detail of the face of Adam after cleaning.

85 (*Opposite, right*) Lunette of Azor and Sadoc: detail of the male figure on the right after cleaning. The preparatory drawing can be seen showing through.

(going over the cartoon with a pointed tool so as to scribe a groove in the *intonaco*). He did incise the outlines of the tablets bearing the inscriptions, but this was done directly onto the plaster, using nails, cords and a ruler. The *giornate* (that is, the amount of work that the artist was able to carry out before the *intonaco* dried) are enormous – three *giornate* at most per lunette – which explains why Michelangelo worked so fast, sometimes making small changes but always as he went along and while the plaster was still wet.

Michelangelo's approach to the ceiling was quite different. The only areas where he dispensed with cartoons were the bronze-coloured nudes, the landscapes, and some of the figures in the Genesis stories. On the first half of the ceiling, his cartoon

86

drawings were all transferred to the ceiling using the pouncing technique, except for the decapitated form of Holofernes in the 'Judith' scene and the angel in the 'Expulsion from Eden'.

On the second half of the ceiling, he continued to use this technique for the figures of Prophets, Sibyls and Naked Youths, but switched to the indirect incision

87

technique in the triangular sections above the windows and for the Genesis stories. Special cases are the 'Creation of Man' and the 'Punishment of Haman', where pouncing is supplemented by the incision technique. *Pentimenti* are here relatively common. Some were done on a completely fresh layer of *intonaco*, others at the end

88

of the day, before the plaster had completely set, by scraping away the top layer and laying a thin veil of fresh plaster with a brush. Others again were done *a secco*, when the plaster was completely dry, for instance the left arm of the Naked Youth to the right of the prophet Joel, which was not originally bent but stretched out along the

90

drapery. The only areas intentionally painted on dry plaster were the medallions at

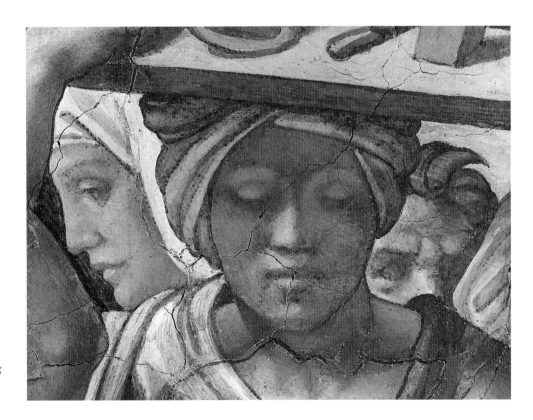

86 Detail of the 'Flood' scene after cleaning: the careful original pouncing of the outlines is visible through the paint.

 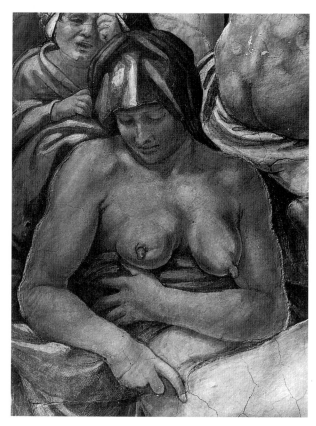

the feet of the Naked Youths, where the outlines and gilding were carried out *a secco*.

Michelangelo could dispense with cartoons for the lunettes because the surfaces were vertical and at an acute angle to the viewer on the ground, and he probably wanted to complete the work quickly. It is interesting in this context that in the apse of Santa Maria Novella, Florence, where, according to Vasari, Michelangelo had worked as a young man with Ghirlandaio and other members of his workshop, the higher the work progressed the more sketchy the cartoons and the painting became. However, whereas Ghirlandaio had delegated these less important areas of the work to his collaborators, the Sistine Chapel lunettes were painted by Michelangelo himself, for the very reason that he was not using cartoons. It is also significant that Michelangelo called on collaborators from Ghirlandaio's workshop to assist him in Rome. They remained with him until the 'Temptation' scene, working mainly on the secondary decoration but also helping to execute the initial scenes, the first of which, on the evidence of the sequence of *giornate*, was the 'Flood'.

The cleaning has thus revealed a Michelangelo different from the one we had come to know and love, but more understandable as an artist, since he is now seen to fit into the technical and artistic tradition of his time. Though a sculptor by vocation, in his work on the Sistine Chapel he displayed a technical mastery which should for ever dispel the myth that he was a novice in this field. Other 'discoveries' include his use of a typically Tuscan palette, his early training – previously a matter of conjecture – in the workshop of Ghirlandaio, and his influence in the use of

89

87 (*Left*) Triangular vaulting above the lunette of Asa, Josaphat and Joram: detail in raking light, showing the incisions made when transferring the very sketchy drawing from the cartoon to the *intonaco*.

88 (*Right*) 'The Flood': detail of the nude woman squatting in the foreground, after cleaning. Note the slight widening, in *mezzo fresco*, of the outside contour of the arms.

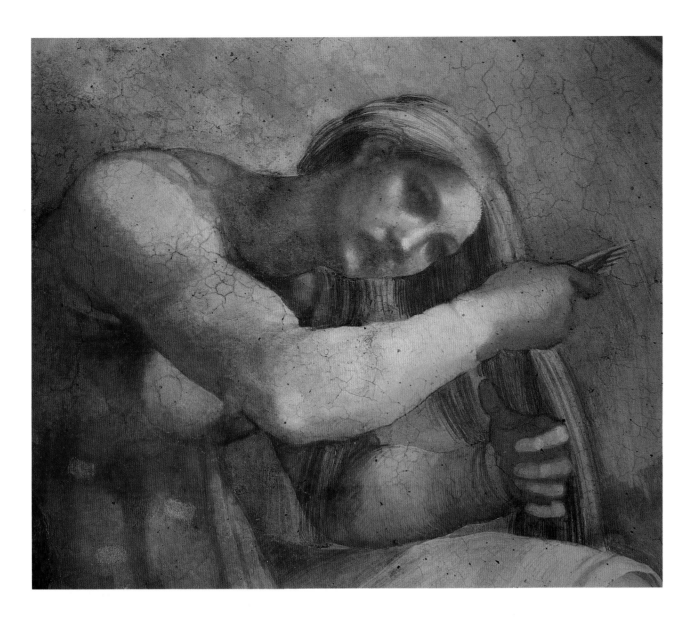

89 Lunette of
Aminadab: detail of the
female figure on the
right, after cleaning.

colour on early Florentine Mannerists such as Andrea del Sarto, Rosso, Pontormo, and even Beccafumi.

Drawing on their previous experience in cleaning the scenes by Matteo da Lecce and Hendrick van der Broeck, which presented very similar problems, and tests carried out first on the lunettes and then on the ceiling, the restorers eventually chose the solvent known as AB 57, the suitability of which was checked every time the scaffolding was moved to a new area. AB 57 is a cleaning mixture which has been in use for over twenty years. It consists of 25 grams per litre of bicarbonate of ammonium (NH_4HCO_3); an equal amount of bicarbonate of sodium ($NaHCO_3$); and 10 cubic centimetres of a 10% solution of Desogen, a fungicide and antibacterial agent, all combined in a carboxymethyl cellulose gel. The mixture, which acts only during actual contact, is applied for three minutes, then wiped away with a sponge soaked in distilled water. The surface is allowed to dry for twenty-four hours, and the procedure is repeated. Further local applications may be necessary, followed by

103

a final thorough washing down. AB 57 was used only on the true fresco areas. At a later stage, the areas painted *a secco*, first treated with a solution of Paraloid B-72, an acrylic resin, to act as a consolidant, were cleaned using specific organic solvents, without water – or else treated by methods allowing the use of water-based solvents.

How thoroughly the paintings should be cleaned was not a subjective matter. The aim was to recover completely all the shades of colour applied by Michelangelo; otherwise his work would have appeared flat and lacking in volume. Even so, it was decided to retain the thin layer of dirt that had formed on the frescoes while the *intonaco* was hardening and in the years immediately following. The need for repainting following the cleaning was minimal, given the excellent state of preservation of the frescoes. Where necessary, that is on the areas of loss, it was executed exclusively in watercolour, with vertical or crossed brushstrokes, after applying a 91 preparation of lime and marble powder to the ground.

The whole operation has been carefully documented by a wealth of drawings and photographs, and since 1981 has been filmed for the Vatican Museum's Archives by the Nippon Television Network, Tokyo.

A photogrammetric survey carried out on the ceiling will make it possible to monitor its future condition. Special computer software was created for recording all the information gathered in the course of the operation. Dimensions and data on the state of conservation of the paintings and the techniques used by Michelangelo can all be displayed on a graphics workstation located on the scaffolding – a modern equivalent of Michelangelo's cartoons. The computer has a central memory of 4 megabytes and a 330-megabyte hard disk, and the images can be 92 printed out using a plotter.

It was a matter of chance that in 1980 work began with the lunette of Eleazar, probably the first of the series painted by Michelangelo. When they came to the ceiling, the restorers deliberately started with the area adjacent to the entrance wall and from there followed the artist's own progress. Step by step they were able to relive the process of creation, gaining understanding of the difficulties Michelangelo encountered and how he solved them. Given the importance of the task and the shockwaves experienced – by the restorers themselves first of all – when the results began to be known, it was clearly impossible to wait until the work was finished before revealing the newly cleaned paintings to the public. The Chapel has therefore been constantly open to visitors, and the scaffolding was designed to cover only a small part of the total painted area, so that the cleaning operation could be followed from below. Access to the scaffolding itself has had to be restricted, for practical reasons and in the interests of safety, to a limited number of specialists, art-historians and restorers, who have unfailingly given helpful advice and by their very presence provided the most natural form of control and oversight of the work.

The scaffolding currently being used for the restoration of the 'Last Judgment' is quite different, as are the technical problems presented by this fresco. Unlike the ceiling, which is divided into compartments by painted pilasters and entablature, the 'Last Judgment' cannot be cleaned in separate sections. It therefore demands a thorough knowledge of the whole surface, and preliminary tests had to be carried out on all parts of it. The fresco will therefore be completely hidden by scaffolding until work is finished. The scaffolding itself allows the restorers to work at seven

90 Monochrome
medallion above the
Prophet Isaiah, after
cleaning. The outlines
and gilding were painted
a secco.

different levels, from which they can reach all points of the 180.21 square metres (215 square yards) of wall space.

Michelangelo's technique here differed in several respects from his work on the ceiling. In particular, he used natural ultramarine – a colour of great delicacy – for the blue of the sky; he executed whole areas *a secco*; and he adopted certain pigments, notably lake and Naples yellow, which required the use of a binder.

Unlike the ceiling, the 'Last Judgment' has frequently been retouched and over-painted, mainly because it is so much easier to get at. Of these overpaintings, special mention must be made of the famous '*braghe*' ('breeches') added in fresco to conceal the private parts of St Biagio and St Catherine (St Biagio was totally repainted) and *a secco* on other figures. Contrary to general opinion, not all these draperies date from the censorship operation decreed by the Council of Trent (1545–63): they respond in various ways when tested for ultraviolet fluorescence, and some may even have been added in comparatively recent times.

Given its different technical problems and state of preservation, the method adopted for cleaning the 'Last Judgment' has been very different from that employed on the ceiling. The fresco is first washed with distilled water alone, then treated alternately with a 25% ammonium carbonate solution – $(NH_4)2CO_3$ – and a nitro thinner. After twenty-four hours the carbonate solution is applied a second time, through four sheets of Japanese paper. After nine minutes, the paper is removed and the area cleaned with a small sponge soaked in the same solution. This is followed by rinsing several times in distilled water. This method has given excellent

91 Detail of the 'Flood' scene after cleaning, showing retouching. The blank area has been filled in using watercolour and cross-hatching.

92 Drawing of the incisions used to transfer the outline of the 'Creation of the Sun and Moon and the Creation of the Plants' from the cartoon to the *intonaco*. Red lines = indirect incision; blue lines = direct incision executed with ruler, cords or compass; black dots = holes for nails used to fix cords or compasses.

results on the figures. A slightly different technique has been used for the sky. The application of the ammonium carbonate solution is briefer and, since the pigment will not even stand cleaning with a soft brush, foreign matter has had to be removed by dabbing: a sponge soaked in water is applied to the surface, pressed against it and then removed. This technique takes off all the dirt contained in the pigment without rubbing the surface.

The conditions which caused the rapid deterioration of the Chapel's frescoes in the past no longer exist, but in the long term there is still the problem of pollution. In future the paintings will not be protected by applying resin or other types of varnish, which inevitably deteriorate in the space of a few years, but by improving the microclimate of the Chapel. Measures already taken or being implemented include a special anti-dust carpet for the stairs giving access to the Chapel; a new 'cold' lighting system, suitably shaded, to eliminate the updraughts resulting from the heat generated by the previous lights, and to give a better view of the paintings when natural light is inadequate; hermetic window seals and air filters to exclude harmful gases and other pollutants; and finally an air-conditioning system to reduce and monitor changes in temperature and humidity.

Acknowledgements

This chapter is an updated version, with a completely new set of illustrations, of an article by F. Mancinelli, G. Colalucci and N. Gabrielli in *Scienza e Tecnica*, yearbook of the *Enciclopedia della Scienza e della Tecnica*, published by Mondadori, Milan 1987. The translation is by Simon Knight, in association with First Edition Translations, Cambridge.

Both the ceiling and the 'Last Judgment' were restored by Gianluigi Colalucci of the Conservation Studio of the Vatican Museums, with Maurizio Rossi, Piergiorgio Bonetti and Bruno Baratti. The analyses and scientific tests were carried out at the Vatican Museums' Scientific Research Laboratory, by Nazzareno Gabrielli with Fabio Morresi, Luigi Gandini and Giorgio Barnia.

The illustrations were supplied by the Vatican Museums, courtesy of Nippon Television Network Corporation, Tokyo.

Further Reading

E. Steinmann, *Die Sixtinische Kapelle*, 2 vols, Munich 1901–5.

B. Biagetti, 'La volta della Cappella Sistina', *Rendiconti della Pontificia Accademia Romana di Archeologia* XII (1936).

R. de Campos and B. Biagetti, *Il Giudizio Universale di Michelangelo*, Rome 1944.

C. de Tolnay, *Michelangelo. The Sistine Ceiling*, Princeton 1945.

R. Salvini and E. Camesasca, *La Cappella Sistina in Vaticano*, Milan 1965.

J. Wilde, 'The Sistine Ceiling', in *Michelangelo. Six Lectures*, Oxford 1978.

P. and L. Mora and P. Philippot, *Conservation of Wall Paintings*, trans. E. Schwarzbaum and H. Plenderleith, London 1984.

C. Pietrangeli, 'I recenti restauri nella Cappella Sistina', *Rassegna dell'Accademia di S. Luca*, 1982, pp. 1–9.

Various authors, *The Sistine Chapel. Michelangelo Rediscovered*, London 1986.

Various authors, *Michelangelo e la Sistina. La tecnica, il restauro, il mito*, Rome 1990.

6 The Equestrian Statue of Marcus Aurelius

Alessandra Melucco Vaccaro

The statue of the emperor Marcus Aurelius (AD 121–80), set up by Michelangelo in the centre of the Piazza del Campidoglio on the Capitol in Rome, is the only 93, 94 equestrian bronze monument from the classical period to have come down to us intact. This chapter will show how and why this great sculpture has survived in spite of 1,700 years in the open air, while all the others have been destroyed, melted down or broken into pieces so that only fragments remain.

It is essential for those who have to restore such an important and famous monument to understand the ways in which their predecessors over the centuries faced the same problems and overcame them. Although the statue has survived, its past has left indelible marks on it. Ironically, it is because of the interest and concern of so many generations that the statue has suffered damage, unwittingly inflicted with the intention of preserving it. Some of these past interventions, as will be seen, have worsened its condition rather than improving it, and certainly today's conservation standards and techniques are very different.

93 The statue of Marcus Aurelius before restoration, in the Piazza del Campidoglio, Rome.

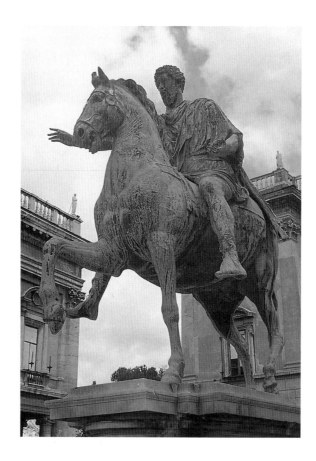

The story of the most recent restoration begins in 1979, when a terrorist bomb exploded in the Piazza del Campidoglio, damaging some of the buildings. It so happened that for the first time in Rome's history the office of mayor was held by an eminent art-historian, Giulio Carlo Argan. Even though the statue bore no obvious signs of damage, Argan called for an immediate on-site inspection. This showed that although the monument had not suffered in the explosion, there was serious active corrosion and that its overall condition was worrying; there were cracks and local damage everywhere, in particular to the horse's rear feet. It was therefore decided to move the statue to the Istituto Centrale del Restauro for further research and whatever restoration might prove necessary.

Very little is known about this exceptional monument, neither the name of its creator, nor when and why it was erected. In recent years the knowledge of bronze equestrian statues from the classical period has increased, thanks to underwater finds such as the Augustus found in the Aegean Sea and now in the National Museum, Athens, and to the reappraisal of neglected fragments in museums such as the statue of Domitian or Nerva in the National Museum at Naples. But these are fragments, and the Marcus Aurelius has remained the only complete example. As a result it has been the model for all Western equestrian statues of later ages. However, during ancient times it was by no means unique; rather it was only a variation on a theme in which details of the pose, the clothes, the attributes and the symbols assumed enormous importance. Fourth-century sources mention as many as twenty-two larger-than-life equestrian statues in Rome alone.

In this case the horse is proceeding at walking pace, with only its front hoof raised. The Emperor, seated on a saddle cloth, wears the *paludamentum* (military cloak) but underneath only a tunic and no armour; on his feet are thin leather sandals. His right arm is raised in the gesture known as *adlocutio*, indicating that he is about to speak. In spite of the military exploits which made Marcus Aurelius famous, therefore, the monument seems to emphasise the civil, rather than the military, aspects of power.

The equestrian statue as a type has a long history. Originally Greek, it was used to express the aristocratic power of the horseman during the period of the Archaic oligarchies; it was later taken over and transformed by Alexander the Great and his successors, who gave it an heroic significance. The Romans had already adopted it

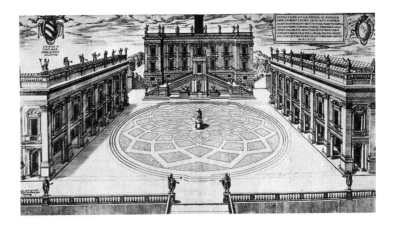

94 The Piazza del Campidoglio in 1568, by Emile du Pérac.

by the sixth century BC, and the historian Livy (59 BC–AD 17) tells us that an equestrian statue of the heroine Cloelia was set up at the top of the Via Sacra in the Forum, in recognition of her exceptional courage. With the passing of the centuries, the erection of an equestrian monument remained the greatest tribute that could be paid to a mortal by decree of the Senate, and both in Rome and in less important centres these statues were usually placed in the most crowded and important part of the Forum, that closest to the Curia (senate chamber). Even during the Empire, in spite of the emperors' monarchical aspirations, the decision to erect an equestrian monument remained the Senate's prerogative, but new locations began to be chosen: the statue of Trajan, for example, was placed in the middle of the new Forum that he had built.

Where the statue of Marcus Aurelius originally stood is not known. It may have been close to the Curia or perhaps, according to another theory, near the column in the Piazza Colonna which relates in its marvellously sculptured reliefs the story of Marcus Aurelius' wars in Germany. While the statue was being restored, it was seen to have a lack of symmetry: from certain viewpoints it appears disjointed and almost deformed, an impression which disappears as one moves round towards the diagonal. This might be explained if the statue had been designed not to stand alone in the centre of a square, where Michelangelo subsequently erected it, but rather to be part of a more complex equestrian group, which might have included a statue of the Emperor's son Commodus. Commodus might have implemented the work after Marcus Aurelius' death in AD 180 and included a representation of himself as well.

A study of the head provides more information which helps to date the work and establish the circumstances under which it was conceived. For political reasons sculptured portraits of the emperor were always widely circulated, and the image frequently updated. We know of many official portraits of Marcus Aurelius, which have been classified and reliably dated. Before restoration, when corrosion obscured the fine detail, the portrait on the equestrian bronze appeared to be of mediocre quality, much inferior to some of the marble examples. Restoration completely changed this view, however, making it possible to place the portrait in the years AD 160–76. However, the representation could also be a posthumous one.

Another puzzle is how and when the statue came to be placed in front of the Basilica of St John Lateran, the Cathedral of Rome, where it stood in the tenth century AD, when it was first mentioned in any written source. This statue of a great pagan emperor is thus first known not in its original classical context but as the result of Christian reuse. The great Roman antiquarian Carlo Fea (1753–1836) suggested that the statue was believed by the populace to be that of Constantine (c.285–337), the first Christian emperor, simply because it had been placed in front of the basilica that Constantine himself had erected and given to the Pope, and that it was for this reason that it had escaped the general destruction of pagan statues. It is known that Constantine appropriated stone reliefs from monuments erected in honour of other emperors and reused them in his own Arch near the Colosseum, and the practice of reusing earlier monuments by adapting them and dedicating them to other emperors was fairly common. Indeed, in the most recent research, reuse is becoming seen as one of the oldest and most widespread means of preser-

vation. We cannot therefore exclude the possibility that it was Constantine himself who set up the equestrian monument to Marcus Aurelius under his own name and placed it close to his basilica. Moreover, during the early medieval period, a remarkable collection of antiquities was amassed there, intended by the new power in Rome (the Papacy) to symbolise both the continuity of the Roman Empire and the victory of Christianity, the one true faith, over the Empire and its pagan idols.

Popularly known as the 'Horse of Constantine', the statue was shown as an important monument on early maps of the city. However, sometime between the thirteenth and the end of the fourteenth century it must have undergone a mutilation which changed its symbolic meaning and had serious consequences for its physical condition. Two medieval sources, reliable guides to Rome written for educated visitors in the second half of the twelfth century, the *Mirabilia Urbis Romae* by Benedetto Canonico and the *De Mirabilibus Urbis Romae* by Master Gregorius, state that the statue represents not Constantine but one of a number of possible legendary figures, perhaps a heroic peasant or soldier said to have captured a barbarian king who was besieging Rome. Both guides describe a figure being trampled beneath the uplifted hoof of the warhorse, with his hands bound behind his back.

Of the fallen figure there is no longer any trace, but it is clear that it must once have existed, since the authors of the guidebooks were obviously trying to interpret what they actually saw. Similar compositions are widely found in representations of 95 the emperor on the battlefield. This would also explain the severe damage to the front raised hoof of the horse, caused when the figure was removed. The loss of the figure of the 'barbarian king' not only resulted in a diminished emphasis on the sovereign's supreme power, but the group as a whole lost a vital prop which gave it physical stability. Examination of the bronze during restoration clearly revealed signs of serious injury. The left flank of the horse is severely deformed, and on the same side extensive but very skilful repairs are also evident. This suggests that the statue either fell down or was torn from its pedestal. However, the figure of the rider cannot have been in the saddle at the time, since it bears no corresponding damage. In 1452 one Nicholas Muffel, a visitor to Rome, described the statue as lying on the ground in the Lateran piazza. At this time the political situation in Rome was very uncertain: the exile of the popes to Avignon (1305–77) and the Great Schism

95 Silver coin (much enlarged) of Trajan
(AD 98–117), showing a barbarian under the
horse's raised hoof. British Museum.

(1378–1417) had resulted in the gradual decline of the Lateran and neglect of the basilica in favour of St Peter's. At the same time, there was a struggle against the temporal power of the Papacy, and the symbolic centre of this liberation movement was the Capitol, seat of the Senator of Rome.

Pope Paul II, and then Sixtus IV, tried to improve the situation by restoring the statue, which was still the most prestigious object in the Lateran piazza. We know from records of payments made at this time that Paul II commissioned a famous medallist, Cristoforo di Geremia, to carry out repairs in 1466–8. These must have been considerable, since a scaffold with more than 600 oak planks was erected for the purpose, at the cost of 300 golden florins. Shortly afterwards, Sixtus IV commissioned further work from two goldsmiths, Leonardo Corbolini and Leonardo Guidocci, presumably for regilding the statue, paying them 465 golden florins and 100 ducats. The work was concluded in time for the Holy Year of 1475 with the provision of a new and worthy pedestal.

None of this succeeded in halting the decline of the Lateran, however, and it became urgent for the Pope to crush the aspirations of the emerging classes. The dream of independence was finally shattered by Pope Paul III, and it was he who in 1538 called on Michelangelo to transform the symbolic area of the Capitol into an emblem of papal power, to redesign it and to place the equestrian statue at its centre. The monument now underwent yet another transformation. No longer Constantine, the first Christian emperor, it was recognised by Renaissance scholars as Marcus Aurelius, the philosopher emperor. Having lost the figure of the 'barbarian' on the ground and with it the iconography of absolute power, Marcus Aurelius could be seen not as a sovereign but as the Stoic philosopher who holds out his hand to the world in a gesture of peace.

Judging by the difficulties encountered in 1981 when moving the statue to the laboratory for restoration, Michelangelo must have found moving it to the Piazza del Campidoglio no easy task. Many drawings and engravings depict the statue both before and after its removal from the Lateran. They show that even after the fifteenth-century restorations described above, the statue was still physically unstable. Two supports can be seen under the rider's feet, clearly intended to relieve the horse's legs of part of the weight. In all the images depicting the statue after its removal to the Campidoglio, however, the supports have disappeared. Unfortunately, the archives provide no information as to what repairs Michelangelo made to enable him to move the statue safely.

The presence of gilding is an important factor in reconstructing the monument's conservation history. The statue was originally gilded. Scholars of the late medieval period had already observed and recorded this important feature of ancient bronzes, and it seems certain that during the fifteenth-century restorations the gilding was renewed and replaced in many areas, as we know from the records mentioned above. Samples taken for metallographic examination have confirmed that there are superimposed layers of gold leaf in many places, and this agrees with what can be seen on the surface. On the muzzle of the horse the bridle has lost its relief decoration, but gilding is present on these areas. This indicates that it was added by a restorer after the relief work had been lost. As noted above, the repairs on the chest and flank of the horse, carried out with notable skill and aesthetic judgement

96

96 The statue of Marcus Aurelius before its removal from the Piazza del Laterano: two piers can be seen below the rider's feet. Drawing by an anonymous sixteenth-century artist. Fossombrone, Biblioteca.

and accurately imitating the ancient modelling, bear no traces of gold and therefore apparently belong to a different period of restoration. It is thought that these major repairs are the work of Michelangelo.

The work carried out in the more recent restorations was fairly easy to identify: detailed reports and accounts exist which correspond with the material evidence. The year 1835 saw the completion of restoration work directed by many illustrious nineteenth-century personages, including Carlo Fea and the Danish neoclassical sculptor Bertel Thorvaldsen, in association with the Spagna Foundry. The physical instability of the monument was clearly critical, and for this reason most attention was paid to the horse. The iron support structures inside it were replaced, and Thorvaldsen personally moulded a missing piece of mane. The raised hoof was repaired, perhaps in the place where traces remained, like an old wound, of its contact with the figure of the 'barbarian' which had been torn away in medieval times. But, more drastically, the hooves were filled with a mixture of lead and tin, in the hope of correcting the horse's dangerous tilt to one side. This only worsened the situation because without resolving the basic problem of the group's instability, it added conflicting forces and tensions to a structure already weakened through being without its fourth prop over a long period. Moreover, the coefficients of expansion of lead and tin differ from those of bronze, so that these metals behave differently under the influence of heat. One cannot, however, contemplate reversing this intervention, since the mechanical means which would have to be employed would destroy the original bronze.

97, 98 There is also a detailed account and splendid photographs of the restoration which took place in 1912. The parlous condition that the bronze was in at that time is made only too clear by the long list of repairs. Inside the horse alone were inserted 28 large, 48 medium and 102 small bolts, and 22 copper wedges. Six large pieces of bronze were fixed on the surface of the horse, with 8 copper wedges and 185

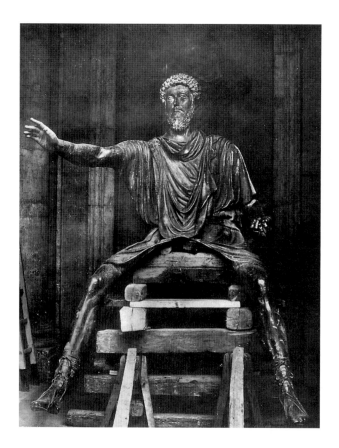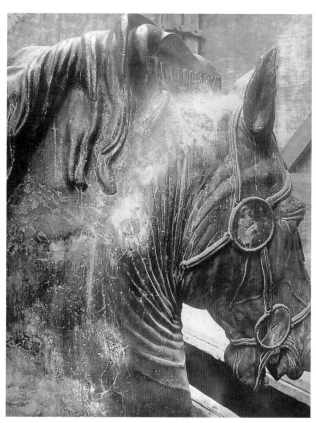

97, 98 The statue
during the 1912
restorations.

large, 654 medium and 1,133 small bolts. This restoration therefore consisted partly in the replacement of previous repairs which had given way and partly in fixing with new bolts previous repairs which had deteriorated. The work was carried out using threaded screws, which are easily recognisable.

This, then, was the state of the monument when it was replaced in the piazza. It remained there for nearly another seventy years without any care or maintenance, while around it the urban environment continued to change, eventually reaching present levels of pollution.

Before the most recent restoration could begin, it was necessary to reconstruct the metallurgical processes used in creating the statue. This was a particularly difficult task, because the monument has undergone so many interventions that it can be seen as an anthology of the different techniques used across the centuries. A second difficulty arose from the fact that studies in metalworking techniques are much more advanced for the classical period than for any other. Archaeologists have paid much more attention to this subject than art-historians, and because of the scarcity of work in this field there were often no other examples with which to compare observations and suppositions about the post-classical repairs and the dates at which they were in fact carried out. Only after future research will it be possible to confirm that the conclusions reached are correct.

However, quite a lot is known about ancient bronzeworking, and on the Marcus Aurelius specialists were able to recognise evidence of the principal stages of the casting process, particularly on the internal surfaces. These are in general less

affected both by finishing techniques and by subsequent repairs, and usually provide a great deal of information. The findings from a visual examination were documented and compared with data from a complete X-ray, as well as with results from analysis of the alloy.

99　　Specialists in ancient bronzeworking are now substantially in agreement that by the end of the sixth century BC the Greeks had already developed the technique which has been used ever since to make large bronze groups. This is the indirect lost wax technique, and its principal characteristic is that it enables the bronze to be cast in sections which can later be joined together. With the indirect lost wax method, a piece-mould made from some refractory material such as clay and powdered brick is taken from the original model, which may be of clay, wood or some other material. The mould is then dismantled, the model removed and the mould completely or partially reassembled, depending on whether the bronze is to be cast

a

99 Scenes from an Attic red-figure cup by the 'Foundry Painter', c.500–475 BC, Berlin, Staatliche Museen.
(a) A bronzeworker assembles a statue (right), while another tends the furnace hearth (left); behind it a man operates the bellows. In the background hang models of feet, tools and plaques.
(b) Watched by onlookers, perhaps the sculptor and/or the client, the bronzeworkers carry out the final surface finishing on an over life-size statue.

b

in one piece or in sections. The mould or moulds are then lined with wax and filled with a clay core. Core-pins are driven through the mould, through the wax layer and into the core to hold it in place. The complete assembly is now baked, so that the wax runs out through vents provided in the mould, leaving a void into which the bronze is poured. The mould is then broken open to reveal the bronze. If the bronze has been cast in sections, these now have to be joined. The method was in part designed to overcome the difficulties of maintaining the continuous high temperatures which were necessary for casting large quantities of bronze with the combustible materials then available (i.e. wood and charcoal), but it also required skilled soldering techniques to join the different parts of the statue together. The ancients were in fact consummate masters in the technique of first creating and then concealing soldered joins.

Traces of the indirect lost wax process were clearly recognisable on the Marcus Aurelius, and it was possible to identify the sections which had been cast separately and then soldered together. The division into sections took into account both foundry requirements and aesthetic effects. This was clearly no easy task, given that the rider alone was constructed in seventeen pieces, although the horse comprised only fifteen, being of simpler geometry and structure and having fewer undercuts. Constructing the group out of many pieces had another advantage: the interior of the statue was accessible, and it was therefore possible to carry out repairs from within.

The quality of workmanship found on the statue was extremely high. The average composition of the alloy is relatively constant, and the casting is on average only four to eight millimetres thick. Armed with knowledge and technical means far less sophisticated than those of today, the ancient bronzeworker developed both a fund of experience and a consummate skill which today we attempt in vain to match with modern tools. In the work carried out on the statue in the Renaissance period, probably by Michelangelo, the soldering was poorly executed and the quality of the bronze in the restored areas was lower than that of the ancient casting, because the lead component in the alloy had separated and was irregularly distributed.

The ancient bronzeworker also knew how to make good the defects which were revealed when the mould was opened after casting. A large number of patches, some no more than a few millimetres long, others larger and irregular in shape, were applied all over the outer surface in order to hide small imperfections and irregularities. They were placed in meticulously cut sockets and positioned by hammering. The surface was then finished by means of alternating hot and cold treatments.

Like the most important Roman bronze sculptures, the Marcus Aurelius was then covered with gold, which hid any remaining surface irregularities. Although ancient sources state that mercury was used in gilding from the late Republican period onwards, experts have not found traces of mercury on all gilded Roman bronzes. An analysis of the gilded surface of the Marcus Aurelius, in the most protected areas where the medieval and Renaissance repairers do not seem to have reached, failed to find any trace of mercury in the gold and confirms that a method of gilding called by the French term 'à la hache' was employed. This was a mechanical process, using a succession of hammer blows followed by burnishing to attach the gold leaf

onto the bronze surface, which was previously scratched with an iron brush, or otherwise roughened, to increase adhesion. Gilding with mercury, or fire-gilding, to give it the modern name, was not used by the Romans on large bronze sculpture until the late second or third century AD. The reason is that for fire-gilding to be completely successful the statue must be made of almost pure copper, which is much more difficult to cast than the usual alloy of leaded bronze, of which the Marcus Aurelius is made. The best-known examples of fire-gilded copper statues are the four gilded horses from the Basilica of St Mark in Venice.

The most recent restoration of the statue took four years of research, examination and cleaning tests, and two years of actual restoration followed by a series of discussions between technical experts and city administrators concerning the merits of re-erecting it outside or keeping it in a controlled environment.

During the preliminary stages traditional techniques such as X-radiography were combined with the use of fibre optics for examining the inaccessible interior of the statue. X-ray fluorescence, neutron activation analysis and metallography were employed, as well as chemical and microchemical analysis, to determine the composition of the alloy and corrosion products; examination with ultrasonic sound was used to determine the thickness of the casting and the locations of cracks and other damage. In order to appreciate fully the mechanical aspects of the structural problem

100, 101

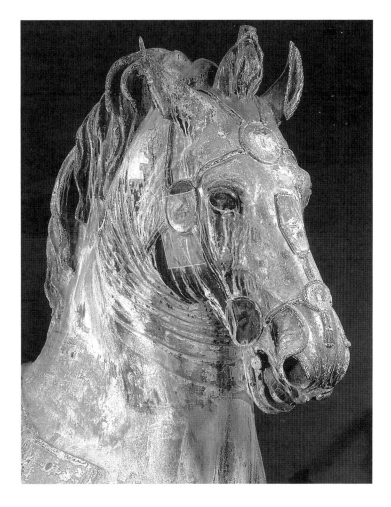

100 Detail of the horse's head during cleaning tests in 1984: several different corrosion products are visible on the surface.

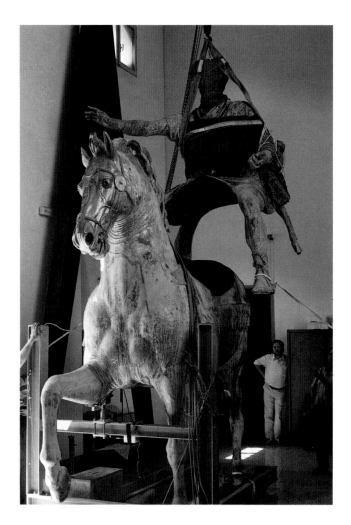

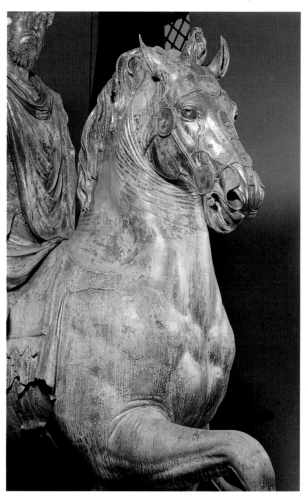

– to establish the amount of stress put on the horse by the weight of the rider, and to evaluate the direction and intensity of such stresses – photoelasticity and electrical extensimeters (strain gauges) were used, combined with a special form of speckle interferometry.

In order to minimise the stress inflicted on the statue by the various tests, a system of computerised simulation on a 1:5 three-dimensional model was carried out, both to study the reactions caused by the distribution of weight and to measure in the real situation of the Campidoglio the periods of exposure to the sun during the day, so that the sequence of thermic shocks could be evaluated. A thermovisual survey was made, using instruments similar to those employed in the medical field, to determine on the basis of meteorological and climatic data which areas of the statue were most subject to the formation of condensation, which is very harmful because it causes corrosion.

Once the composition of the corrosion layers had been established, cleaning tests were carried out. The first aim of cleaning is to remove any unstable bronze corrosion products and particles deposited from the air which initiate cyclical deterioration processes. One of the requirements when choosing a cleaning agent was that it should not be in the form of a liquid, which, while penetrating under the patina

101 (*Left*) The statue undergoing tests to determine its structural condition (1988).

102 (*Right*) The horse's head after restoration.

103 (*Opposite*) The statue of Marcus Aurelius after restoration. It can now be seen in the Capitoline Palace Museum, Rome.

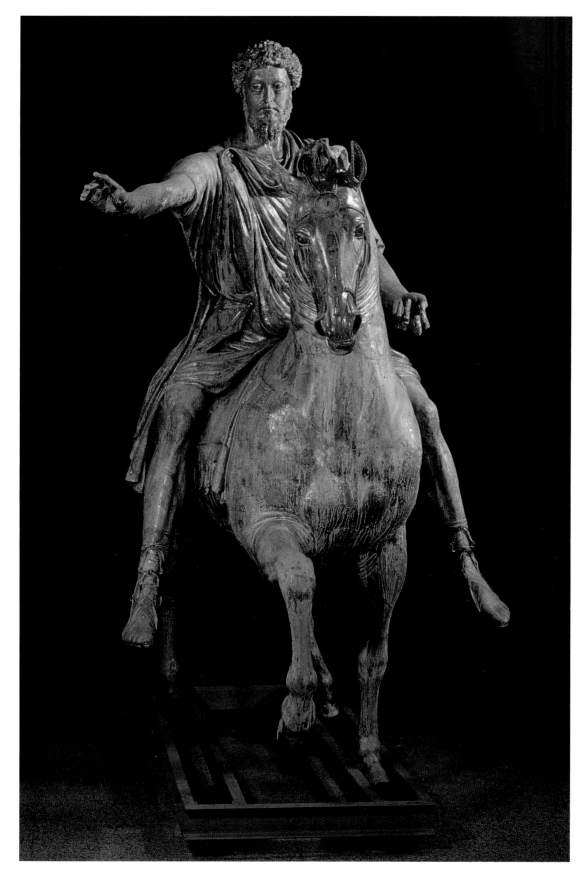

layers and dissolving some of them, might also cause the gold leaf to become loose. The effectiveness of ion exchange resins on the black deposits on gilded statuary had already been proved when cleaning the bronze horses of Venice. These were therefore used on the dark marks and over the gold, while a sequestering agent for copper (trisodium EDTA) was used in the areas with light or dark stripes or where gold had already been lost. Precision mechanical tools – dentist's drills and micro-hammers – were first used to remove the thickest deposits, both inside the statue and on external areas not exposed to the washing action of rainwater. Cleaning was stopped when the right balance had been achieved between removal of the dangerous materials and the desire not to remove any components of the alloy. Normally cleaning is followed by treatment with a corrosion inhibitor, but the presence of gold leaf, as in this case, means that commercially available products cannot be used. Treatment was therefore completed by three coats of a very dilute acrylic resin (5% Paraloid B-72), to make the gold leaf readhere to the bronze surface.

By this stage the sculpture had revealed much of the original sensitivity of its modelling and a considerable quantity of gold had been exposed. Unfortunately

104 Work on the statue in the final phase of restoration in 1987–8.

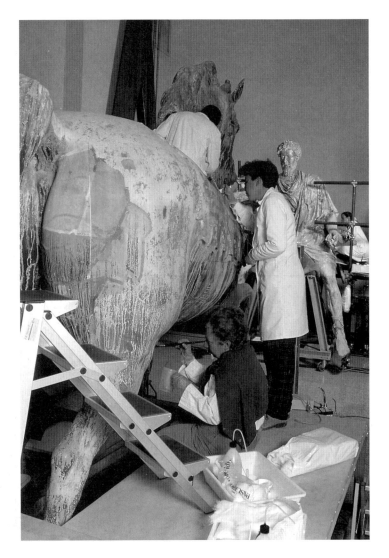

cleaning also revealed all the previous patches, repairs and marks of incorrect handling left on the monument during the course of its history. To make these less obvious, a retouching technique more commonly associated with easel paintings was used on a bronze for the first time, and to good effect. In this case the technique of *rigatino* ('striped retouching') was adapted to the variegated aspect of the bronze: before the final treatment with acrylic resin, the surface was tinted with streaks and small superimposed dots of watercolour to blend in with the surrounding area. However, the cracks and losses formerly concealed under the thick deposits were so widespread that closing them was impossible.

Even after restoration the condition of the bronze and the physical stability of the monument remain extremely fragile, and the gold would be lost if it were to be exposed once again to the polluted air. The conservation group therefore requested that the statue be kept in a protected environment and not out of doors. After long discussion, a solution – on a temporary basis at least – was found by placing it under cover close to the Piazza del Campidoglio. Since 21 April 1990, the anniversary of the mythical foundation of Rome, the statue has been on view in the Capitoline Palace, in a room where it is seen as though through a window. The architectural loss inevitable with a compromise solution like this is outweighed by the stunning view of the sculpture, which looks magnificent. Perhaps one day a good copy may be placed on the now empty pedestal in the Piazza del Campidoglio, as has been done with the four horses on St Mark's Basilica in Venice.

Acknowledgements

The author and publishers are grateful to Judith Swaddling of the Department of Greek and Roman Antiquities, British Museum, for her advice on this chapter. Fig. 93 is by W. A. Oddy; Figs 94 and 96 are from H. Egger, *Römische Veduten*, vol. II, Vienna 1931; Fig. 95 is from H. Mattingly, *Coins of the Roman Empire*, vol. III, London 1966, pl. 11.12; Figs 97–8 are from the Capitoline Photo Archives; Fig. 99 is from A. Furtwängler, *Beschreibung der Vasensammlung im Antiquarium*, Berlin 1885; and Figs 100–104 are courtesy of Lorenzo de Masi.

Further Reading

The Horses of San Marco, Venice, London 1979.

F. Haskell and N. Penny, *Taste and the Antique: the Lure of Classical Sculpture 1500–1700*, London 1981.

A. Melucco Vaccaro and A. Sommella Mura (eds), *Marco Aurelio, storia di un monumento e del suo restauro*, Milan 1989.

7 The Piranesi Vase

Eric Miller

Although nowadays we may enjoy a restored ancient sculpture from an aesthetic point of view, archaeologically we regard such restorations as unethical. This was not the case 120 years ago, when archaeology was in its infancy. At that time the Trustees of the British Museum saw no reason not to acquire the Piranesi Vase, even though they were aware of its extensive restorations. Nevertheless, the Trustees and the Keeper of Greek and Roman Antiquities were no doubt influenced by Piranesi's own published text on the Vase, in which he states: 'This monument was found in a site [excavation] in Hadrian's Villa in 1769. We think that this Vase was made by the same famous sculptors of many other works which Hadrian used to have in his villa.' These words, together with a description in the objective style of the art-historian and which included the observation that 'this kind of invention has never been seen before', were undoubtedly intended to deceive, because what had in fact been discovered at the Villa of Hadrian in 1769 was not an ancient vase but 'a great number of Fragments of Vases, Animals of different sorts and some elegant ornaments'. This is how Gavin Hamilton (1730–97), the Scottish neoclassical painter, described the finds in a letter to the scholar and collector Charles Townley (1737–1805). It was Hamilton's excavation of the site that unearthed the fragments which were acquired by Piranesi.

Drawing on both his creative and scholarly background, the engraver, architect and antiquarian Giovanni Battista Piranesi (1720–78) exercised his talents to make convincing marble reproductions of Roman antiquities, conceived and executed upon enough original material to qualify them (at least to his own satisfaction) as restorations, which he then sold to wealthy collectors. The eighteenth century was the heyday of the Grand Tour of the ruins of the ancient world, especially popular with the British, many of whom became collectors of the objects they saw there. One such English collector was Sir John Boyd (1717–1800), who bought the Vase and shipped it from Rome to England in 1770. Boyd had built a mansion at Danson, near Welling in Kent, about eight years previously, and he had the Vase erected in the conservatory. After his death the mansion, known as Danson Hill, was sold in 1807 to John Johnston. The Reverend Castell, in his book *Bexleyheath and Welling* (1910), writes '. . . with Danson Hill he [Johnston] acquired some works of art he [Boyd] had brought over from Italy, including the handsome Danson Vase.' Johnston died in 1828.

On 21 March 1862 a Mr A. Johnston wrote to the Trustees of the British Museum offering the Vase for sale. Although the Museum had its own expertise, the Trustees invariably sought the opinion of the sculptor Richard Westmacott RA in such matters. Westmacott was the son of Sir Richard Westmacott RA, whose last major commission had been the group of sculpture in the pediment of the British Museum.

Westmacott paid a visit to Danson and wrote to the Trustees on 23 May 1862:

It has suffered much from breakage – it has been repaired – and the modern restorations are extensive – but in some parts these are very fair, but they are unequal – as it has occupied its present situation /a Green House/ for about 50 years. I could not learn whether the repairs were made before or after its removal into the building so that I am unable to speak as to the strength of the work – but I think with careful casing and bracing, it might be carried in two portions without danger, by *Spring Waggon*. The fastenings or pins of the repairs seem to be of *iron* – and it may be necessary to cut some of them out, to prevent the bursting of the marble by the expansion of the metal in a damp atmosphere.

By 'expansion of the metal in a damp atmosphere' Westmacott was referring to the expansion that occurs when iron corrodes, although it is hard to understand how he was able to draw such a conclusion, as the dowels are not visible. It is

105 One of Piranesi's own engravings of the Vase, taken from volume II of his *Vasi, candelabri, cippi . . .* (1778).

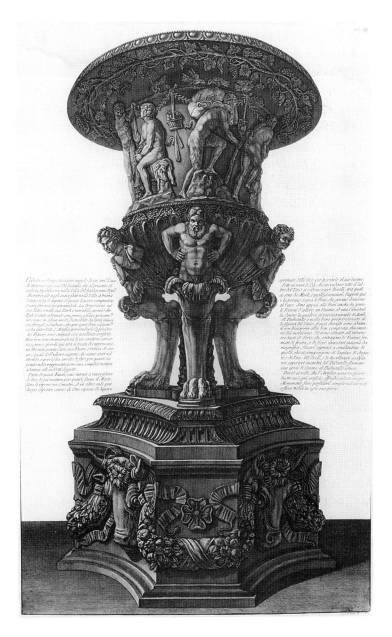

possible that he had extrapolated it from the repairs that he saw, in which case some of them must have rebroken, but he did not convey this in his letter.

The Vase was sent to the Museum on 11 October 1862, even though the Trustees were not to purchase it until March 1868. In the meantime, it had been partially repaired at Johnston's own expense, and set up in one of the two sheds which had been erected in front of the Museum to house the marbles from the Mausoleum at Halicarnassus (in modern Turkey) while repair and mounting work was carried out by masons. These sheds were flimsy, and the windows were often broken. They were hot in summer and cold in winter. It is likely that the Vase could be viewed there, at least from time to time, by members of the public, because it was reported to the Trustees on 10 October 1862 '. . . that since the 14th June last, persons desirous of seeing the sculptures from the Mausoleums Cnidus and Cyrene, have been admitted to the glass sheds under the colonnade on application to the Chief Messenger.'

We next hear of the Vase in the *Illustrated London News* of 25 September 1869, which reported, under 'Ancient Vase at the British Museum', its appearance two or three months earlier 'in the centre of the entrance hall' and that, 'It has been carefully restored under the superintendence of the Keeper of the Greek and Roman Antiquities, the broken parts being rejoined with copper fastenings'. 106

During the next fifty years the Vase was twice moved to a new site in the Museum. Then, between the two world wars, it became the victim of a change in attitude. Already before the First World War the tolerance of restorations of heads and limbs missing from ancient figurative sculptures was wearing thin, and after the war this anti-restoration feeling grew to include purely decorative sculpture. The Vase was therefore consigned to storage in the basement, where it joined other restored pieces no longer acceptable for exhibition.

As early as 1933 the Trustees made plans for the protection of objects in the event of another war with Germany, and in 1939 these plans began to be implemented. The sculptures in the collections of the Department of Greek and Roman Antiquities were taken down, and some were placed in ground-floor galleries where sandbag shelters were built over them. Other objects were sent to the basement stores, while the finest pieces went to a repository established in the Aldwych Underground railway tunnel. This operation was continued throughout the war, but there is no mention of the Vase in the records. It was not important enough for the Aldwych tunnel, and as it was already in the basement in 1939, it almost certainly stayed there.

In 1955 the Vase was lent to the Ministry of Works for exhibition in the Orangery at Kensington Palace. It spent the next twenty years there, and was returned to the Museum in 1976. It was stored in the basement in a dismantled condition, and would probably be there still if it had not been for the decision to mount an exhibition on fakes.

Major exhibitions are planned up to five years in advance, and work on their design may begin two or three years before the opening date. The Department of Conservation becomes involved as soon as objects are chosen, so that these can be prepared in good time for display. Consequently, when the Vase was selected as the centrepiece for the exhibition *Fake? The Art of Deception*, scheduled to open in March

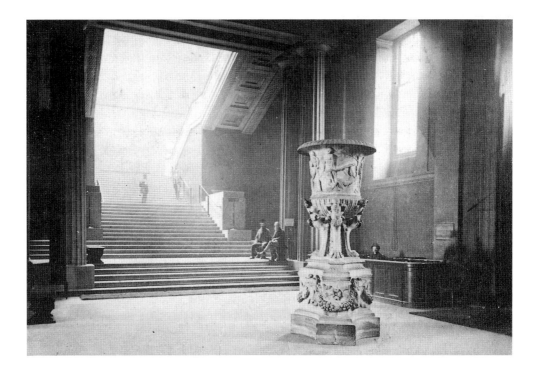

106 The Piranesi Vase in the Entrance Hall of the British Museum, *c.*1875.

1990, the pieces were brought to the stone workshop in May 1989. Here they were examined in order to determine the condition of the marble and the stability of the overall structure of the Vase.

The ancient parts of the Vase date from the second century AD, but the second-century work has never been fully differentiated from the modern (eighteenth-century) work because weathering, and perhaps a certain amount of distressing (artificial weathering), has made the task too difficult. On the base, however, it seems fairly certain that two of the bulls' heads are ancient. The legs supporting the *krater* (the vase proper) are much restored and the central shaft is modern. Some of the figurative sculpture appears ancient but, so far, expert opinion about it remains uncommitted. The fragments that make up the krater have been definitely dated: they are mostly modern but are regarded as an accurate restoration. The rim is modern. Carrara marble was used by both the ancient and the modern carvers.

Centuries of weathering have roughened the surface of the ancient marble, but it is likely that the severest and most debilitating effects from this source occurred during a brief period of subjection to the polluted London atmosphere, probably while the Vase was in the makeshift sheds under the colonnade. However, with the exception of some of the lacy foliate detail, which has been weathered through and through, the marble shows no sign of any significant weakening.

The Vase divides into three sections: the base section (the pedestal) and the middle and upper sections forming the krater and its support. Fig. 108 shows the base section in plan, and it is evident from this and Fig. 107 that its function as a support structure is performed mainly by the two sturdy standing stones A and D and the equally sturdy member that acts as a capstone spanning the space in between. However, the capstone is in three pieces and, according to photographic evidence from the restoration of 1869, the joints run transversely – that is to say, in their

weakest orientation – in relation to stones A and D. Close examination of these joints revealed no outward signs of degradation.

The six standing members of the base section lock into a rudimentary but stable structure when tightly cramped together at the top. The function of the limestone core, which was placed too low to share the load of the superstructure, seemed to be to increase the solidity of the base section, but the means by which it was integrated were missing. These may simply have been baulks of timber and/or wedges.

The two very thin panels, C and E, are composite pieces containing substantial amounts of ancient stone. Both panels are reinforced by cast slabs of a weak mortar or aggregate-bearing plaster, which have little compressive strength and therefore no load-bearing capacity. The slab reinforcing panel E was loose and came away easily. It had been roughly hewn to conform approximately with the contours of the back of the panel, and was secured to it with two wooden dowels (now perished) and a thick intervening layer of plaster of Paris, into which the slab had been pressed. The other panel, C, although apparently of the same construction, still held together firmly.

The middle section is a tripod, but with a central shaft which is actually the primary support for the krater. Without this shaft, the severe angularity of the legs would stress the marble beyond its limits. Indeed, breaks have occurred in the past at all points of greatest stress. At the junction of legs and bowl (through the bodies of the bearded figures) there are major repairs to all three legs, and one of these repairs was found to have failed again. In addition, the repair carried out to the heel of the lion-foot, where one of the legs had at some stage sheared in two, had also

109

107 (*Right*) Diagram showing the structural divisions of the Vase.

108 (*Below*) Plan of the base section, showing the positions of the capstone joints. The outer broken line represents the base slab, and the rectangular stippled areas the cast reinforcing slabs.

broken for the second time. Below the heel in that part of each leg subjected to straight compression (the lion-feet), the marble is joined in two places, and all but one of these joints were disrupted. Finally, the legs terminate with shallow plinths which are united sculpturally with the lion-paws that apparently rest upon them. In turn the plinths stand on the capstone, bedded in plaster. These plaster beds had all separated at one or other of the marble interfaces.

It seems probable that all these breaks had occurred and the repairs continued to fail because the structure – which, if undisturbed, adequately performs its function of supporting itself and the upper section – cannot withstand the shocks and vibrations of transportation, even over short distances.

The upper part of the tripod structure (the bottom of the krater) is a modern (eighteenth-century) bowl, to which the legs and other purely sculptural elements are joined. The outer skin, with its decorative gadrooning, is a pastiche of ancient and modern pieces, fixed to the bowl with plaster of Paris. Gaps between pieces and large voids are filled with plaster, and the whole surface appears to have been abraded to produce a unifying smoothness. The examination revealed no deterioration in the integrity of this composite piece.

While marble has great compressive strength, under other kinds of stress it is relatively weak and brittle. Consequently, disturbances such as transportation, erection and dismantling can also result in minor damage such as scratching, chipping, pressure spalling and breaking. Many small fragments of marble accompanied the Vase to the workshop for reattachment, but unfortunately others have been lost and some of these losses have been restored – not always skilfully – with plaster of Paris.

The upper section, which is simpler and less intricately carved, has been less

109 Exploded view showing the breakdown of the middle section on separation of the broken joints.

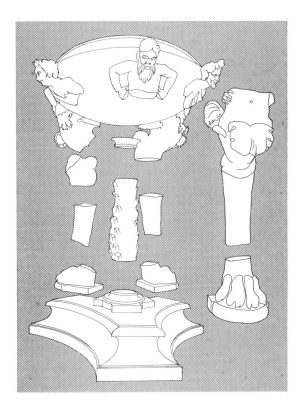

affected by these disturbances. It consists of the top part of the krater, which, like the bottom part, has been restored by fixing ancient and modern pieces to a core component and then, apparently, abrading the whole surface to produce a uniform finish. A wide rim, in two parts joined by cramps, rests on the top of the krater. All these pieces were found to be in good condition.

There was evidence that a previous cleaning operation had taken place, presumably after the Vase was acquired by the Museum and before it was put on exhibition in 1869. Before this time the Vase had apparently spent some years exposed to the atmosphere – probably in the sheds mentioned earlier – where it acquired a thick layer of disfiguring black dirt consisting principally of carbon and sulphate particles, probably from coal-burning. These would have reached the marble by various means, but were probably mainly carried in the water droplets of the infamous 'pea-souper' smogs of the nineteenth and early twentieth centuries.

This type of dirt is easily loosened by prolonged soaking with water, followed by brushing and swabbing. One method of 'soaking' is to cover the surface with a layer of wet clay, but if this is done carelessly, air can be trapped in the form of bubbles under the clay, causing hard-edged black stains which remain after brushing and which are often impossible to eradicate entirely unless action is taken immediately. Many such stains were found on the base and middle sections, together with more extensive black dirt residues beneath undercuts and in other awkward places, some of which had been scratched with a pointed instrument.

Besides such stains caused by human intervention, dirt can become intractable when it is deposited on weathered surfaces. 'Weathering' includes all the processes by which stone is naturally altered, and one effect of it is the microscopic fissuring of the surface by etching along grain boundaries, thus creating the conditions for fine particulate dirt to become deeply ingrained in the surface. Such dirt is partially inaccessible to cleaning, and white marble may be turned permanently grey by it. Moreover, iron – which is often present in marble – may become oxidised at

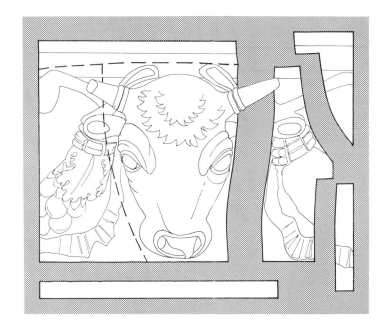

110 The right-hand side of panel E separated into its component pieces. The joints at left and top were firmly held together.

the surface, producing a discoloration varying from yellow to reddish-brown. Iron staining, as it is called, is irreversible except by methods that also damage the marble. The Vase had been affected to some degree by both these phenomena.

It was decided to clean the Vase before making the necessary repairs. In recent years, low-pressure steam has been used for cleaning marble and other types of stone. Steam is pressurised to 2.5–5.5 atmospheres in a boiler, and is then directed at the surface of the stone by means of a hand-gun. The high-energy combination of moisture, heat and pressure loosens the bonding between dirt and stone more rapidly than traditional washing methods, and is, in particular, more effective against ingrained dirt. On the other hand, the treatment is rather harsh, and surfaces must be examined beforehand to ensure that they can withstand it without damage. In addition, particular care must be taken when cleaning marble, as overheating can cause expansion in the densely packed calcite crystals and this may lead to a break-down of intergranular bonding.

With the aid of steam cleaners, the Vase was cleaned in approximately two and a half weeks. All recently accumulated dirt was removed, but traces remained of the black, hard-edged stains and the deeply ingrained dirt.

The first section to be repaired was the base. When the Vase was being examined, the loose reinforcing slab had been separated from the back of the composite panel E, exposing the plaster layer. This would have to be removed mechanically before

111 The recon-
structed legs standing
in position on the
capstone.

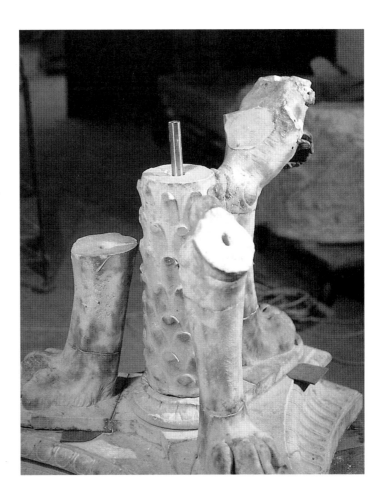

112 (*Above*) One of the legs about to be rejoined. Stainless steel dowels were used, and the dowel holes filled with a polyester and sand mix.

113 (*Right*) The equilibrium of the bowl was restored with improvised weights.

any new adhesive could be applied. The panel was laid face down on cushioning material, but vibrations from the hammer and chisel began to dislodge pieces from the panel itself, signalling the absence of dowels and a possible disorderly collapse of the other pieces. As a precaution against further damage to vulnerable edges, the panel was stood up again and the cushioning material arranged to arrest the fall of pieces as they came away. Paper tissue was also pasted over all the joints, using polyvinyl alcohol, a water-soluble adhesive. The tissue used was an acid-free lens tissue with randomly orientated fibres; it is capable of conforming with any contour when wet and gains considerable strength when impregnated with adhesive. When it was dry, the tissue was cut along the joints, using a scalpel to separate the components. The object of this tissue facing was to make it easy to retrieve any flakes that might be dislodged despite the precautions, so that they could be restuck immediately.

110 The remaining plaster was then removed from the back and the joints were allowed to separate. Only the right-hand side of the panel came apart. The component on the left remained firmly fixed, almost certainly because dowels had been used there, no doubt on account of its greater size and weight. The marble was then cleared of all traces of plaster. At the same time, after checking for loose flakes, the front surfaces were cleared of facing tissue and adhesive, using steam.

The use of dowels greatly increases the strength of joints, and two stainless steel dowels were used for each joint in the panel, in association with a thixotropic polyester resin adhesive. The reinforcing slab was dowelled to the back of the panel, but before squeezing them together the panel was liberally 'buttered' with a mixture of polyester resin and sand.

When it came to considering the limestone core, it was decided that the Vase would be better served by a new core that would participate in supporting the

114 (*Right*) Fillings were made with a pulverised marble and acrylic resin paste.

115 (*Far right*) Retouching was carried out using acrylic colours.

superstructure and thereby also more fully perform its primary function, which was to consolidate the base section. The material chosen to make the new core was aerated concrete, which is lightweight, available in block form and, according to the manufacturer's data, capable of fulfilling a load-bearing role provided the courses are properly bedded in mortar for good load distribution. As it is also highly water-absorbent, the blocks were sealed with an acrylic emulsion to prevent them from dehydrating the mortar in which they would be bedded.

Dismantling joints is often made easier by raising the object off the ground and using its own weight, or parts of it, as a separating force. This technique was used when dismantling the middle section. The bowl was cradled with slings – delicate detail being protected with cushioning material – and lifted a few centimetres with the aid of a gantry hoist. The joints had been made with plaster and copper dowels. Some breakdown had already occurred within the plaster, and this could be completed relatively easily by twisting the legs round and back. In each case, the uppermost joint, which supported the greatest weight, was preferentially separated. The shaft was removed by the same method. However, for the lower joints the separating force had to be exerted manually or by driving in timber wedges. One or two were more easily dealt with by sawing through the dowel and drilling into the plaster.

The pieces were reassembled more or less in the reverse order to that in which they had been dismantled. The first stage was the reassembly of the separated legs, which would then be reunited with the bowl. The reconstructed legs were stood in place on the capstone, but the bowl could not be positioned on them correctly 111 because it no longer hung straight in its slings. Its equilibrium was restored using any heavy objects that came to hand! In the event, however, none of the joints would 113 meet without some adjustment to the positions of the legs, and finding an acceptable compromise involved four conservators – one to minimise the displacement of each of the three legs, and a fourth to operate the hoist. During the numerous attempts at assembly, four of the five newly made joints were broken. On dismantling them again, it was discovered that the failure was caused by pronounced cracking in the polyester resin adhesive, due to shrinkage during polymerisation. This was eventually overcome partly by using dowels of a larger diameter, and partly by mixing the 112 resin with sand in equal proportions. By substantially reducing the volume of the resin in this way, the shrinkage was reduced to a minimum. (The option of using an epoxy resin to resolve the adhesive problem was rejected. Epoxies are stronger and shrink less during polymerisation, but they are also considerably more resistant to the action of solvents. This limits their use in the treatment of antiquities because it makes their removal very difficult. Polyester, on the other hand, is quickly broken down by methylene chloride, the active ingredient of common paint strippers, and is therefore said to be 'reversible'.)

Once the best compromise positions for the legs were finally established, these were recorded by datum marks to allow removal and accurate replacement when required. The only way of ensuring that every joint was correct was for all three legs to be in the right position while each one was joined on, redressing the equilibrium of the bowl between each addition. The shaft was added last.

Because of the compromises which had had to be made, none of the plinths at the ends of the tripod legs rested flat on the capstone; they would therefore be

susceptible to damage from point-loading (i.e. when a load is not evenly distributed over a wide area of contact but is concentrated on an area small enough either to overcome the compressive strength of the stone, causing crushing, or to distort the structure, causing breaks, particularly in joints). Under the previous construction this problem had been solved by bedding the plinths in plaster, but this method had the disadvantage that beds would have to be prepared anew every time the Vase was reconstructed. The solution was therefore to bed them in polyester and sand, but to separate the bed from the capstone with polyethylene sheeting, so that bed and plinth would travel together. A similar bed was prepared for the shaft, but for ease of application it was bonded to the capstone.

To test the tripod, the krater was set on it and the effect examined after twenty-four hours. Predictably, the fifth joint, beset by shrinkage cracks, had finally given way. . . .

At last, early in November 1989, a trial assembly was carried out. The trial presented an opportunity to test – with the aid of a hardboard template – the theory

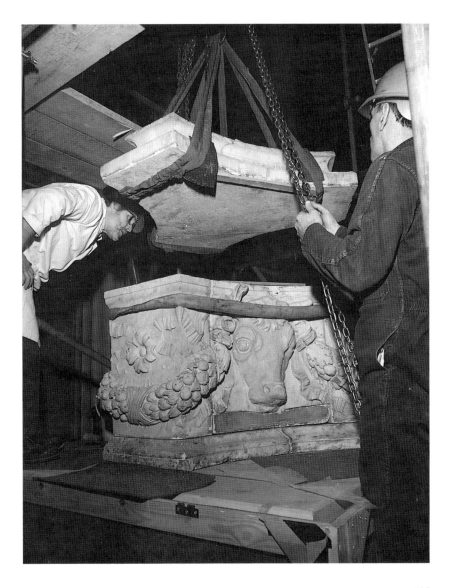

116 The capstone being lowered into position.

that the capstone should be orientated so that the joints in it ran longitudinally in relation to the standing stones A and D. However, the test demonstrated that the capstone would only fit in the position already assigned to it.

For the trial the new core was installed in the base section, but without mortar it was too short to perform its function. It was nevertheless reassuring that the Vase was perfectly stable without it.

While the Vase awaited mounting for exhibition, the loose fragments that had accompanied it were refixed, and gap-filling and colour-matching work was carried out on the middle section. Within the limitations of the materials, the intention was to make the joints and other repairs as unobtrusive as possible. Because of the fine texture of the Carrara marble, a paste was prepared using a very fine grade of 114
pulverised marble and Paraloid B–72, an acrylic copolymer which is reversible in a number of solvents, including acetone. Acrylic paints were used for colour-matching. 115

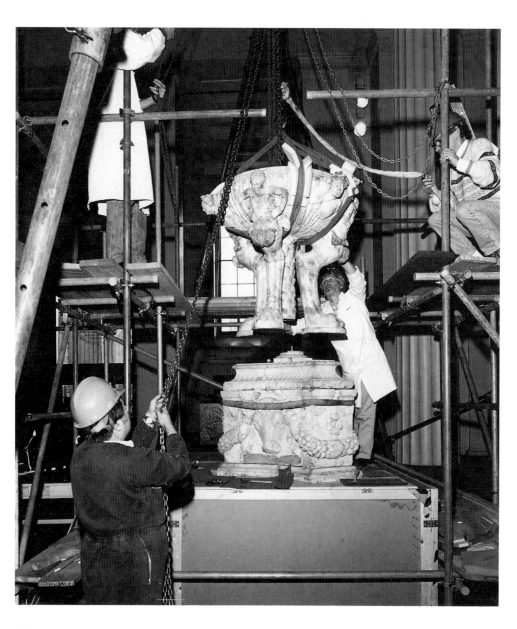

117 Setting the middle section in place.

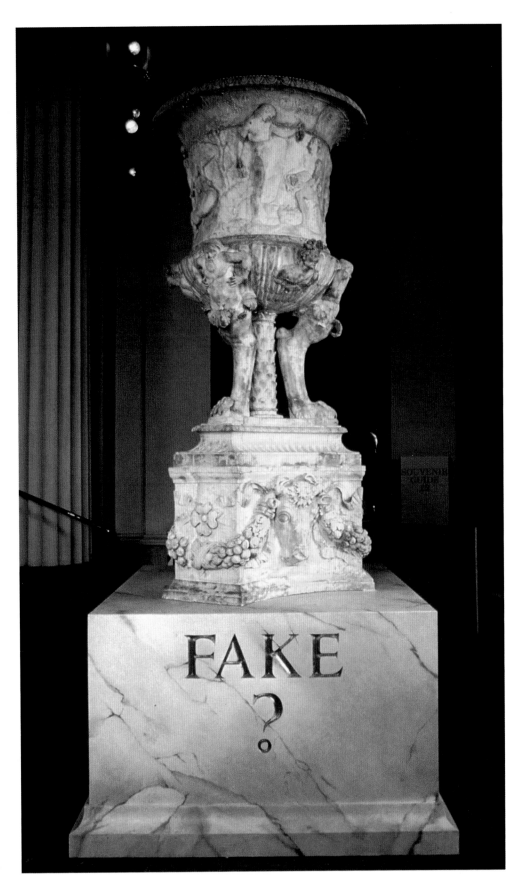

118 The Piranesi Vase
as it appeared in the
exhibition *Fake? The Art
of Deception* at the
British Museum in 1990.

Originally, the most favoured place for the Vase to stand during the *Fake?* exhibition was at the centre of the first landing on the main stairs leading from the Museum's Front Hall, which would have given an extra height of about a metre (3 ft). However, the estimated cost of twice erecting a gantry hoist with one end in the Front Hall and the other halfway up the stairs (the second time for the dismantling of the Vase) was around £8,000. Possible alternative sites were strictly limited, and a position at the foot of the stairs was quickly settled on, subject to a structural engineer's report. The British Museum building is rather elderly, and the condition of substructures is always inspected where the siting of a heavy exhibit is planned. The combined weight of the Vase and the plinth on which it was to stand was about 4.5 tonnes.

The plinth was a steel structure, 1.1 m (3½ ft) high, sheathed in medium-density fibre board and painted rather convincingly to resemble marble. After it was set in place, it remained encased in protective boards while a mobile gantry hoist was centred above it. An access scaffold was then erected inside the gantry.

On 23 January, working with staff from the Department of Greek and Roman Antiquities and in full view of the public, the assembly began. The protective board was removed from the top of the plinth, leaving the sides still hidden. The base slab, in two pieces, was hoisted into position and carefully centred. Next the standing stones were assembled, and polyethylene sheeting laid over the base slab to prevent contact with the mortar bed upon which the aerated concreted core was constructed.

During the trial assembly the standing stones had shown a tendency to move when the capstone was being positioned, and against this possibility the cramps were set in gypsum plaster. The stones were united with the core by cast plaster bridges (made using paper bundles as crude formers), and once these had hardened, mortar was heaped on the core to bed the capstone. Like the base slab, the capstone was 116 separated from the mortar with polyethylene sheeting.

The erection of the Vase took a little longer than the trial assembly because of 117 the restrictions of working in close proximity to members of the public. Nevertheless, the rim was placed in position on the fourth day. After the removal of the scaffold and gantry, all that remained to complete the presentation of the Vase for exhibition was the filling and colour-matching of the base-section. On 9 March 1990 the boards were finally removed to reveal the brash new 'marble' plinth with its gilded 118 inscription, 'FAKE?'.

Acknowledgements

The author would like to thank his colleagues in the Stone, Wallpaintings and Mosaics Conservation Section of the British Museum for their practical contributions to this project, and in particular to Jennifer Dinsmore for her suggestions regarding the manuscript. All photographs in this chapter are © The Trustees of the British Museum.

Further Reading

A. H. Smith, *A Catalogue of Sculpture in the Department of Greek and Roman Antiquities*, vol. III, British Museum, London 1904.

N. Penny, *Piranesi*, London 1988.

M. Jones (ed.), *Fake? The Art of Deception*, exhibition catalogue, British Museum, London 1990.

8 The Hockwold Treasure

Andrew Oddy and Robert Holmes

On 2 February 1962 an amateur archaeologist, Frank Curtis, was excavating on the line of a Roman road at the edge of a plantation near Blackdike Farm on Hockwold Fen, Norfolk, when he chanced upon a hoard of Roman silverware. The discovery was reported to Norwich Castle Museum, whose then curator, R. R. Clarke, re-investigated the site a few days later and found another piece of silver (a handle from a silver cup).

The silver appeared to have been deliberately buried in a specially dug hole, so the declaration of the find as Treasure Trove, at a coroner's inquest at Methwold on 20 February 1962, was a mere formality. The law of Treasure Trove is ancient, dating back to the reign of Henry I (1100–1135). In essence it states that whenever objects of gold or silver are discovered in the ground they must be the subject of a coroner's inquest to decide whether they were buried *with the intention of being recovered*, as opposed to being lost or deposited in the ground as a ritual offering. If the treasure is declared to have been lost or ritually deposited, it becomes the property of the landowner. If, however, the coroner's jury decides that the treasure was hidden for safe keeping with the intention of recovery, it is declared to be Treasure Trove and then belongs to the Crown. Nowadays the treasure is offered to an appropriate local or national museum which customarily rewards the finder with the commercial value of the objects, as decided by an independent valuation committee.

The Hockwold treasure was acquired by the British Museum, where it underwent nearly twenty years' study before being conserved, restored and eventually put on exhibition in 1981. Among the more important questions which had to be answered were: what was the date of the silver; why and when was it buried; what exactly did the hoard consist of; and could and should it be restored? The first two questions could only be fully considered once the third and fourth had been answered.

The hoard consisted of twenty-four principal pieces of silver and nine smaller fragments which together clearly comprised the remains of a number of silver cups of the late Republic or early Roman Empire, between about the mid-first century BC and the mid-first century AD. On the basis of the fact that there were five cast silver pedestals and five (crushed) silver bowls, the thirty-three pieces were divided up into five boxes and presumed to represent the remains of five cups. However, an immediate problem was the fact that the hoard apparently contained thirteen handles, not ten.

119–23

The obvious next step was to carry out a complete restoration, but the decision to do this was a matter of debate. If the crushed and distorted shape of the silver had been entirely the result of burial, the decision to restore would have been straightforward. But the appearance of the individual fragments clearly showed that

137

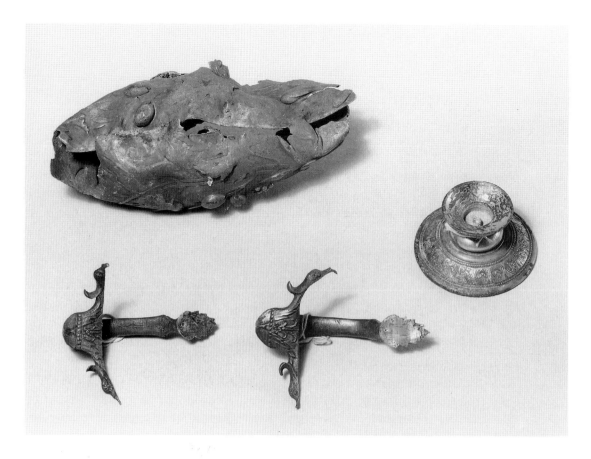

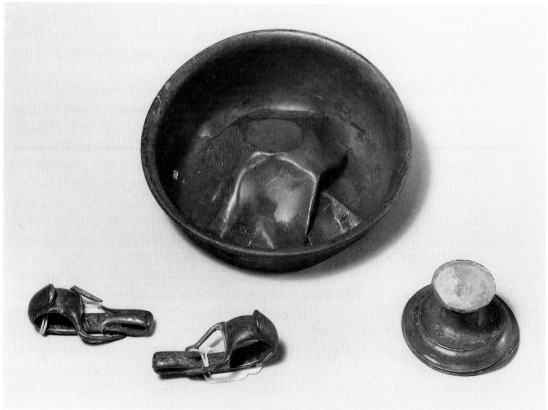

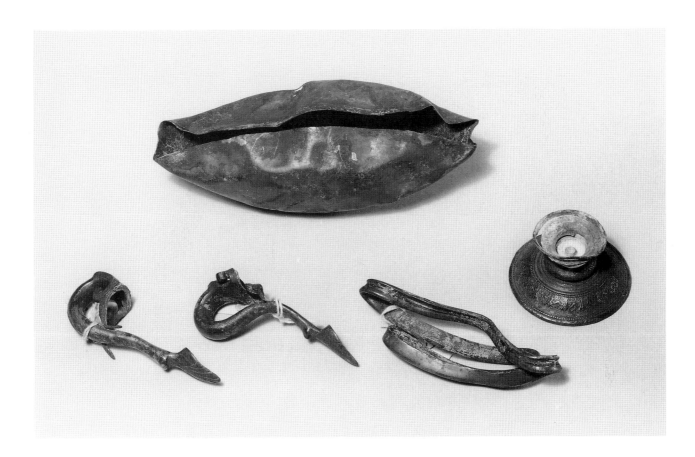

119 (*Opposite, top*)
Figs 119–23 show the Hockwold Treasure as it was received in the British Museum in 1962. It was arbitrarily divided into five boxes because the five bowls suggested that the hoard consisted of five cups. This picture shows the outer skin and pedestal foot of cup no. 1, with handles from another cup.

120 (*Opposite, bottom*)
The fragments of cup no. 4.

121 (*Above*) The inner skin and rim of cup no. 1, with handles and a pedestal foot from other cups.

the treasure had been deliberately damaged *before* burial. In particular, the cups had been squashed and broken into their separate components – bowls, handles and pedestal feet – which had then been further distorted by hammering, bending and folding.

Why should this damage have been done if the cups were sufficiently valuable to have been buried for safe keeping in the first place? Three plausible answers spring to mind. One distinct possibility is that the cups represent the loot from a robbery, hidden by the thief until the hue and cry died down, when he would presumably have melted them down into an ingot which he could more conveniently sell. The fact that the extra handles suggest that the hoard is not complete merely indicates that the thief must have kept back a few bits of silver for immediate use. Selling the stolen property bit by bit would minimise the risk of suspicion: just as criminals today are often caught as a result of their ostentatious life-style, this must also have been the case in antiquity.

A second explanation is that the hoard consists of scrap metal belonging to a silversmith which was quite legally awaiting melting down and recycling. The problem with this theory is that only one type of object is represented in the hoard – that is, silver cups – and one might expect a silversmith's stock to include a wider variety of object and possibly some silver in ingot form. However, a silversmith might keep his stock hidden (buried?) in several places to guard against total loss in the event of one hiding place being discovered. Furthermore, the deliberate damage to the silver would not be surprising if this were the hoard of a smith.

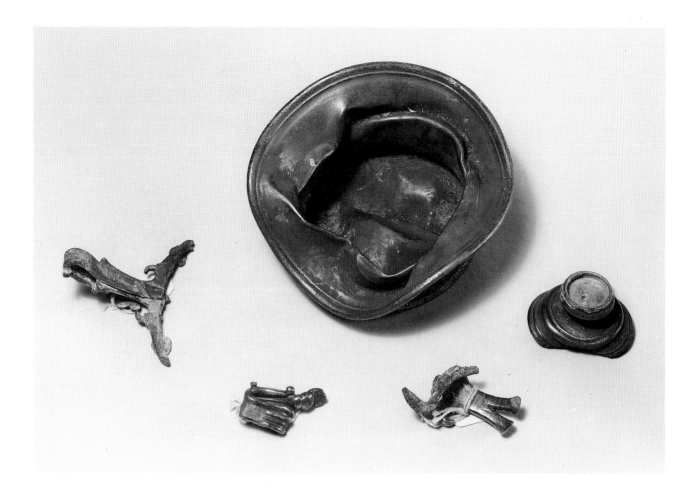

This last point also applies in the case of the third explanation – that the hoard is a votive deposit. It is well known that the Celtic peoples of Northern Europe frequently made offerings of metal objects to their gods, and that such objects were first ritually damaged so that they would not subsequently be recovered by unscrupulous fellow-devotees and put back into use. One particularly common practice was to make an offering of a sword which had been deliberately bent in one or two places. However, these ritual offerings were often made by throwing the objects into a river, lake or swamp, and there is no doubt that the Hockwold treasure was buried in a hole specially dug for the purpose. This might fit with Roman as opposed to Celtic practice if there was evidence of the burial having taken place within the precincts of a temple; however, this is not the case, although two Roman buildings and two temples are known to have existed within the general area of Hockwold. The ritual deposit theory can therefore be eliminated, although it is just possible that the treasure could have been temple bullion hidden for safe keeping by the priests rather than a personal offering by a devotee.

The deliberately damaged condition of the cups made it possible to dismiss a number of other explanations for their burial (discounting that of casual loss, which is clearly ruled out). First, could the cups have been hidden in time of trouble by a wealthy owner? The answer must of course be no, as he would not have damaged them first. A second possibility was that the treasure was an offering in a grave.

122 The bowl and pedestal foot of cup no. 2, with handles from other cups.

123 The bowl and pedestal foot of cup no. 3, with components from other cups.

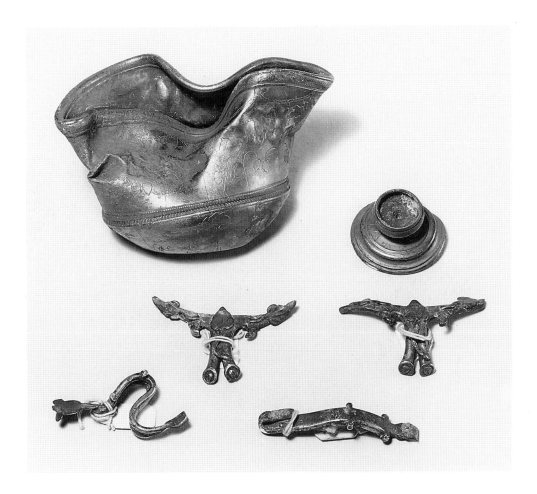

Such offerings are well documented, and the other two finds in England of Roman silver cups of the same period are both from the burials of Iron Age aristocrats. These burials, at Welwyn and Welwyn Garden City, were in fact cremations and contained only two and one comparable silver cups respectively, but they also contained numerous other grave goods. The absence both of other grave goods and of any skeletal material at Hockwold, combined with the deliberately damaged condition of the cups, virtually eliminates the possibility that the treasure was a grave offering.

The most likely explanations for the burial of the hoard therefore seem to be that it was either loot from a robbery or a silversmith's stock of silver for recycling. However, the possibility that it might have been bullion associated with a temple, as opposed to a silversmith, cannot be ruled out.

In deciding whether to restore the cups, it was necessary to weigh the benefits to scholarship of doing so against the loss of the appearance of the cups at the time of burial, bearing in mind that restoration is often an irreversible process and that if future generations of scholars question the shape of the vessels it will be impossible to return them to their condition 'as found'. Arguments in favour of restoration were that the presence of extra handles meant that the original content of the hoard was uncertain; that the crushed shape of the vessels prevented them from being fully studied and evaluated from an art-historical point of view; and that, from a

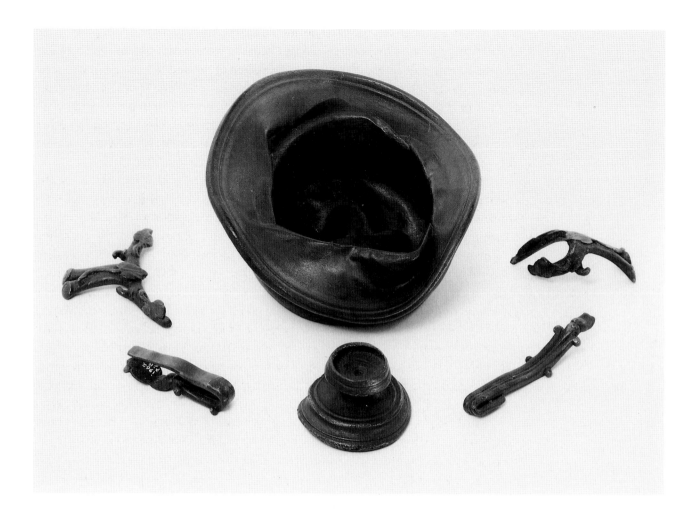

124 Electroformed
replica of cup no. 2, made
to record its condition
before restoration.

museum point of view, in their as-found state they were not very satisfactory exhibits. Arguments against were that the cups were buried in a deliberately damaged condition, and that restoration would involve heating them to a high temperature (annealing), which would irreversibly alter the metallurgical structure of the silver and slightly alter its composition. However, the first point could be dealt with by adequate photographic recording and the other two by a metallurgical examination of the silver before conservation and by chemical analysis of the metal.

The result of the deliberations was a decision to restore the cups to their original shape, but, in addition to the photographic record of the cups 'as found', replicas were made of the fragments of one of the cups. This cup (no. 2) consisted of a 124 complete but distorted bowl, an undistorted pedestal foot, and two handles each separated into two components (which partially explained the apparent existence of too many handles). All these pieces had been deformed to a greater or lesser degree. Replicas were made by the process known as electroforming (or, more commonly but less correctly, electrotyping). Moulds of the original fragments were made using a tough but flexible material called silicone rubber. This has a thick, creamy consistency when freshly mixed, but takes on a rubbery consistency when set. For technical reasons the moulds had to be made in several pieces. When the moulding was complete, the surfaces of the moulds were rubbed over with flake silver so that

they would conduct electricity. The moulds were then plated with copper in an electroplating tank. The resulting copper replicas were removed from the moulds, backed up with soft (tin/lead) solder to strengthen them, and trimmed to the correct shape by cutting away any excess metal with a piercing saw. The various components of each of the fragments were then soldered together and electroplated with silver to simulate the metal of the original. In this case the original object was black, rather than bright and shiny, as a result of corrosion during burial, so the replicas were also tarnished by treating them with a solution containing sulphide.

Once the photographic record was also complete, the way was clear for the restoration process to begin. First, however, it was essential to determine whether annealing and reshaping were feasible. This would depend on how deeply the corrosion had penetrated into the metal and on the composition of the corrosion products on the surface. Silver which has been shaped by working and annealing has a metallic structure consisting of microscopic grains. The boundaries between these minute grains, which look rather like the joins in crazy paving when viewed on a metallurgical microscope, are most susceptible to attack by corrosion during burial. When corrosion is slight, the corrosion products will penetrate only a short distance along the grain boundaries and the metal can be softened by annealing. When the corrosion is severe, however, it will penetrate along the grain boundaries from all surfaces until it meets in the centre of the object. In this case, the structure of the object will consist of a three-dimensional network of corrosion product containing islands of uncorroded silver (the remains of the original grains). In this condition it is impossible to soften silver by annealing. Another problem in trying to anneal extensively corroded silver is that the usual corrosion product on excavated silver is silver chloride, which melts at only 455°C, well below the usual annealing temperature for silver of about 650–700°C.

In the event, X-ray diffraction analysis of the corrosion product on the surface of the Hockwold silver showed, somewhat surprisingly, that it was silver sulphide rather than the more usual silver chloride. Numerous metallographic examinations showed that the handles and pedestals had suffered only very little penetration by intercrystalline corrosion (typically well below 0.1 mm but occasionally up to 0.15 mm), but that the bowls had been more deeply penetrated. Even the repoussé cup shown in Fig. 119, which was visibly in the worst condition and where the intercrystalline corrosion was extensive, retained some 'spring' in its metal. The conclusion was that it would be safe to anneal and reshape all the fragments, but that the greatest care should be taken with two of the bowls, which were very thin (these eventually proved to be inner and outer linings of the same cup, no. 1). As an extra precaution, a minute fragment of one of the thin bowls was slowly heated in a furnace to determine its melting point, which proved to be in the region of 925–950°C. This showed that annealing could be carried out with great care, ensuring that the temperature of the metal did not exceed about 900°C.

A start was made with the two plain bowls (cup no. 4 and what proved to be the inner skin of cup no. 1). They were heated to red heat using a gas/air flame from a blow torch, with the objects resting on furnace bricks on a soldering bench. Annealing is a skilled, but nerve-racking task which must be carried out in a darkened room so that the moment when the silver begins to glow red can be easily

125

seen. It is important to keep the flame moving so that every part of the metal is heated to the same degree of redness, and it is essential not to overheat any one area because of the danger of melting the fragile silver. This is a particular problem when the silver is very thin, as was the case with the lining of cup no. 1, but fortunately the colour of the glowing silver is a very good guide.

As soon as every part of the silver had reached the annealing temperature, it was allowed to cool somewhat and then plunged into a container of 10% sulphuric acid for one to two minutes. This softened and dissolved the corrosion products, as well as the copper oxide which had formed on the surface during heating as a result of the reaction of the small amount of copper in the silver with oxygen from the air. When cold, the silver was rinsed thoroughly and brushed with a soft brush and very fine pumice powder to remove the rest of the corrosion products and the copper oxide.

The silver now looked cleaner than when it came out of the ground, and was soft enough for the reshaping process to begin. Much of this could be done with the hands, but where tools were necessary they were made of materials which were softer than the silver: wood, leather and horn. Wooden and horn mallets, wooden stakes and leather cushions are used in reshaping so that the folds and creases in the metal can be eliminated without the silver being stretched. If undue force or metal tools are used, the metal may be distorted and the eventual shape may be slightly different from the 'original' one as a result.

Reshaping, then, is a painstaking and slow business of easing out the folds and creases bit by bit, so that the object begins to reshape itself. In the hands of an experienced conservator there is no question of getting the shape wrong, as there will be only one possible shape in which all the cracks just close up at the point when the folds and creases are finally eliminated. However, the process of reshaping also tends to harden the metal somewhat, and it was necessary to repeat the annealing process once or twice in order to ensure that the metal remained soft and that cracks did not form as the crushed silver was unfolded.

125 Metallographic cross-section through a fragment of cup no. 1, showing that the corrosion had penetrated below the surface of the metal.

An important point to remember in this process is that the surface of the metal may still retain evidence about the method of construction or the use to which an object was put. It is therefore essential to examine the surface carefully, both before and during the reshaping process. What the conservator is looking for, in particular, are tool marks, graffiti (especially craftsmen's assembly marks), evidence of wear, and patches of solder or rivet holes which indicate where other components were originally attached.

As work proceeded on the first two bowls it became obvious that one of them had originally had an attached foot and handles, but that the thinner one bore no evidence of either. It appeared to be an approximately hemispherical bowl with no signs that it had ever had a base which would allow it to stand upright – a rather important characteristic for a drinking vessel! This problem could not be solved until all the silver had been reshaped and cleaned and was ready for assembly, so another bowl was selected for treatment.

Three bowls remained – two thick ones which seemed to form a pair but whose shape was clearly not a simple hemisphere, and the second of the two thin bowls, badly damaged but with repoussé decoration. It was decided to leave this one to the last, and to proceed with the most substantial one of the pair (cup no. 3). This bowl was squashed in a vertical plane, and although it was covered in black corrosion products it was not too seriously creased. Treatment was carried out exactly as for the first two bowls: a thorough examination for tool marks and traces of solder, followed by heating to red heat in a darkened room, and finally immersion in dilute sulphuric acid. Again, some of the reshaping could be carried out by hand, but this bowl was thicker than the previous ones and more use had to be made of the tools. As the flattened bowl gradually opened out, the vessel again in effect reshaped itself, this time assuming a waisted form. Re-annealing was carried out frequently, and particular care was taken with the engraved decoration on the bowl and with the evidence for the position of the foot and handles. When the bowl was opened up sufficiently to allow access to the inside, the reshaping was concentrated on the bottom and then worked up the sides to the rim; when the form became symmetrical it was obvious that the original shape had been achieved.

The second of the pair of bowls (cup no. 2) was more seriously deformed, as it had clearly been deliberately crushed downwards while it was standing upright on its foot, as if somebody had stamped on it with a heavy boot. The mark of the top of the foot is clearly visible inside the bowl, and when the bowl was turned over, one of the pedestal feet was found to fit exactly into the folds of the squashed shape. The bowl was severely folded and creased, with cracks and small holes in the silver. The reshaping was carried out as described above, with the added complication in this case that the cracks in the silver had to be repaired as the work progressed. This was done by joining them with a commercial silver solder, using borax as a flux. Soldering was kept to a minimum, but was the only way of satisfactorily repairing the torn silver and of replacing loose fragments, as the metal was too thin to be joined with an adhesive.

The last bowl to be reshaped was the most fragmentary and the only one with relief decoration in repoussé work. The annealing was carried out successfully, but as the bowl was reshaped by gentle pressure with the hands, several cracks had to

126–30

131

be soldered, as with cup no. 2. This time it was necessary first to thoroughly clean the edges of the cracks with an airbrasive machine. This is a miniature sand-blaster, which directs onto the object a jet of mildly abrasive particles in a stream of compressed air, abrading away all traces of corrosion near the edges of the cracks. In order not to damage the silver, it is important to choose an airbrasive powder which is softer than the metal but harder than the corrosion layers. When the edges of the joins were clean, borax was applied as a flux and granules of solder were placed along the join. The silver was then heated with a large gas/air flame so that the whole object gradually reached the melting point of the solder. When this happened, the solder melted and flowed into the crack. The loose fragments of silver were rejoined to the bowl in the same way, and eventually the bowl was restored to its original shape. In this case, however, the bowl was not complete, and large holes remained where the original metal had completely corroded while in the ground. Nevertheless, sufficient metal remained to make it possible to see exactly where the pedestal foot had been soldered into position. Surprisingly, there was no similar 132 evidence for the attachment of handles.

When the restoration of this bowl was complete, it became clear why the other thin bowl, which had been restored first, bore no evidence of either handles or a base. These two bowls fitted together, one inside the other, forming a double-skinned bowl. This is a common method of making cups when repoussé decoration

126 The bowl of cup no. 3 before treatment.

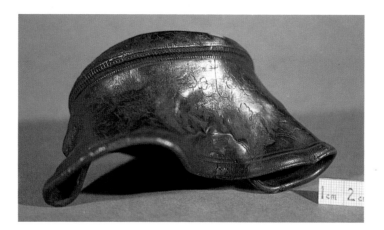

127 The same bowl after annealing.

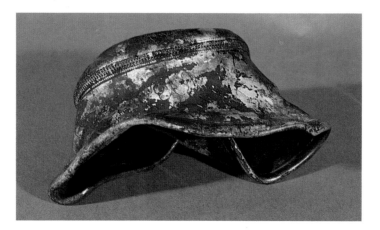

128 Bob Holmes working on the bowl of cup no. 3.

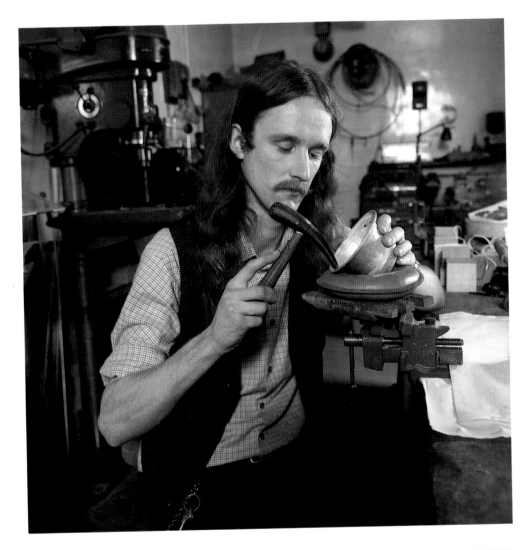

129 (*Below, left*) The restoration of the bowl of cup no. 3 nears completion.

130 (*Below, right*) The fully restored bowl of cup no. 3, ready to receive the pedestal foot and handles.

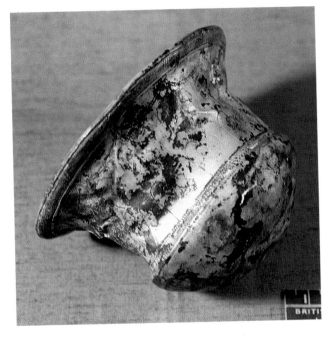

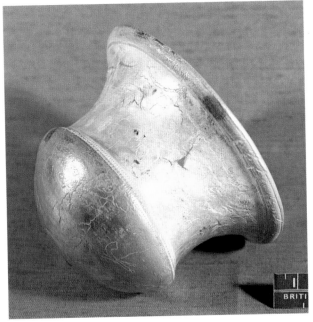

is involved, because the outer skin can be made of thinner silver, which is easier to work into the relief design, and the smooth inner bowl is easier to keep clean. The loose rim was then identified as part of this vessel, and when reshaped it was found to fit exactly to the lining and was accordingly soldered on to it. When the cup was originally constructed, the space between the outer bowl and its lining would have been filled with a suitable packing material which flowed when heated but set hard when cold. This would have prevented damage to the repoussé work if the cup were dropped or knocked. Examination of thin sheet-metal jewellery dating from the Roman period and earlier has revealed the use of pitch, sulphur and mixtures of sand and resin as packing materials behind repoussé work, but in this case there remained no trace of whatever had been used.

Thus far the restoration had resulted in four bowls, and the five pedestals and thirteen handles remained to be treated. When the 'handles' were examined, six of the fragments had pairs of marks on them, showing that they were actually component parts of only three rather elaborate handles, the marks indicating where they had originally been soldered together. Another handle, without marks, matched these three exactly, and these two pairs fitted perfectly on to the pair of waisted cups. Of the remaining six handles (three pairs), one fitted exactly on to cup no. 4, leaving two almost matching pairs, neither of which fitted on to cup no. 1. Combined with the fact that no trace of any patches of solder for handles had been found on the outer skin, this was further evidence that this elegant double-skinned vessel had had no handles.

The final task was to determine which of the bases belonged to which cup. The base of cup no. 2 had already been identified, so the one that matched it obviously belonged to the other waisted bowl (cup no. 3). Of the three remaining pedestal bases, the odd one clearly fitted on to the plain bowl (cup no. 4), leaving a pair of matching bases, one of which fitted the double-skinned bowl (cup no. 1).

Hence, when the reshaping was complete, the hoard could be seen to have consisted of four complete cups, three of which had originally been fitted with

131 The bowl of cup no. 2 before restoration, showing the pedestal foot resting in the depression made when the cup was squashed.

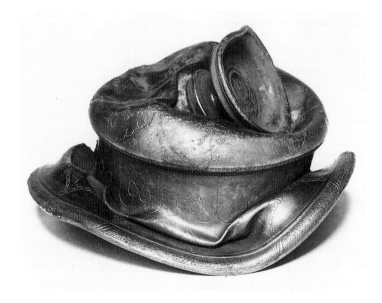

132 The outer skin of the bowl of cup no. 1, showing the position of the pedestal foot as indicated by the traces of the original solder.

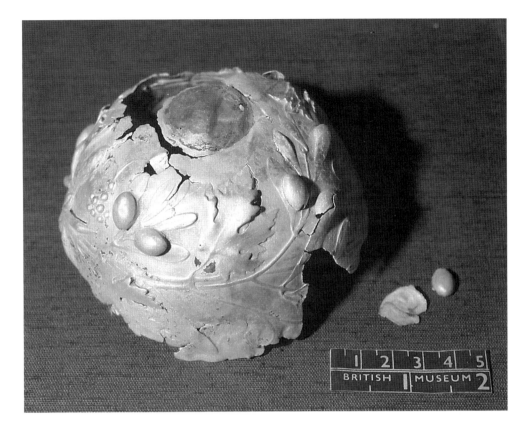

handles, two spare matching pairs of handles and one spare base which matched that on cup no. 1. As these early Roman drinking cups were usually made in pairs, it is possible to postulate that there must originally have been a pair to cup no. 1, of which only the pedestal foot has survived, and that there were two more matching cups, only the handles of which have survived. Finally, it can be suggested that there would have been a matching pair to cup no. 4, but that no parts of it have survived.

Once the components of each cup had been unequivocally identified, it only remained to polish the silver surfaces gently and to attach the handles and bases to the bowls. Annealing and reshaping leaves the silver looking very matt white in colour: it loses its typical shiny surface as a result of the oxidation and removal from the surface of part of the small amount of copper in the alloy. Something of the original shine was restored by polishing with a proprietary foam silver cleaner mixed with detergent. This was rubbed over the surface with a brush with glass fibre 'bristles', which are harder than normal bristles but softer than a wire brush.

Finally, the handles and bases were stuck in position, using a household epoxy adhesive for the bases and a heat- and waterproof cellulose nitrate adhesive for the handles. Adhesives were used rather than solder for two reasons. First, the remains of the original solder would not be contaminated with a new solder of a different composition, and second, the handles and bases would be easily removable if some-one in the future wanted to study the methods of construction of the cups in greater detail.

The complete restoration of the Hockwold treasure has thus resulted in the addition of four new cups to the known corpus of early Roman tableware, but it has

133

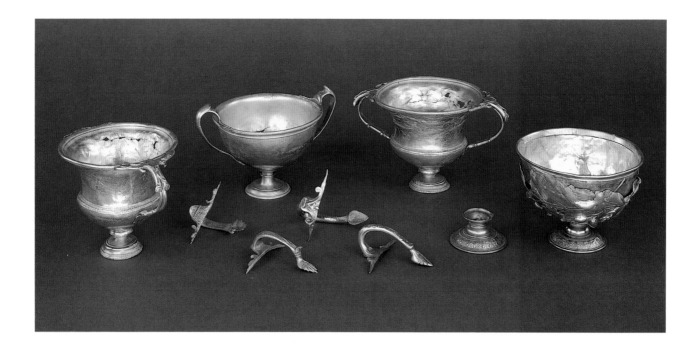

also raised a number of questions. Apart from the obvious one as to whether there were originally eight cups in the set, and, if so, what happened to the missing bits, the greatest enigma concerns the date at which they were made. Is it possible to situate them more precisely than the first century BC or AD? Unfortunately, these cups have very few parallels, none of which can be closely dated. It is known that Roman cups were imported into Britain before the conquest in AD 43, and it is also possible that the senior officers who commanded the army of the invasion would have brought similar luxury tableware in their baggage. Were the cups perhaps imported by some Celtic chieftain before the conquest, becoming part of the booty of inter-tribal warfare, or were they among the effects of a Roman general or government official, from whom they were stolen in the disturbances which accompanied the expansion of the frontiers of Roman Britain? The consensus of opinion points to an 'Augustan' style for the cups, but does this necessarily imply an Augustan date for their manufacture? Until similar silverware is discovered in a securely dated excavation, it is impossible to be more certain.

133 The Hockwold Treasure after restoration. From left: cups no. 3, 4, 2 and 1. British Museum.

Acknowledgements

The authors are very grateful to a succession of archaeometallurgists – Vera Bird, Tony Hartwell and Howard Cheetham – who worked on the Hockwold silver over the years, and to Kenneth Painter and Catherine Johns who, as the curators responsible for the treasure, requested that the restoration should be considered and then carried out. All photographs in this chapter are © The Trustees of the British Museum.

Further Reading

B. Green, 'The Hockwold Treasure, Norfolk', *Archaeological News Letter*, March 1962, p. 154.

C. Johns, 'The Roman silver cups from Hockwold, Norfolk', *Archaeologia* 108 (1986), pp. 2–13.

D. E. Strong, *Greek and Roman Gold and Silver Plate*, London 1966.

F. Baratte and K. Painter (eds), *Trésors d'Orfèvrerie*, exhibition catalogue, Paris 1989.

9 The 'Roman de la Rose' Tapestry

Norma Borg Clyde

The 'Roman de la Rose' tapestry, which depicts a scene from a well-known medieval poem of the same name, is a fifteenth-century textile, thought to have been woven in Tournai about 1460. It is considered to be a fine example of the period, and the skill of the weavers is evident, particularly in the faces and hands of the figures and the details of their dress. Before conservation in 1985–6 at the Textile Conservation Centre at Hampton Court Palace, the tapestry was in poor condition, having been extensively patched and repaired in the past, and was in need of cleaning.

Tapestry can be described as a weft-faced technique, in that the weft yarns completely cover the warp yarns; the presence of the warp yarns, however, is evident from tapestry's ribbed appearance. It is a plain weave, i.e. each weft yarn passes over one warp yarn and then under the next. However, the weft is not passed continuously from one selvedge to the other, as different colours are used to make up the design.

As a method of making patterned textiles, tapestry weaving has been used all over the world. One of the earliest known tapestries was discovered in an Egyptian tomb of about 1400 BC, and words for tapestry are found in both Greek and Latin literature. An early mention of tapestry weaving occurs in the *Metamorphoses* of Ovid (43 BC–AD 17 or 18), in the story of the competition between Minerva and Arachne.

The large pictorial hangings which are most commonly thought of when tapestry is mentioned began to be made in Europe by the fourteenth century at the latest. From this time, the production of tapestries increased steadily, centres of weaving being found in countries such as Belgium and France, where wealthy rulers provided patronage and where the wool trade flourished. From the point of view of quality, tapestry weaving was at its peak in the late fourteenth, fifteenth and early sixteenth centuries, when the designs reflected and exploited the techniques of weaving to the full.

Gradually, however, the pieces became more like paintings, with designs created by artists rather than by weavers. By the beginning of the nineteenth century many major workshops had stopped functioning. Large hangings became unfashionable, and the remaining workshops diversified into the manufacture of upholstery fabrics and other furnishings. A slow revival began in England with William Morris (1834–96) and at the workshops founded at Windsor in 1876. The French designer Jean Lurçat (1892–1965) was very influential in the present century, and gradually a number of tapestry weaving workshops have been reinstated and new ones set up.

The *Roman de la Rose*, the poem illustrated in this tapestry, is the work of two authors. It was begun in the first quarter of the thirteenth century by Guillaume de Lorris, about whom little is known. Probably born in Lorris near Orléans, of an aristocratic family, he is thought to have written the poem at the age of 25. As he

left it unfinished, he may have died young. Some forty or more years later it was taken up by Jean de Meun (Meung), who was born in the village of Meung-sur-Loire, also near Orléans, and whose surname was Chopinel or Clopinel. He attended the University of Paris, and his work suggests that he was a well-read intellectual. Much of his poetry, both in translation and in the original, still survives, including most of the *Roman de la Rose*.

Written in the form of an allegorical dream, Guillaume's poem tells of the quest for love, in the form of a rose: the narrator is both the dreamer and the lover, and the rose is his loved one. The lover wanders along the River of Life and comes upon a Garden of Delight, which is protected by a wall. The wall is decorated with paintings of the qualities which threaten courtly existence. Inside the garden an arrow from the bow of the God of Love strikes the poet, setting him off on his quest for the rose. The lover desires to pluck the rose but is hindered by various allegorical figures such as Danger, Shame, Jealousy and Fear. However, he is also helped by Bel Accueil (Fair Reception), Frankness, Pity and others. In the second and longer section of the poem, Jean de Meun introduces a more serious tone, alluding to the morals of the women of the day and the corruption of the Church, making a strong comment on the society of his time.

The tapestry is thought to depict the last scene of the poem. At the upper left we see a priest delivering a sermon. On the right is a tower under siege; Dieu d'Amour (the God of Love) and Venus draw their bows, directing their arrows at the tower. Various figures, such as Danger, defend the tower from within. The lover kneels between the pillars at the base of the tower and takes the rose. The tower appears to be a representation of a female figure, looking slightly shocked as the lover steals the rose, and the figure on the right holding a scroll is thought to be the poet. Reds, blues, browns, beiges and creams dominate the colour scheme, which is characteristic of fifteenth-century tapestries.

The design includes a considerable amount of text. Many of the figures are named, the scroll held by the poet contains a legible text, and running across the top of the whole scene are several stanzas of verse, one of which is incomplete. Many of the words are abbreviated, and this, added to some changes made by previous restorers of the tapestry, make transcription and translation of the text difficult. However a suggested translation is as follows:

After the priest had delivered a sermon on nature, the whole company/rout made its way thither in haste with skirts tucked up into belts, shouting, 'Let us attack without sparing ourselves! Let us win pardon and recompense!'. And Venus quickly seized the bow, with which she set fire to the fort. When the lover saw the walls begin to blaze and all the guards take to their heels, he came upon two pillars: he wanted to make his way towards these in order to make sure of satisfying his desire according to the good pleasure of Fair Welcome. On his knees he came before the arrow-slit, where he had his pleasure of the rose, for he plucked it without any difficulty.

The poet's scroll is thought to say:

Here the author brings his book to a close; the said author calling himself the lover, who relates the story in the form of a dream-vision so that no one may censure him too severely. And so when he had managed to pluck the bright red rose, he spoke these words, thus ending his account: 'All at once it was daybreak, and I awoke.'

The tapestry, which measures 414 cm high by 475 cm wide (13 ft 7½ in × 15 ft 7 in), is not complete, clearly having been cut on all four sides. However, most of the loss appears to have occurred on the left-hand side, where several feet may be missing. This is only conjecture, but it seems reasonable to suppose that the incomplete stanza of verse would have been approximately the same width as the two complete ones. There has probably been very little loss on the other three edges, as the design appears to be complete: the text comes to an end with the poet's epilogue on the scroll. A tapestry of this period would not have had a border.

The tapestry has a woollen warp, and a weft consisting mainly of wool but with a considerable amount of silk, used particularly in the highlights, and also some silver-gilt metal thread. On examination, the wool was in general found to be slightly brittle, but in good condition considering the age of the tapestry. The exception was the dark brown wool weft, which was more degraded than the rest, possibly as a result of the use of iron as a mordant in the dyeing process. The silk weft yarn was weak, and the metal threads were tarnished, appearing grey in places. The whole piece was soiled with dust, both ingrained and on the surface. It was fully lined on the back with linen: this lining was also soiled and dusty.

The tapestry had been extensively repaired in the past, at several different times, resulting in many areas of weakness. One of these was the dark brown wool weft already referred to. Some of these dark brown areas had been repaired by simply cutting away both warp and weft from the weak areas, making clean, sharply cut holes into which brown wool tapestry-woven patches were inserted. These patches were visually quite acceptable but were themselves now degraded and very poorly secured, giving inadequate support. The insertion of these particular repairs had involved the loss of some of the original weave; more of the weave was now being lost as tension at the joins of these patches pulled weft yarns off the warp. There were also several large holes where both warp and weft were missing, and around the edges of these the fibres were brittle and yellowing. These areas, and some of the weak areas at the edges of the tapestry, had been supported on patches made from a great variety of materials, including loop pile carpet, double cloth, triple cloth, fulled wool, plain weave fabrics, and patterned weaves in wool and linen. The rose itself is an appliquéd patch of a later date: from the reverse it appears that the
135, 136 original may have been a rosebud, rather than a full-grown flower head as now.

Some, but not all, of these repairs were visually quite effective. However, they were causing physical stress to the tapestry's structure in various ways: some patches gave support to the larger holes, but many were too thick and were attached in such a way that they only added to the stress on the fibres and in some places were causing pulling and puckering. An unsightly thick brown thread had also been woven into large areas of the piece. The colour was inappropriate; it looked dead and flat.
137 Looking at the reverse of the tapestry, it was obvious that this thread had never matched the original. The yarn was too thick and was not always woven at the correct tension or sometimes even in the correct technique. This too was therefore causing much distortion and stress in the weave structure.

As a result of these previous interventions, the design was marred, so that it did not read as clearly as it should have, and the tapestry was still weak and in need of support. It is not known when these various repairs were carried out: it might have

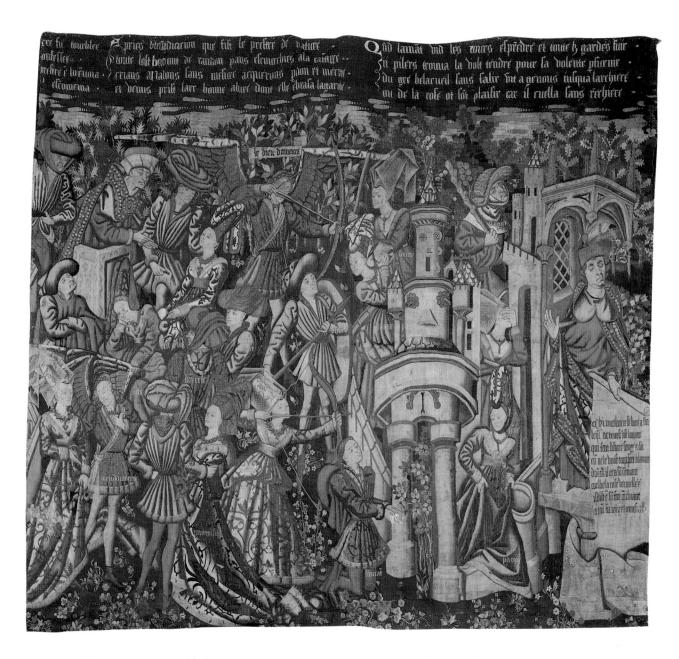

been possible to date them if there had been more documentary evidence relating to the history of the tapestry and its past owners. Dye analysis of the repair threads and fabrics might also have given some indications. However, such an investigation fell outside the brief for this project.

Traditionally tapestries needing repair were rewoven, often at the same workshop where they were made. This work, done by skilled weavers, was often visually successful, if historically confusing. However, when tapestry went out of fashion and the manufactories closed down, the technique of tapestry weaving was less widely practised. Tapestries were therefore often repaired by people who did not understand how they were constructed. Such an understanding is clearly a vital part of the training of any conservator, who also needs to know how the environment affects textiles and who must be familiar with the chemical structure of fibres and

134 The 'Roman de la Rose' tapestry before conservation. Probably woven in Tournai (Belgium), c.1460. 414 × 475 cm. Private Collection.

135, 136 (*Above, left*) Detail of the rose, an appliquéd patch of a later date. (*Above, right*) Detail of the rose seen from the reverse side, indicating that it was originally much smaller.

137 (*Right*) The head of Danger, from the reverse. The heavily applied repair yarn is clearly visible, and was probably never correctly colour-matched to the original.

dyes as well as the history of tapestry and the changing fashions which influenced its design and use.

To explain the conservators' approach to the treatment of this piece, it may be useful to clarify the difference between conservation and restoration in this context. Conservation seeks to preserve a piece in its present state, providing favourable conditions for its long-term survival. The aim is to use a minimum of new materials and to disturb the piece as little as possible. Restoration, on the other hand, seeks to return an object as far as possible to its original state. In the case of tapestries this can be very disruptive to the structure and to the original material, and sometimes very confusing historically as well as visually. When conserving a tapestry, therefore, it is sometimes appropriate to give it support but not to try to reconstruct any of the design. Generally, however, in order for the tapestry to continue to fulfil its function as a pictorial piece, the flow of the design should appear uninterrupted to the eye of the viewer. How this is achieved depends on the particular tapestry, its age and design, its strength and the wishes of the client. In this particular project different solutions were used in different areas.

The tapestry was fully photographed and documented and then cleaned. It was decided to remove as much of the soiling as possible, both because it was unsightly and because it could affect the long-term preservation of the tapestry. The soiling was probably acidic and might therefore help to accelerate the progress of degradation. The treatment began with the removal of the lining. Both sides of the tapestry were then carefully surface-cleaned using low-power vacuum suction, protecting the tapestry where it was weak with a monofilament screening.

The next step was to wet-clean the tapestry, but before it could be immersed in water every precaution had to be taken to ensure there would be no damage. Tests were therefore carried out to show how the tapestry would react to the proposed treatment. Samples of all original and repair weft yarns were taken from the reverse of the piece. Enough of each sample was taken so that each dye could be tested separately in various solutions. The first was the proposed detergent, which is neutral in pH; this was followed by both alkaline and acidic solutions and deionised water.

Since the tapestry would be wet for some time, the samples were left in the test solutions for several hours. The tests indicated that the dyes were wash-fast, and it was therefore decided to proceed with wet-cleaning. The weak areas of the tapestry were supported during the wet-cleaning process by temporary patches of nylon net. Some of the thicker repair patches were removed in case they hindered the washing or drying of the tapestry in those areas.

When wet-cleaning a large textile it is usual to lay the piece out flat. However, owing to the size of this tapestry, it was necessary to devise a slightly different approach. The tapestry was loaded onto two rollers, which were then placed on a long narrow washing surface fitted with a funnel at one end to allow the water to drain away. The tapestry was wetted and allowed to soak in some of the wash solution until the fibres were saturated. It was then washed section by section with a gentle up-and-down sponging action, with no scrubbing or sideways movement. Softened water was used, with a wash solution consisting of a non-ionic surface active agent with a neutral pH and no additives; a soil-suspending agent was added to prevent the redeposition of dirt particles on the tapestry.

Both sides of the tapestry were washed in this way. Afterwards the detergent was removed by gently rinsing the tapestry in softened water. A final rinse in deionised water followed. Excess water was then blotted out of the tapestry with absorbent cloths. Finally the tapestry was laid out flat to dry. After cleaning, it was less brittle.

When the tapestry was first soaked, three things began to happen. A strong brown colour was released into the water, a deep red colour also flooded out, and a very strong, pungent smell was given off. It was thought that the brown was some kind of soiling, both on account of its colour and because a very slight musty smell was noticed. Moreover, it did not appear to be related to any particular area or colour in the tapestry. The red coloration of the wash water was more surprising, as all the tests had shown the dyes to be wash-fast. After wet-cleaning no bleeding of colour from one area to another could be detected. However, the thicker yarn profusely woven into the piece during a previous restoration appeared to have changed from a strong rust-brown colour to a greenish rust-brown, and this may have been the source of the red colour in the water.

The pungent smell continued to be released into the atmosphere throughout the wet-cleaning process – so much so that the two conservators washing the tapestry had to don fume-absorbent masks and gloves. Once the tapestry was dry, the smell was no longer noticeable. In order to discover the source of the fumes, which might have been caused by a toxic chemical which could be harmful to the conservators either through skin contact or inhalation of fibres, some of the thicker patches which had been removed before wet-cleaning were tested. It emerged that the substance was naphthalene and that although a very high level had been present in the tapestry most of it had been washed out during cleaning. Naphthalene is known to have been sprayed on to furnishing textiles in the past, and it was often placed inside storage rollers in the form of small packets containing moth balls. However, there are no records to indicate how this particular tapestry became contaminated with such high concentrations of the chemical.

Once the cleaning was complete, the support work could begin. New materials used in tapestry conservation include wool weft in various thicknesses depending on the fineness or coarseness of the weave. This often has to be dyed by hand, as it is difficult to find ready-dyed wools of suitable quality and in a wide range of colours. Wool is also used for rewarping: in this case the yarn is thicker and must also be dyed before use. In the silk areas a stranded cotton yarn is used. Cotton is chosen for several reasons: it is difficult to find a supply of silk of the right texture and in a good range of colours; also the lustre of the new silk often prevents it from blending well with the old silk weft. Stranded cottons are readily available in a wide range of colours and are reasonably priced. They also have a longer life than silk yarns. A stronger thread, such as linen or polyester of a suitable gauge, can be used to resew the woven slits that occur in tapestries at the joins between two colours. While aiming to be unobtrusive, the repaired areas need to be identifiable on the reverse of the tapestry, and this is one of the reasons for working on to a support fabric. This is usually a linen scrim which has been washed in order to preshrink it and to remove any dressings applied during the manufacturing process.

At the Textile Conservation Centre most of the support work is done using a stitching technique attaching the tapestry to the support fabric. Whether the support

142–3 (*Above, left*) Before conservation: a hole patched with a complex weave. (*Above, right*) After conservation: the patch has been removed and the design visually completed by the insertion of three dyed patches of wool fabric.

144 (*Right*) After conservation: a large patch has been removed, the area rewarped and conservation stitching completed. The design continues across the conserved area.

138–41 (*Opposite, top left*) A large hole patched with a piece of loop pile carpet, before conservation. (*Top right*) Conservation in progress: the carpet patch has been removed, and the linen support fabric can be seen underneath. (*Bottom left*) After attaching a patch of linen fabric between the support fabric and the tapestry to act as a secondary support, new woollen warps are threaded across the hole. (*Bottom right*) Conservation stitching reinforces the weak area and visually completes the design.

runs the full extent of the reverse of the tapestry – full support – or only in localised areas – patch support – depends on the condition of the piece. The stitching technique most commonly used is often referred to as 'couching', an embroidery term, and in many cases involves stitching a series of bare warps on to the support fabric. This technique, which is used when the weft is missing, seeks to simulate the weave of the tapestry by stitching over one warp, under the next and over the third in one direction, then catching the alternate ones when coming back. Where a warp is broken or missing, a new warp thread is inserted to bridge the distance between the broken ends. 138–41

A piece of this size has to be mounted on to a frame and worked on section by section. If it is to have a full support, a three-roller frame is required. One side 145 edge of the tapestry is attached to an outer roller and most of the tapestry rolled on. The prepared support fabric is attached and rolled on to a roller in the middle of the frame, and the free edge is attached to the second outer roller. The free edge of the tapestry is brought over the middle roller holding the support fabric and laid on to the linen. The linen support must be attached on grain to the tapestry, i.e. the warp and weft of each must run parallel and not askew, otherwise distortion may occur. Therefore the support must be carefully applied. This is achieved by attaching the support to the tapestry gradually, with lines of running stitch along the full height of the piece and approximately 25 cm (10 in) apart. This also helps to control the inclusion of a slight excess of linen to tapestry in each section. This excess is included across the width of the tapestry, to allow for the stitching taking up some of the fabric, but not in height, so that the weight of the tapestry is supported while hanging. The support is attached in sections: when conservation stitching is complete in one section, the next is measured, and so on.

One of the problems with this particular tapestry was the number and variety of previous repairs. When planning how to deal with these, it was necessary to consider a number of questions. How extensive were the repairs? Were they so integrated into the piece that to remove them would not only leave a mammoth task ahead in terms of conservation stitching, but would be very destructive for the tapestry as a whole? How much of an improvement would a new repair be? How much distortion were the repairs causing? Were they pulling and puckering? How visually disruptive were they? Were they now an integral part of the history of the piece?

Because of the generally weak condition of the tapestry, it was decided to give it a full support. As all the edges were cut and not absolutely straight, pieces of suitably dyed woollen fabric were inserted along the starting edge to allow a straighter edge to be made on completion. All four edges were treated in a similar way. In areas where particularly large patches had been removed, leaving large holes, it was necessary to insert a supplementary linen patch between the tapestry and the full support. This linen was more closely woven and was attached with no excess, in order to maintain the tension of the tapestry. Once this was in place, the broken and missing warps were replaced by individually threading new warps across the gap. The new warps, even without the weft in place, began to bring the tension back into this area. These new warps were then couched onto the backing.

Often there is enough evidence within a tapestry, and sometimes documentary evidence as well, to show how the design continued in missing areas. Where this

145 The tapestry mounted on a three-roller frame during conservation. The roller farthest from the conservator holds untreated tapestry, and that closest to the conservator the conserved work; the middle roller carries the linen support.

144

142, 143

was the case in this particular tapestry, it was possible to indicate the missing design by varying the colours of the couching threads as appropriate. In other areas, where a large hole occurred in an area of solid colour rather than intricate pattern, a different approach was taken. Suitably dyed woollen fabric was inserted and stitched into place, in the same way as at the edge. This was found to be visually more successful than rewarping and couching in these areas, while still providing the necessary support and allowing the design to be read from a distance.

Where areas had large patches, the decision whether or not to remove the previous repairs was not difficult. However, in other areas of the tapestry there was much debate over whether or not to remove smaller repairs. In particular, it was often difficult to decide how much of the thick yarn to remove. Where it was pulling the warp and weft out of alignment, removal was necessary, but in places where it was woven at the correct tension and was solidly part of the tapestry it was impossible to remove it without disfiguring the piece further and disturbing much of the remaining original weave in the adjacent areas. However, there were many areas that fell somewhere between the two extremes, and a continuous decision-making process therefore went on throughout the conservation work.

Other areas of weakness included the tapestry-woven patches which had been inserted. Despite their own weakened state, it was decided to leave them in place, couching them onto the support as normal and making the joins secure.

The conservation stitching occupied three people for almost eighteen months. When this part of the work was completed and checked, the piece was further fully lined with a pre-washed cotton twill fabric, to act as a protection against dust and as a buffer against the wall on which it would eventually hang. The lining was sewn on while the tapestry was still on the frame, by simply exchanging the position of the two outer rollers so that the tapestry faced downwards. It was attached to the

146 Detail of the lover plucking the rose, after conservation.

middle roller and gradually unrolled and stitched to the reverse of the tapestry, using locking stitches so that the weight of the tapestry would not pull the stitching across the face. Once the grid was complete, the tapestry was removed from the frame and laid out flat so that all the edges could be sewn. At this point the dyed woollen patches inserted earlier along the cut raw edges were turned under so as to make the side edges perpendicular to the top and bottom. A small slip stitch was used to enclose the edges and protect them from dust.

Finally, before being returned to its owner, the tapestry was allowed to hang for a while to give time for any possible problems to come to light and any adjustments to be made. It looked far cleaner, was strong enough to hang on display, and the design now appeared to flow more evenly.

Acknowledgements

The author would like to thank the staff of the Textile Conservation Centre, in particular Caroline Clark and Dinah Eastop, for their encouragement and help. The conservators who worked on the project were Anne Amos, Kerstin Aronsson, Sandra Bottle, Caroline Clark, Tessa Evans and Su Haywood-Munn. While the project was under way many people kindly showed interest and gave advice, in particular Vincent Daniels and David Baynes-Cope. Thanks are also due to Peter Ainsworth for translating the text of the tapestry. The photographs are © the Textile Conservation Centre, with the exception of Fig. 134, reproduced courtesy of Sotheby's.

Further Reading

H. Göbel, *Wandteppiche*, vol. 1, Leipzig 1923.

G. Wingfield Digby, assisted by W. Hefford, *The Devonshire Hunting Tapestries*, published for the Victoria and Albert Museum by HMSO, London 1971.

G. Wingfield Digby, *The Tapestry Collection – Medieval and Renaissance*, published for the Victoria and Albert Museum by HMSO, London 1980.

10 The Sophilos Vase

Penelope Fisher

147 In 1971 the British Museum acquired an extremely important and beautiful Athenian black-figured *dinos* (wine bowl) and stand dating from about 580 BC. Signed by the painter Sophilos, the bowl and stand are together commonly known as the Sophilos Vase. Sophilos is well known for his vases decorated with animals, but only four signed examples survive and this is by far the most complete. The bowl and stand together measure an imposing 71 cm (approx. 28 in) tall, and the bowl is nearly 42 cm (16½ in) in diameter at its widest point.

The lower three friezes of the bowl and four of the stand are decorated with a total of fifty-two animals and fantastic monsters: lions, panthers, boars, stags, rams, goats, water-fowl and sirens (woman-headed birds). The uppermost frieze portrays the arrival of the divine guests at the wedding feast of Peleus and Thetis, the parents of Achilles. The frieze starts and finishes at the house of the newly wedded couple,

150 where Peleus stands waiting to greet his guests, who form a long procession in front of him. The deities, each with their name inscribed, include Iris, Dionysos, Zeus and Hera, Poseidon, Aphrodite and Apollo, and form a veritable 'Who's Who' of Greek mythology. Between two columns of the house, immediately behind Peleus, is the artist's signature: *Sophilos:megrapsen* ('Sophilos painted me'). The figures and animals are painted in a lustrous black gloss on a terracotta background, with details highlighted in deep red and white and with incised lines. The flat surface of the rim is decorated with a double lotus and palmette chain (repeated on the stand), while the bottom of the bowl is covered with a whirligig design, although this cannot be seen when the bowl is on the stand.

When the Vase was acquired by the British Museum it was already in a restored state. It had been assembled from many fragments, and only a few areas were missing. The surface of the Vase was in remarkably good condition, and the restoration looked recent. However, soon after its acquisition the curator noticed that because the Vase had been allowed to get out of shape during reconstruction, there

148 were several gaps between fragments that should have joined; in particular, there was a gap through the signature, causing it to read *Sophilos:megrapse n*. The Conservation Department was asked to take out the misplaced piece and move it downwards, so that the signature would read correctly. This was done by applying a poultice of paper pulp mixed with methylene chloride, a strong solvent used in paint-stripper, around the edges of the sherd to be moved. When the poultice had softened some of the resin surrounding the sherd, the resin was scraped away and another poultice applied. This painstaking process was repeated over and over again until the sherd was loosened and could be extracted. After cleaning any remaining adhesive from

149 the sherd and the surrounding pieces, the sherd was replaced lower down.

151 In 1978 the Museum acquired five more fragments belonging to the Vase. Three

147 The Sophilos Vase
before conservation.
Made in Athens,
*c.*580 BC. H. 71 cm.
British Museum.

of these had formed part of the collection of the J. Paul Getty Museum in California for some time, while the other two were purchased on the open market. Dr Jiri Frel, then a curator at the Getty Museum, recognised that all five fragments belonged to the British Museum vase. The Getty Museum initially loaned the fragments to the British Museum, but has since made a permanent gift of them. The fragments all featured important areas of the decoration. The three original Getty fragments consisted of a piece of decorated rim, a fragment of drapery, and a piece (in reality, two pieces joined together) with the body and legs of the figure of Iris as well as part of the garment of Peleus himself. The larger of the other two fragments shows the rear of the chariot driven by Poseidon and the front legs of Aphrodite's horses, whilst the smaller fragment portrays the heads of three *horai* (goddesses of the three

148, 149 The artist's signature before and after the misplaced fragment was moved in 1971.

150 Peripheral view of the Vase, showing the arrival of the divine guests at the wedding of Peleus and Thetis and a frieze of animals.

seasons, possibly indicating growth, flowering and ripening of vegetation) walking beside a chariot driven by Athena. It was obviously desirable that all five fragments should be incorporated into the Vase, and so it was returned to the Conservation Department for a second time.

Seven years had passed since the signature fragment had been moved and the conservator who had worked on the Vase had left the Museum, so it was not possible to discuss any of the difficulties that might be encountered when inserting the new fragments. After detailed examination of the Vase it was realised that the material which had been used in the original 'commercial' restoration before 1971 was in fact totally unsuited to the conservation of Greek pottery. It appeared to be very hard and brittle, and was shown by scientific analysis to be a polyester resin. This had been used both as an adhesive to stick the sherds together and as a gap filler.

Finding the positions of the new fragments was easy, but removing the resin which filled the gaps was much more difficult. The rim piece was the easiest to deal with, so that was tackled first. The position of the piece was marked on the filled area, and a saw cut made with a very fine piercing saw down to about 2 mm ($\frac{1}{16}$ in) from the pottery edge. The vibration from the saw was in fact enough to release the piece of resin infill. This showed that the polyester fill had not bonded to the pottery as strongly as the adhesive between the sherds. The other filled areas, which were totally enclosed and so harder to get at, were scored around with a sharp blade. Owing to the brittleness of the resin it was then possible to remove the infill with a sharp blow from a hammer and chisel. Despite its success, this was an unnerving experience for those involved. No solvents were used, as it was thought they might weaken the surrounding restoration and consequently the whole Vase. Once the filling resin had been removed it was relatively easy to glue the new fragments into place with a cellulose nitrate adhesive, which could be easily softened for adjustment, or for the fragment to be removed at a later date, by the application of acetone as a solvent. The gaps around the fragments were filled with plaster of Paris for a perfect finish, and the plaster painted to tone in with the earlier restoration.

In April 1983 the Vase was returned to Conservation yet again. The gallery in which the Vase was displayed was due for refurbishment, and this was seen as an ideal opportunity to correct all the inaccuracies in the current restoration and to replace the unsuitable polyester resin which had been used. It was therefore decided to dismantle the Vase and reconstruct it again completely.

The polyester resin had been used in a liquid form for sticking the sherds together, but thickened with an inert bulking agent to form the infill. The resin had also been coloured to match the body of the Vase by the addition of pigment. The infill therefore resembled the original fabric too closely from an ethical point of view, as this could lead to confusion between the restored areas and the original pottery. Furthermore, because the resin was so strong, as it began to age and shrink it had placed so much stress on the Vase that new cracks had started to appear. This was most apparent on the base of the stand. The thinner resin used for sticking the fragments together had also penetrated the porous pottery. It would therefore be very difficult to dismantle the Vase, and it was imperative that this be done without causing any further damage to the original fragments.

Where the resin had been thickened and used to fill the missing areas, however, it had not been able to penetrate the pottery. For this reason it was decided to remove the infilled areas first. A small hole was carefully drilled through the resin, taking care not to drill through any pottery that might be projecting into it. A very fine piercing saw was passed through the hole, and the resin infill was carefully sawn around, keeping about 3 mm (approx. $\frac{1}{8}$ in) from the pottery edge. Once most of the resin had been removed, it was possible to extract the remaining slivers of infill with small square-ended pliers. The resin came away from the pottery very easily and cleanly, so all the filled areas were removed in this way. Although it was now full of holes, the Vase remained intact.

Undoing the joins was much more difficult, owing to the very strong grip of the thinner adhesive resin. The Vase was immersed in a bath of tap-water and left to soak, in the hope of thoroughly saturating the pottery and weakening the joins. The

151 The five new sherds acquired in 1978.

water was changed every day, and after four weeks the resin seemed to be relaxing its grip. At this point the water bath was exchanged for a bath of the organic solvent acetone. The acetone would not dissolve the resin but would soften it so that it would eventually break up into small pieces. The bath itself was a polythene container which exactly fitted the Vase, giving the sides some support. After a short while the joins began to give way, and the Vase was dismantled piece by piece. Because the solvent broke up the adhesive rather than dissolving it, the pieces had to be gently pulled away one by one. The advantage of this method was that the Vase did not collapse under its own weight.

The edges of each piece were then brushed to remove the softened resin. However, even after this treatment, minute traces of resin remained. Any traces of old adhesive would result in distortion when the time came to stick the pieces together again, and with so many pieces that distortion could be magnified many times. The pieces were therefore put through a third and final cleaning process using a water-washable paint remover containing a strong solvent dispersed in a thixotropic gel. This was painted along the edges of the sherds. The sherds were then wrapped

152 Detail of the base of the stand, showing the new cracks which had begun to appear as a result of stress caused by the shrinkage of the old resin.

153 The fragments of
the Vase laid out before
reconstruction.

153

in aluminium (cooking) foil to prevent the solvent from evaporating and left until
the paint remover had softened and swelled the remaining traces of adhesive, which
were then picked out with a sharp scalpel. After a final rinsing the fragments were
laid out to dry.

By September 1983 the 118 fragments were ready to be reassembled. They were
laid out on a large table, with the rim pieces in the centre and all the other pieces
arranged according to their respective friezes. As detailed photographs had been
taken before the Vase was dismantled, it was not difficult to locate even very small
pieces. Even without the photographs, the type of pattern and the thickness and
colour of each piece would have been good clues to its position.

Initially the bowl was assembled by working from the base upwards, starting with
a large fragment of the whirligig pattern, to which one piece was added at a time.
As the pieces were being joined it was noticed that the edges of many of the
fragments in the lower half of the bowl had been filed down, presumably during the
first complete restoration before the Vase was acquired by the British Museum.
This was not an uncommon practice in the past, when restorers were less scrupulous

and had less sophisticated adhesives than those available to modern conservators. Two of the most popular adhesives used in the last century were animal glue and shellac, both of which are thick, sticky, brown liquids. If a vase was broken into many fragments, by the time the edges of each piece had acquired a coating of glue the pot could end up significantly larger than it was originally. The restorer might also find he could not fit all the pieces into the 'jigsaw puzzle'. One way of solving these problems was to file away the edges of the sherds to make room for the glue! In the case of the Sophilos Vase the result of this filing was that when the pieces from the upper part of the bowl came to be fitted into position, there was not enough room to accommodate them. There was no alternative but to dismantle the joins and start all over again.

This time the rim pieces were joined together first. The adhesive, a cellulose nitrate, was thinly applied along one edge of the pieces to be joined. The two pieces were carefully aligned, and held in place by strips of masking tape at right angles to the join, on both back and front. Masking tape was used because it will stretch slightly and so keep the pieces under tension. It is also easy to remove, by applying a little industrial methylated spirits. Once the adhesive had started to set, after about half an hour, more pieces could be added, and the Vase once more began to take shape. As the pieces from the lower half of the bowl were added to the upper half, the gaps left by the filed edges were spread over the whole area. Once these gaps were filled and painted, they would be less noticeable.

Eventually the bowl was back in one piece. However, the missing areas still had to be replaced. It was decided to fill these with plaster of Paris, which is light yet

154 (*Left*) A missing area being filled with plaster, showing the support made from dental wax.

155 (*Opposite*) The restored areas were retouched using bleached shellac and fine-ground dry artist's pigments.

strong – but not too strong. It is also very easy to work with and gives an excellent finish, and has been used with great success by several generations of museum conservators to restore pottery.

The first step was to make a support for the plaster out of sheets of pink dental wax. A piece of wax large enough to cover the hole was cut out and held under hot running water. This softened the wax enough to allow it to be pressed against an undamaged area of the Vase with the same profile as the missing piece. As the wax cooled, it hardened again but retained the shape of the Vase. It was then eased away, taking care not to distort its shape, and fastened in position with masking tape behind the area to be filled. Where it was not a perfect fit, minor adjustments could be made with a miniature hot air blower. Once a good seal had been achieved, the void was filled with plaster of Paris.

A useful characteristic of plaster is that it goes through several consistencies as it sets. Runny at first, it gradually becomes thicker until it reaches a 'cheesy' stage, when it is very easy to shape. All these stages were useful when filling the missing areas. Runny plaster was first applied to all the broken edges of the hole, to ensure that good contact was made between the fill and the pottery edge. As the plaster 154 thickened, the void was filled in until the cheesy stage was reached, at which point more detailed shaping was carried out with a metal spatula. When the plaster had just set, the shape was refined with a sharp scalpel, and any excess plaster which had spilled on to the surface of the Vase was easily removed.

All the voids were filled in this manner. When the plaster had dried completely, it was rubbed down to a very smooth finish using increasingly fine grades of garnet paper. These had to be used with great care in order to avoid damaging the fragile surface of the Vase. The paper was cut into small pieces about 2 cm (¾ in) square, and was then rolled up to give a small, easily controllable sanding area. Once the plaster fills had been smoothed to the correct shape and polished with a very fine paper, they were sealed with several coats of white shellac. Tiny air holes and imperfections remaining in the plaster surface were filled with Fine Surface Polyfilla, which was also used in the fine cracks between the joins. The plaster areas were now ready for retouching.

It was very important that the restored areas should be easily identifiable, even in photographs: perhaps another scholar on the other side of the world may one day recognise more of the missing fragments. In the previous restoration, areas of black-figure painting had been completed and inscribed lines continued, making it difficult to distinguish the restored areas from the original surface. This time the missing areas were painted a plain terracotta colour, but for the sake of continuity 155 of pattern the colours were filled in across the cracks between sherds. This allows the viewer to appreciate the beautiful design of the Vase and yet see exactly which pieces are original.

The medium used in the retouching was the same bleached shellac which had served as a sealant. This has been used in the restoration of Greek vases for over 100 years and has not yet been surpassed by a modern material. The shellac is mixed with finely ground artists' pigments, using industrial alcohol as a thinner and brush-cleaner.

Greek vases were made from a high-quality Attic clay which gives a rich terracotta

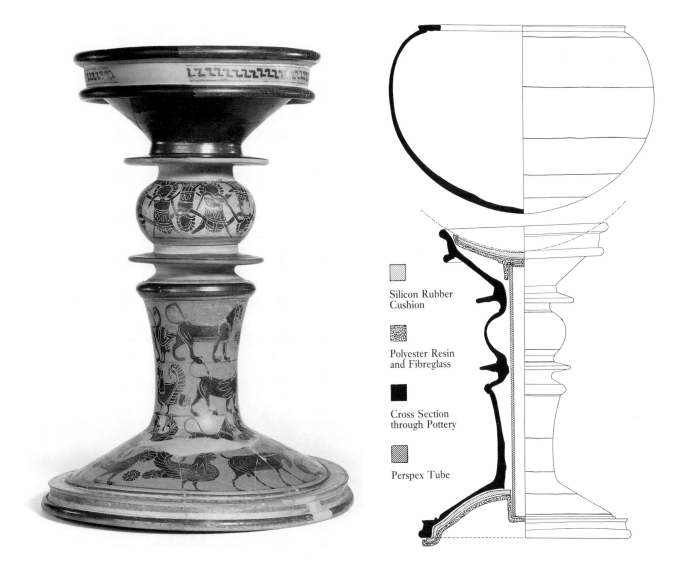

Silicon Rubber
Cushion

Polyester Resin
and Fibreglass

Cross Section
through Pottery

Perspex Tube

156 (*Left*) The stand before conservation, showing the warped base.

157 (*Right*) Drawing showing the profile of the bowl and stand with the mount in position.

colour when fired. When leather-hard, the surface of the clay was first burnished with a rounded agate pebble, or possibly a piece of bone or hard wood. It was then given a very thin wash of ochre to enhance the natural terracotta colour of the clay. The vase was again burnished and the black decoration applied to the polished surface. Any further colours, such as white and red, were added last of all. The palette available to the Greek potters was fairly limited, consisting mainly of white, yellow, red, pink, grey and black. These colours were mostly derived from the same clay that formed the body of the vase, with the addition of various oxides. Occasionally the range was increased by the use of additional colours which were not fired on, although these are mainly found on vases with a white ground or slip, such as *lekythoi*, used to store oils and perfumes. These were fairly fugitive mineral or vegetable colours painted on to the white ground after firing. They included shades of blue, green, yellow, pink, purple and matt black. They have by now usually completely faded, rubbed off or leached away during burial. Gold leaf is also found on some vases.

When restoring the cracks between the sherds on black-figure vases, it is impor-

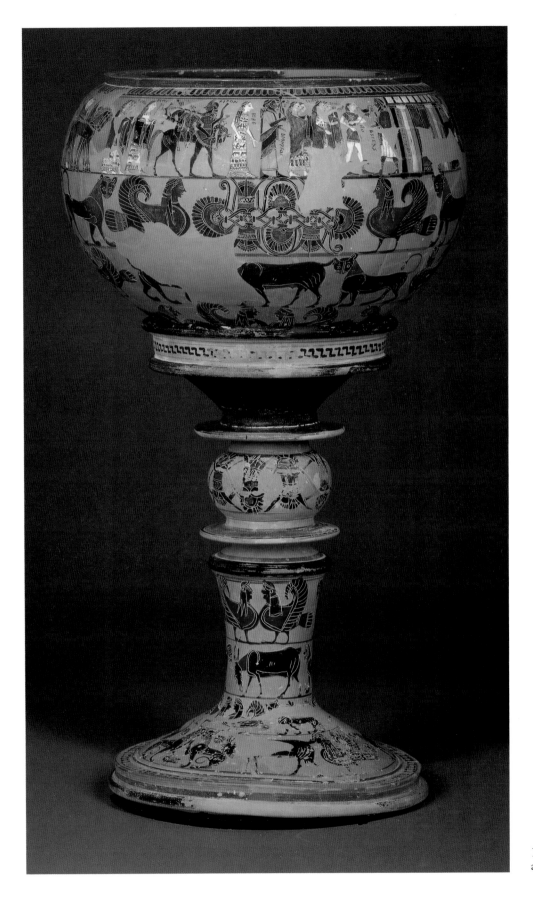

158 The Sophilos Vase after conservation.

159 Detail of the Vase after reconstruction.

tant to follow the same sequence as that used by the original painter. Hence, even in the black areas the layers of terracotta colour were built up first, in order to achieve the richness and depth of the original glossy black decoration. The paint was built up layer upon layer, with a careful sanding using very fine abrasive papers between each coat. Eventually a very smooth, even colour was obtained, and the black areas of the pattern could then be filled in. Again, several layers of paint were needed, carefully sanded and burnished with a special brush made from glass-fibre bristles, to achieve the correct sheen.

The black gloss on the Sophilos Vase has a metallic quality which is in fact the result of a fault in the firing process. When it catches the light in certain directions, this effect can make any restoration look very obvious. The problem was overcome by burnishing powdered graphite into the final coat of paint.

It was originally hoped to leave the stand as it was, at least for the time being. There were not the obvious inaccuracies that were present in the bowl, and it was thought unwise to put the stand through the rigorous process of cleaning off the polyester resin if this was not necessary. However, on examination of the stand, new cracks caused by the ageing polyester resin were discovered. The stand had to support its own weight as well as the weight of the bowl, and it was obviously no

longer in a safe condition to do this. Moreover, the base of the stand had warped during manufacture so that it was in contact with the surface it was sitting on in only two places and could rock backwards and forwards with the slightest vibration. 156 These two areas were therefore supporting almost the entire weight of the Vase. The bowl was also slightly unstable on top of the stand. When newly manufactured, the stand would have been very strong and would have supported the bowl without difficulty. Two thousand five hundred years later, the fragmentary state with pieces missing was putting an unnecessary strain on the fabric. It therefore seemed sensible to make a supporting mount while the stand was being conserved.

The stand went through exactly the same conservation procedure as the bowl, and when it was back in one piece the mount was prepared. It was designed to take into account the warping of the pottery so that the base would stand flat and steady, and also to support the bowl completely independently of the stand. A cushion of silicone rubber was moulded to the shape of the underside of the stand and supported by a case of fibre-glass matting and polyester resin. A similar cushion and support were made for the bowl. The two supports were then joined together using a perspex tube 3 cm (1¼ in) in diameter, which would pass through the hollow centre of the stand. The mount, which is easy to dismantle, fits neatly inside the stand, invisibly 157 supporting the bowl.

After two years the restoration was complete. Peleus and Iris had been reunited 158 with their legs and feet, and the signature now read as fluently as it had when 159 Sophilos proudly signed his masterpiece 2,500 years ago. The Vase, complete with its custom-made mount, was returned to exhibition.

Acknowledgements

All photographs in this chapter are © The Trustees of the British Museum.

Further Reading

J. V. Noble, *The Techniques of Painted Attic Pottery*, London 1966.

A. Birchall, 'A new acquisition: an early Attic bowl with stand, signed by Sophilos', *British Museum Quarterly* 36 (1971–2), pp. 107–9.

R. M. Cook, *Greek Painted Pottery*, 2nd edn, London 1972.

D. Williams, 'Sophilos in the British Museum', *Greek Vases in the J. Paul Getty Museum* I (1983), pp. 9–34.

D. Williams, *Greek Vases*, London 1985.

11 Statue of the Bodhisattva Guanyin

John Larson

Conservators of paintings might naturally expect the original surface of an old work to be obscured by dirty varnish and retouching, but they would not normally expect a picture to have been completely repainted several times. However, when cleaning and conserving polychrome wood sculpture this is a very common occurrence, and conservators specialising in this field have learnt to approach their work like archaeologists, carefully revealing the layers of overpaint, recording their chemical composition and documenting their stratification. In cases where a sculpture has a long history of restoration and refurbishment, the conservator may uncover as many as twenty layers of varnish, paint and gesso (ground). This constant repainting not only blurs the quality of the original carving but also aggravates the natural stresses between the mobile wood of the sculpture and the more rigid layers of the paint and gesso. In some instances, where paint layers have accumulated over a long period, they may form a layer 2–3 mm (approx. ⅛ in) thick.

In much of Europe and North America many great sculpted religious images are now kept in museums rather than in churches and temples. The tendency to display them as works of aesthetic interest, rather than as the focus for religious ritual, means that the museum visitor may find it difficult to understand the true significance of a sculpture for the people who made or commissioned it. This problem is further exacerbated by restoration, which disguises the original character of the carving and decoration with the taste of a later period. The role of the conservator in such cases is not only carefully to reveal the original scheme of decoration (where it still exists) but also to record the subsequent layers, as these can in themselves disclose much about the working techniques and tastes of different periods. When cleaning a sculpture, the conservator can radically change the formal appearance of the object, and in removing a paint layer 0.5 mm thick he may be stepping back in time as much as 100 to 500 years.

The figure of the Bodhisattva Guanyin, now in the Victoria and Albert Museum, was carved in China in the Jin Period (1115–1234). Guanyin is shown seated in the posture of Royal Ease, on a wooden throne carved to simulate rocks. The figure would originally have been placed in a niche carved to resemble the entrance to a rocky grotto, for this is 'Guanyin of the seven seas', seated at ease in a weathered grotto on the shores of his island home, Putuo Shan, off the coast of Zhejiany province in eastern China. In Buddhist belief a Bodhisattva is someone who, through meditation and religious exercises, has prepared himself to enter the blissful state of nirvana. Although he himself is thus freed from the continuous cycle of rebirth, he has chosen to return to help other men achieve a similar release. Guanyin, the Chinese name for the Indian Bodhisattva Avalokiteśvara, has always been a favourite deity with the followers of Buddhism because he is seen as a particularly benevolent

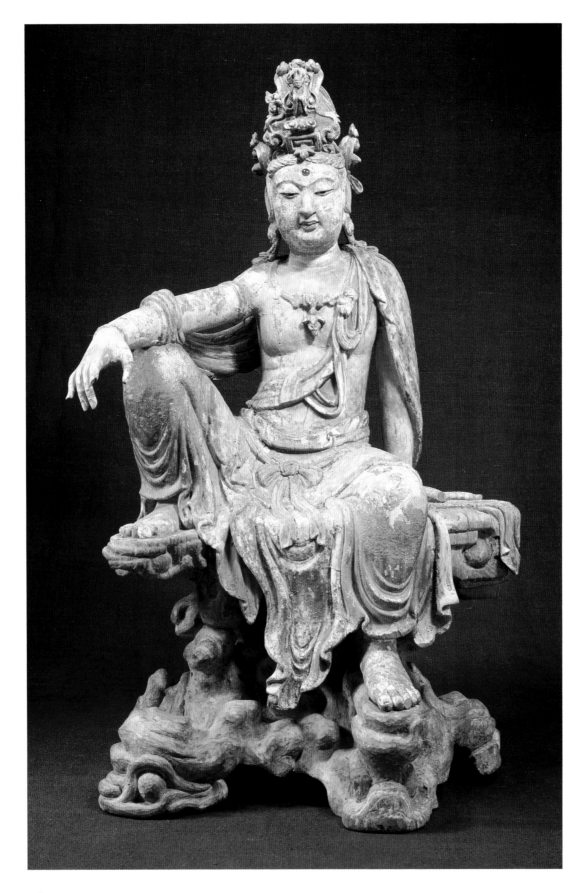

figure, and in this sculpture one can see how the ease of posture, the almost feminine charm and the princely trappings would have produced a comforting feeling in the worshipper.

The figure of Guanyin is not heroic as European god-figures are, but very human in appearance. He has a broad face, long torso, short legs and plump hands with tapering fingers. He is wearing a *dhoti* tied at the waist with a sash to form a double skirt. A long scarf is draped over his shoulder, and the Brahmanic cord is tied around him. He is bejewelled with the five-point crown, a necklet and armlets and bracelets; he wears earrings in his pendant lobes and an *ūrnā* of crystal in the centre of his forehead. His hair is tied into a chignon, with the coronet resting against it.

Although today we see this sculpture as a work of art displayed in a museum, its original function was entirely different. Not only was it the focus of religious worship, but its creation would itself have involved a certain amount of religious ritual. It is common for both Chinese and Japanese wooden sculptures to be constructed with hollow interiors, which were usually filled with religious texts, seeds (associated with ideas of rebirth) and amulets. These were placed in the sculpture at the time of its dedication, and often record the day of dedication, the name of the artist and that of the temple or shrine. Sadly, our Guanyin does not contain any texts or relics of a dedication ceremony. However, many other such sculptures do retain their original documents. One of these, in the Nelson Gallery, Kansas City, is particularly interesting because it carefully records the restoration of the sculpture some 150 years after it was made. The inscription tells us that the image (together with those of a Buddha

161 Buddhist texts found inside a figure of Guanyin. New Orleans Museum of Art.

160 (*Opposite*) The statue of the Bodhisattva Guanyin before conservation. Made in China in the Jin period (1115–1234). H. 130 cm. London, Victoria and Albert Museum.

162 (*Opposite, top*) X-ray of the head of Guanyin, showing the large dowel or post in the centre.

163 (*Opposite, below*) X-ray taken through the waist, showing three vertical dowels.

and another Bodhisattva) was redecorated and repaired by one Feng Xiaoda, a temple artisan, on 10(?) June 1349.

In China, as in much of Europe, it was considered an act of religious duty to maintain sculptures in good order. The physical integrity and the surface richness of an image all help to define its spiritual presence and authority. For the modern conservator who has no cultural affinity with these beliefs, it is difficult to judge how far to proceed with conservation or restoration. Although the Western conservator may wish to reveal the original layers of paint that he knows to be hidden by later accretions, this may go against Eastern sensibilities. The Japanese, for instance, tend to revere ancient surfaces. In Japanese temples and museums one can see many beautiful sculptures that have become darkened by layers of dirt and incense smoke. Under these, traces of exquisite painted and gilded decoration may be visible, but it is unlikely that they will ever be uncovered without a major change in national taste.

In 1978 it was decided that the sculpture of Guanyin was in need of conservation because the painted surface was in poor condition and flaking off. Before it was acquired by the Victoria and Albert Museum in 1935, the sculpture was in a private collection and nothing at all was known of its previous history or of any earlier restorations that it might have undergone. The main difficulty in formulating a suitable treatment, however, was the lack of detailed information regarding the conservation of similar sculptures and indeed of reliable accounts of how such figures would originally have been carved or decorated. It was clear that no cleaning or treatment could begin until a thorough technical examination had been undertaken to identify the materials involved. This analysis would be coupled with a study of Japanese wooden sculpture, the techniques of which were derived from China.

A preliminary examination of the sculpture using a hand lens (\times 10) had revealed that there were many layers of clay, paint, paper and gesso on top of the wood. Although there was no evidence of insect attack in the wood, several splits were visible, suggesting the presence of a number of joints. It was clear that this was a complex wooden structure with an even more complicated paint structure on top of it. The first task was to investigate how the sculpture was originally constructed. Wooden structures are easily penetrated by X-rays, and nineteen different radiographs were taken, covering the sculpture from every angle. Among the interesting discoveries were the fact that the head was carved out of a single block and that this block was joined on to the neck by means of a large wooden post or dowel. A radiograph taken at waist level indicated a joint between the torso and the hips which was secured internally using three vertical tubular dowels. The fact that these dowels appeared to be of a similar density to the surrounding wood suggested that they probably consisted of hollow bamboo tubes. Had they been made of metal, they would have shown up on the radiographs as very dense white shapes.

The radiographs showed clearly that the sculpture was constructed from twelve blocks of wood of irregular size. Neither the head nor the torso was hollowed out to receive sacred texts or amulets, and there were no traces of inscriptions on any of the internal surfaces. The method of construction, although similar to the Japanese *warihagi* system, differed from it in that the individual blocks had not been hollowed to reduce shrinkage of the wood. However, the Guanyin does not appear to have

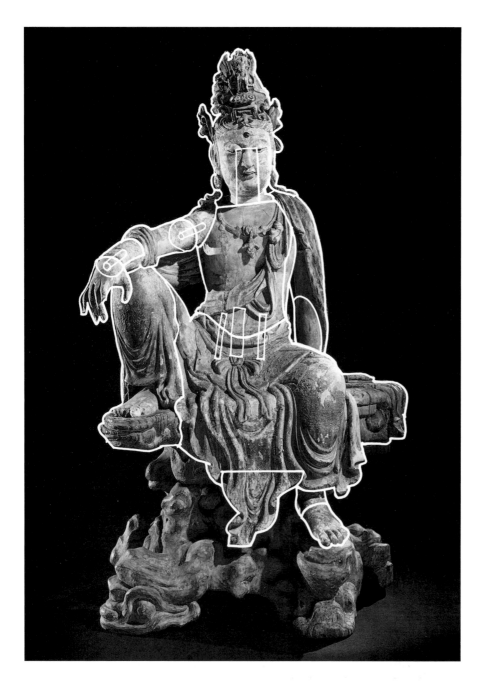

164 (*Above*) Drawing
showing the block
construction of the sculpture
and the dowels.

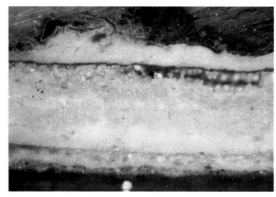

165 (*Right*) A magnified
pigment cross-section
showing the unusual synthetic
green copper pigment found
on the figure.

suffered shrinkage, and the dowels and animal glue which were originally used to hold the wood together are still intact after 800 years.

A small sample of wood, 5 mm (³/₁₆ in) long, was then removed from the underside of the figure, and a similar one from the throne. These were sent to the Jodrell Laboratory in the Royal Botanic Gardens, Kew, for examination and identification. The wood from the figure was identified as *Paulownia* species, commonly known as the foxglove tree. Foxgloves may reach tree size in southern England, but in China they can grow as tall as twelve metres (39 ft) high. The wood from the throne proved to be *Magnolia* species, which also grows to a sufficient size in China to provide blocks suitable for carving sculpture.

At this stage, there was no evidence from radiography or examination of the surface by binocular microscope (× 10–40) that the sculpture had ever been subject to major restoration, apart from the obvious repair of the figure's outstretched right hand. A number of machine-made nails were visible on the radiographs, indicating that some small fragments of wood had been re-adhered in recent times.

It was only when the painted surface was analysed that evidence of important restoration work came to light. Routine pigment analysis involves taking a number of tiny samples, less than 0.5 mm in diameter, from the painted surface of a sculpture. These are usually removed with a fine surgical scalpel. The analyst aims to remove a fragment that encompasses all the layers of paint and ground, including the substrate (in this case, the wood). The samples are then embedded in a clear liquid resin (in this case, a polyester) and when hard the resin and sample are polished so that the layers are clearly revealed. The samples are then examined under a microscope at magnifications ranging between × 100 and × 350. In some cases polarising or ultraviolet light is used. Photographs of the samples are usually taken to provide the conservator with an easy reference to the stratigraphy.

166 In a section taken from Guanyin's raised knee one can see a typical paint and ground structure that was repeated in all the cross-sections. In total some twenty-five

GOLD LEAF	**PERIOD 4 MODERN**
PAPER	19TH–20TH CENTURY
GOLD LEAF	
BOLE	**PERIOD 3 MING**
GESSO	
GOLD LEAF	
BOLE	**PERIOD 2 MING DYNASTY**
GESSO	(1368–1644)
VERMILION AND LACQUER	
KAOLIN AND GESSO	**PERIOD 1 JIN DYNASTY**
WOOD	(1115–1234)

166 Diagram of a typical pigment cross-section from the raised knee of Guanyin.

samples were taken from the surface of the sculpture; many of these revealed a complex sequence involving as many as twelve layers of pigment and ground. The general conclusion that emerged from an analysis of these sections was that the remains of the sculpture's original layer of paint were now obscured by two successive layers of repainting. Owing to the very small size of the pigment samples, however, it was impossible to make any positive statements as to the extent of the remains of each individual pigment layer. This could only be confirmed by carrying out larger cleaning tests on the surface of the sculpture itself.

Although some of the pigments could be readily identified optically and by the use of simple chemical tests, others were sent to the National Gallery in London for more sophisticated scientific testing. The results showed that Chinese artists tended to use many more synthetic pigments (i.e. pigments which are prepared from plants and are not naturally occurring) and dyes than their European counterparts when painting sculpture. For instance, on the hair of Guanyin successive painters had used indigo (derived, like woad, from the plant genus *Indigofera*) rather than a mineral pigment such as azurite to achieve a rich blue colour. (To paint hair blue on figures of the Buddha or a Bodhisattva is quite common in Chinese and Tibetan art, and is one of those aesthetic differences that can be confusing for the Western conservator.) There were many traces of Chinese vermilion, which we know to have been produced synthetically at an early date in China, but it was surprising to find a sample of a beautiful synthetic copper-green pigment (a type of verditer similar to that described by Cennino Cennini in the earliest Italian treatise on painting, *c.*1390). The National Gallery had not found this pigment on any European painting before the fifteenth century, but another example was subsequently found on a thirteenth-century sculpture of Guanyin in the Victoria and Albert Museum. Seen in cross-section, the pigment has a very characteristic appearance as a series of small round particles, like fish roe, with a white centre surrounded by a shell of green. When ground to a fine powder it strongly resembles a pale malachite, and when mixed with an aqueous medium produces a bright emerald green. The manufacture of this pigment involves precipitating a copper salt, such as verdigris, on to an insoluble white material such as calcite. Recent attempts to reconstruct the process of manufacture have demonstrated the importance of temperature and atmospheric conditions for the proper formation of the spherical green pigment particles.

Beneath the original paint layer and subsequent restorations the Chinese painters, like their European counterparts, had used a white mineral ground mixed with glue size to create a gesso, or ground on which to apply their paint. In Europe the mineral element would traditionally be calcium carbonate (chalk) or calcium sulphate (gypsum), but in this case chemical analysis and optical microscopy both showed that kaolin (white china clay) had been used. Kaolin has now been found on many other Chinese sculptures and appears to be one of the most common grounds used for painting sculptures in both China and Japan, the other being white lead.

In the cross-sections and during the examination of the surface it was found that the most recent layer of restoration (dating from the late nineteenth or early twentieth century) had been laid down on a thick layer of very fibrous paper. It appears that when refurbishing an ancient sculpture, Chinese restorers would disguise losses of paint, gesso and cracks in the wood by covering them with a layer of paper and size.

165

167 Detail of the
statue's right knee,
showing the flaking paint
surface before
conservation.

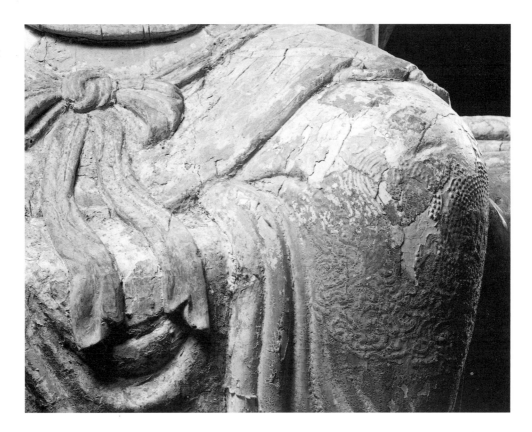

They would apply a layer of white lead or kaolin gesso over this, and then repaint the surface as though it were an original one.

Although analysis of the pigment layers had shown that glue size was used as a binding medium for most of the pigments, Chinese lacquer (derived from the tree *Rhus vernicifera D.C.*) was found to have been mixed with the vermilion pigment on the *dhoti*. In general, most mineral pigments preserve their brilliance better in glue size than in oil. Oil tends to saturate and therefore darken many pigments, and it does not seem to have been used on most Chinese sculpture.

Once the thorough examination of the structure of the sculpture and the complex layers of restoration had been completed, it was possible to formulate a course of treatment. It was clear that the paper layer and all the pigment above it was the main cause of damage to the surface of the sculpture, and the removal of this would not only improve the aesthetic appearance of the object but also reduce the disruption caused by the expansion and contraction of the paper. However, it was decided to leave some small areas of the paper *in situ*, to allow future conservators to analyse them if required. For this initial stage of cleaning, a mixture of distilled water and acetone (50/50) was applied with small cotton wool swabs to the area of the raised knee. Although this had little cleaning effect, it did swell the layer of paper beneath the overpainting sufficiently to make its removal with a scalpel feasible. Next, a mixture of a slow-evaporating reagent (2-ethoxy ethanol) with water was tried; this further softened the paper and oil-gilding, making its removal easier. (The early layers of gilding were all water-based; only the very last top layer of gold was laid on with oil.) However, the layers of gilding and gesso beneath the paper were so

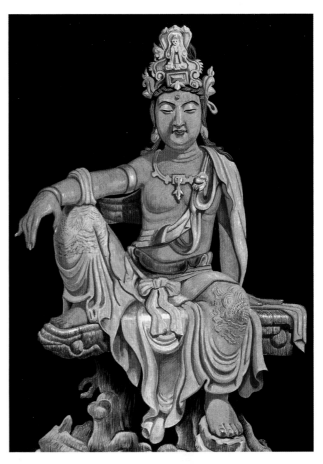

friable that it was impossible to continue to remove the softened paper without risking further damage to them. It was therefore decided to combine the cleaning operation with consolidating the layers under the paper. As the paper seemed to extend over the whole surface of the sculpture, it was felt that this technique would be suitable for all areas and not just the particular area being dealt with at that time.

A 5–10% solution of polyvinyl acetate resin was dissolved in equal parts of acetone and 2-ethoxy ethanol. When applied to small areas of the sculpture this solution penetrated the paper layer and caused it to swell, but it was also sufficiently 'tacky' to hold the fragile layers underneath in place while the paper was removed with a scalpel. This procedure was obviously painstakingly slow, but, as can be seen from photographs taken before treatment, the surface was badly decayed and cleaning would have been impossible without some form of consolidation.

During the cleaning of the gilded *dhoti* the conservators uncovered evidence of a paint layer which had not been seen in the paint sampling survey. This is of course one of the problems connected with trying to extrapolate information based on the evidence of tiny samples in order to reconstruct the original appearance of a much larger surface. Under the thick grey paper were fine layers of water-gilding over kaolin gesso, but in an area where these had flaked there was a bright red layer with a fine line of gold leaf on top of it. This suggested that the elaborate gilded decoration of the *dhoti* was not in fact original, but the result of later restoration. On removing

168, 169 Colour reconstruction drawings showing the sculpture as it originally appeared (*left*) in the Jin period (1115–1234) and (*right*) in the Ming period (1368–1644).

170 (*Opposite*) The statue of Guanyin after conservation, restored to its appearance during the Ming period.

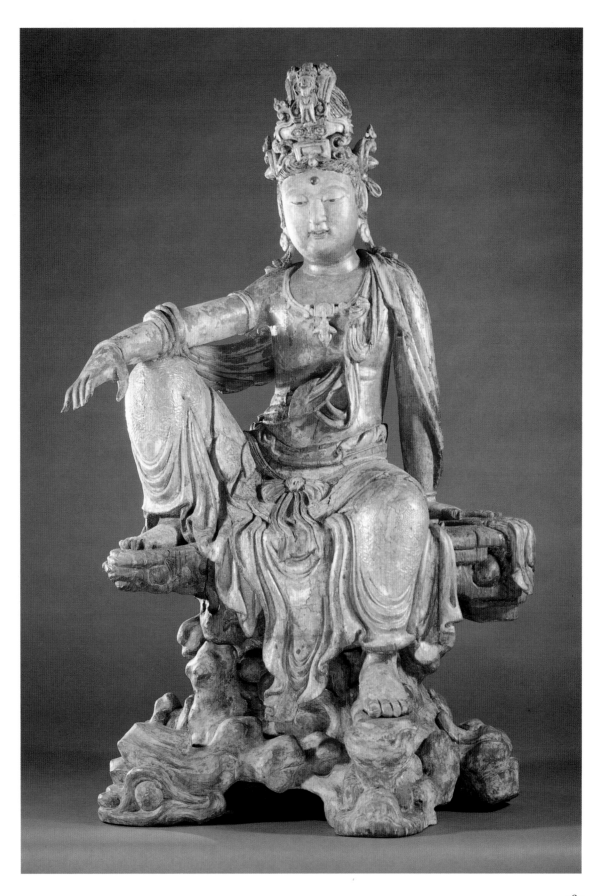

some of the gilding and gesso at the side of the raised knee, it could be seen that these robes had originally been painted red, using a mixture of vermilion pigment and Chinese lacquer. Over the red, a series of fine lines in gold leaf had been laid (using the technique known in Japan as *kirikane*, or 'cut-gold') to further emphasise the lines of the drapery folds.

The work of cleaning was spread over a period of two years, one particular area being investigated at a time. Among the interesting discoveries were the fact that on the neck and chest of the figure, beneath the layers of red lead, kaolin and paper, the torso was covered with a fine coating of gold leaf over a layer of bright vermilion red. It seemed quite extraordinary that the flesh areas on the sculpture should be gilded. Indeed, the gold leaf was so thin that the vermilion underneath would originally have given the gold a reddish tint, making the sculpture look as though it was made of copper-bronze. By contrast, on the back of the neck the bottom layer of paint was actually a bright pink, representing normal flesh colour.

It was now clearly established that the sculpture had originally been painted and had then been subject to three restorations. The characteristic differences between the first two restorations have made it possible to link them to specific stylistic changes marking the differences in the treatment of sculpture between the Jin and the Ming dynasties. By drawing comparisons with other sculptures of known date it has been possible to construct the following chronology of restoration:

Period 1 Jin dynasty (1115–1234)

Periods 2 and 3 Ming dynasty (1368–1644)

Period 4 Late nineteenth to early twentieth century

The justification for dating the original painting of the sculpture to the late twelfth century is based on the existence of many other examples of naturalistically painted sculpture with known dates and provenance. The layers of periods 2 and 3 (period 3 is merely a refurbishment of period 2) have been dated on the basis of comparisons with other Ming sculptures in many different media. Further examination of Ming 168, 169 sculptures in wood, ivory and bronze has shown a distinct taste for elaborately decorated metallic-looking surfaces irrespective of the substrate material. It appears that Ming sculptors would often vary the brashness of the metal by applying semi-transparent red glazes over them to achieve the effect of a coppery lustre.

That the history of this Guanyin is not entirely unusual has recently been proved by work on a smaller figure of the Bodhisattva which is in a private collection. The conservation of this piece by Sophie Budden and Valerie Kaufmann has revealed layers of decoration of both Jin and Ming periods that correspond exactly with those found on the Victoria and Albert example.

During the cleaning of the Guanyin it became clear that such conservation was only feasible in cases where the conservator could work in close co-operation with art-historians and scientists. For the conservator to make any decisions regarding cleaning it was first necessary to possess a broad spectrum of historical and scientific data. Throughout the work the conservators were keenly aware that they were breaking new ground and could easily destroy important historical evidence or end up with a sculpture that looked more like a scientific experiment than a work of art. Although it would have been technically possible to remove the Ming decoration and

to reveal the original paint layer underneath, to do so would have risked damaging the Jin painting and would irretrievably have destroyed the Ming decoration.

170 The figure of Guanyin has always had great presence and beauty, but the work of conservation and cleaning has revealed some of the fine detail on its surface. The subtle curve of the thigh and the evidence of musculature in the arms have been uncovered, and the details of the jewellery and costume have been defined. Thus not only have advances been made in the analysis and understanding of a complex sculpture, but the beauty of a great masterpiece has been enhanced.

Acknowledgements

The author would like to thank Josephine Darrah, Ashok Roy and Raymond White for the analysis, and Rose Kerr for the art-historical background to this chapter. The photographs are © The Trustees of the Victoria and Albert Museum, with the exception of Fig. 161, which is reproduced courtesy of the New Orleans Museum of Art.

Further Reading

O. Siren, *Chinese Sculpture from the 5th to the 14th Centuries*, 4 vols, London 1925.

G. Gabbert and W. Lieb, 'On the use of a gastro-fibrescope for reading inscriptions on the inside of Japanese sculptures', *Studies in Conservation*, vol. 15, no. 4 (1970).

K. Yamasaki and K. Nishikawa, 'Polychromed sculpture in Japan', *Studies in Conservation*, vol. 15, no. 4 (1970).

L. Sickman and A. Soper, *The Art and Architecture of China*, 2nd edn, London 1978.

N. Kyotaro and E. J. Sano, *The Great Age of Japanese Buddhist Sculpture AD 600–1300*, Kimbell Art Museum, Fort Worth, 1982.

W. Watson, *Art of Dynastic China*, London 1982.

D. Gillman, 'A new image in Chinese Buddhist sculpture of the 10th to 13th century', *Transactions of the Oriental Ceramic Society* 47 (1982–3).

J. Larson and R. Kerr, *Guanyin: a Masterpiece Revealed*, London 1985.

Eskenazi, *Ancient Chinese Sculpture from the Alsdorf Collection and Others*, London 1990.

V. Harris and K. Matsushima, *Kamakura: the Renaissance of Japanese Sculpture 1185–1333*, exhibition catalogue, British Museum, London 1991.

Index